3ds max 6 ESSENTIALS:
A REAL-WORLD APPROACH

3ds max 6 ESSENTIALS: A REAL-WORLD APPROACH

DAVID J. KALWICK

CHARLES RIVER MEDIA, INC.

Hingham, Massachusetts

Publisher: Jenifer Niles
Production: Publishers' Design and Production Services, Inc.
Cover Design: The Printed Image
Cover Image: David Kalwick

CHARLES RIVER MEDIA, INC.
10 Downer Avenue
Hingham, Massachusetts 02043
781-740-0400
781-740-8816 (FAX)
info@charlesriver.com
www.charlesriver.com

This book is printed on acid-free paper.

David Kalwick. *3ds max 6 Essentials: A Real-World Approach.*

ISBN: 1-58450-267-3

All brand names and product names mentioned in this book are trademarks or service marks of their respective companies. Any omission or misuse (of any kind) of service marks or trademarks should not be regarded as intent to infringe on the property of others. The publisher recognizes and respects all marks used by companies, manufacturers, and developers as a means to distinguish their products.

Library of Congress Cataloging-in-Publication Data

Kalwick, David J.
 3DS Max 6 essentials : a real-world approach / David Kalwick.
 p. cm.
 ISBN 1-58450-267-3 (pbk. with cd-rom : alk. paper)
 1. Computer animation. 2. 3ds max (Computer file) 3. Computer graphics. I. Title.
 TR897.7.K355 2004
 006.6'96—dc22
 2003028074

Printed in the United States of America
04 7 6 5 4 3 2 First Edition

CHARLES RIVER MEDIA titles are available for site license or bulk purchase by institutions, user groups, corporations, etc. For additional information, please contact the Special Sales Department at 781-740-0400.

Requests for replacement of a defective CD-ROM must be accompanied by the original disc, your mailing address, telephone number, date of purchase and purchase price. Please state the nature of the problem, and send the information to CHARLES RIVER MEDIA, INC., 10 Downer Avenue, Hingham, Massachusetts 02043. CRM's sole obligation to the purchaser is to replace the disc, based on defective materials or faulty workmanship, but not on the operation or functionality of the product.

A special dedication goes to my eldest daughters, Nicole and Megan, who truly are the most wonderful children a dad could ever hope for. I love you both dearly. Thank you for being who you are.

Additionally, I dedicate this book to my family and friends who have stood by me, not only while I was writing this book but also for the past two years, especially Farrell, Doug, Debra, Annie, Jovita, John, and Elisa. You've all been there for me in some way and you are special to me. Thank you for being there.

I'd also like to welcome two most beautiful angels to the world, my twin daughters Emma Grace and Hanna Rose.

CONTENTS

CHAPTER 15 RENDERING—GETTING TO PIXELS **351**

CHAPTER 16 PARTICLE FLOW FOR MODELING AND EFFECTS **375**

APPENDIX A 3DS MAX FILE FORMATS **395**

APPENDIX B ABOUT THE CD-ROM **397**

INDEX **399**

PREFACE

In today's fast-paced world, there are many designers looking for a quick solution. This book is designed to reduce the learning curve of 3D animation drastically, but it's not a replacement for experience. Throughout the book you will learn new skills and practice various techniques with hands-on tutorials, but you still have to work hard to master your craft. If you truly love this art form, make it your passion, study the tutorials, and you will succeed. This book strives to make the journey an exciting one. It's up to you to take the first step.

3ds max 6 Essentials: A Real World Approach is intended to take you from a very limited knowledge of 3ds max to a level of intermediate proficiency. Extensive tutorials engage you while introducing the tools that are new to 3ds max 6. Because the tutorials explain why and how certain tools are used, you'll learn not only how to handle the task at hand, but also how to tackle future modeling and animation problems.

Anyone who is interested in making the most of the 3ds max 6 toolset should read this book. Extensive tutorials engage you, while making use of tools that are new to 3ds max 6. The book contains information that pertains to creating 3D animation in the real world. It's not a book on 3D theory; it focuses on solving modeling and animation problems that occur in the professional world of 3D graphics. All of the tutorials build sensible models, not random shapes, and provide an abridged version of the overall procedure of creating an animated short. Throughout the book you are encouraged to apply the procedures to expand your knowledge and use of the tools.

ACKNOWLEDGMENTS

Behind every author is a team of dedicated individuals, all striving for the same goal. I'd like to thank all those at Charles River Media who have helped put this book together, especially Jenifer Niles for being patient when things ran slow and for understanding life's challenges.

I'd also like to thank Chris Neuhahn for his technical editing, objective critiques, and invaluable suggestions.

Finally, thanks to all those at discreet for their work in creating an excellent product and keeping me connected to it, especially David Marks.

ABOUT THE AUTHOR

David Kalwick is a discreet Certified Instructor who has written several books on 3ds max over the past nine years. He has taught thousands of 3D artists through his books and corporate training seminars as well as personal instruction. David also teaches at the Art Institute of California, San Diego, and at University of California, San Diego Extension.

David is the founder of Absolute Zero, a presentation graphics company that specializes in forensic animation and interactive trial presentations. He has supported numerous trial teams nationwide, with graphics and interactive media. In addition, his animations have been used in technical and medical applications throughout the world. More information about Absolute Zero and trial graphics can be found at *www.abszero.com.*

On the personal side, David enjoys surfing, traveling, and playing the didgeridoo. The didgeridoo was first played in Australia by the Aboriginal tribes of Northeast Arnhem Land. For more information about didgeridoos and native Australians or David's upcoming trip to Oz, go to *www.loudstick.com.*

1

INTRODUCTION

In this chapter

- Manipulating the Views
- Introduction of the 3ds max 6 Interface

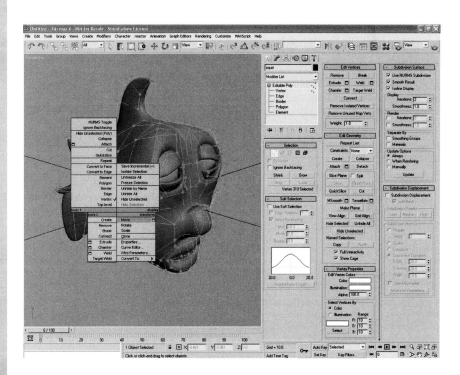

Welcome to 3ds max 6! This version of 3ds max is by far the most exciting version in terms of features and interface design. Whether you are new to 3ds max or an old 3D pro, working in 3ds max 6 is a breeze. At first glance, you will see loads of buttons and controls, and you may even be somewhat overwhelmed. Take a deep breath and relax. Shortly, you will find 3ds max 6 to be the most intuitive 3D program in the industry. Hold on—you are about to begin a fantastic journey.

THE VIEWS

The most noticeable attribute in 3ds max 6 is the views. A view is a means of seeing the model or environment that you are creating. The default setup in 3ds max is a four-view layout, as shown in Figure 1.1. The default layout comprises three orthographic views (Top, Front, Left) and one Perspective view.

Whereas an orthographic view portrays all objects in actual size relative to one another, a Perspective view shows how objects would look in the real world (or based on a real-world lens). Orthographic views are es-

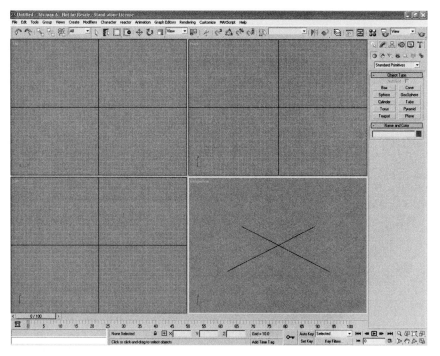

FIGURE 1.1 The default view layout in 3ds max 6.

sential when modeling, because objects are not distorted by distance. Figure 1.2 shows the difference between an orthographic Front view and a Perspective Front view. Notice the difference in how the objects appear.

A view is activated when you click within that view window. A yellow band appears around the perimeter of the active view. You can manipulate active views by zooming, panning, and rotating using the View Tools.

Right-clicking on a view activates the view without deselecting any currently selected objects. If you click the left mouse button, the selection is deselected.

VIEW TOOLS

Many tools and hot keys are available to configure the views to suit your needs. In the lower-right portion of the interface is a group of icons, the View Tools. The View Tools dynamically change, based on which view is active. Figure 1.3 depicts the View Tools with the Perspective window active.

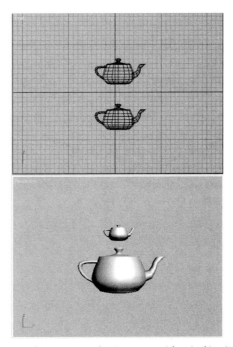

FIGURE 1.2 Both teapots in this image are identical in size. In the Perspective view, the top teapot is farther away and appears smaller, whereas in the orthographic Front view, it is shown in its actual relative size.

Get to know the View Tools and their shortcut keys because navigating a view quickly is essential to efficient modeling. Table 1.1 explains the View Tool icons and their shortcut keys.

 To deactivate any tool, including the View Tools, right-click in the active view. The tool cursor is replaced with a standard cursor, and the tool is no longer active.

FIGURE 1.3 The View Tools, from left to right: the Zoom, Zoom All, Zoom Extents Selection, Zoom Extents All, Field of View, Pan, Arc Rotate, and Min/Max.

TABLE 1.1 View Tool Icons and Shortcut Keys

VIEW TOOL	SHORTCUT KEY	DESCRIPTION
Zoom	ALT + Z	Moves the view closer or farther away from the scene. By zooming, you can quickly see detail or an entire scene. This tool also works when rolling the mouse wheel or clicking the middle mouse button.
Zoom All	NA	Zooms all views simultaneously.
Zoom Extents	NA	Zooms the active view to show all objects in the scene. Click and hold the icon to reveal the Zoom Extents Selected option, which zooms the active window to just the selected object.
Zoom Extents All	NA	Zooms out so that all objects can be seen in all views.
Field of View	NA	Changes the lens length used in the Perspective view, thereby changing the distortion of objects in the distance and along the edges of the view. A wider field of view gives the illusion of more depth in a scene but also causes distortion. In orthographic views, this view becomes the Region View, which enables the view to zoom in based on a region selected in the view.
Pan	NA	Moves the view in four directions (up, down, left, right) without changing the zoom distance. Alternatively, you can click the middle mouse button or the mouse wheel while dragging the mouse to cause the view to pan without clicking the Pan Tool.
Arc Rotate	NA	Rotates the view around the scene or selected object without changing the distance the view is from the scene. Click and hold the icon to reveal options for rotating the arc around the selected objects or their components. Press the ALT key and the middle mouse button or mouse wheel and drag the mouse in a view to rotate the arc in the current view.
Min/Max Toggle	ALT + W	Makes the active view fill the interface, thereby covering the other three views.

MANIPULATING VIEWS

You can control how objects are displayed in 3ds max 6 using the previously described View Tools. The following tutorial will familiarize you with manipulating the views.

ON THE CD

TUTORIAL **MANIPULATING THE VIEWS**

1. Start by opening a file. Click the File menu and choose Open.
2. The File Open dialog box (shown in Figure 1.4) opens. Navigate to the *Tutorials/Chapter 01* folder and highlight the *vase.max* file.
3. Click the Open button or double-click the *vase.max* file. The .max file opens, and each of the four views displays the scene from different angles, as seen in Figure 1.5.
4. Right-click in the Perspective view to make it the active view. The border around the Perspective view turns yellow, indicating that it is the active view.

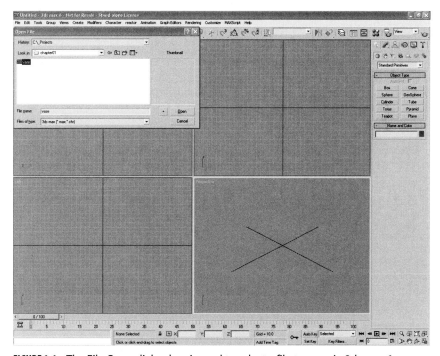

FIGURE 1.4 The File Open dialog box is used to select a file to open in 3ds max 6.

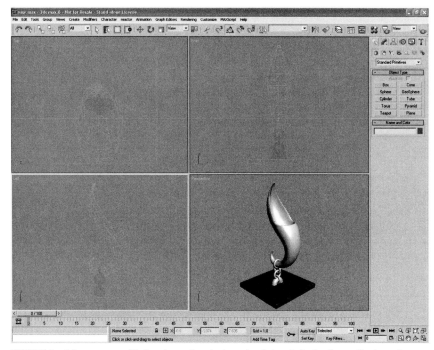

FIGURE 1.5 After a scene file has been loaded, each of the default views displays the scene from a different angle.

5. Click the Zoom icon in the lower-right corner of the interface. Click and drag up and down in the Perspective view. The vase moves closer and farther away. This is called zooming.

If you zoom in and your image looks something like that shown in Figure 1.6, you have zoomed into the camera's clipping planes. Don't panic. Clipping planes will be discussed later. For now, be assured things are okay.

6. Activate the Zoom All tool, and repeat the clicking and dragging in the Perspective view. Notice now that all views are adjusted simultaneously.
7. Click the Zoom Extents icon. The active view now displays all the objects in the scene.
8. Select one of the links on the chain in the Perspective view.
9. Click and hold on the Zoom All icon. From the flyout menu, shown in Figure 1.7, select the second option, Zoom Selected. This option looks like a white box (as opposed to the gray box in Zoom All). After you release the mouse button, the active view zooms in so the selected object fits within

FIGURE 1.6 The missing geometry in this image is due to the view's clipping planes. To correct the missing geometry, zoom out slightly.

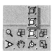

FIGURE 1.7 The Zoom All flyout menu. From top to bottom, the icons are Zoom All and Zoom Selected.

the active view. All other views remain as they were. Figure 1.8 shows the Perspective view zoomed in using the Zoom Selected tool with the chain object selected.

10. Now select the Field of View tool. Click and drag in the Perspective view. Notice that no matter how far you drag the cursor, the object doesn't pass the camera. The Field of View tool changes the focal length of the camera lens and doesn't move the camera, like the Zoom and Zoom All tools do.

11. Now click the Pan tool. Clicking and dragging in the Perspective view (or any other view) moves the view in the horizontal and vertical planes but doesn't change any other aspects of how the scene is viewed.

12. Going back to the Perspective view, click the base component of the vase scene. Select the Arc Rotate tool. A trackball overlay is placed in the Perspective view, as shown in Figure 1.9.

13. Click and drag inside the circular portion of the trackball overlay. Notice how the view rotates around the vase.

14. Click and drag outside of the circular trackball overlay to rotate the view along the z axis only.

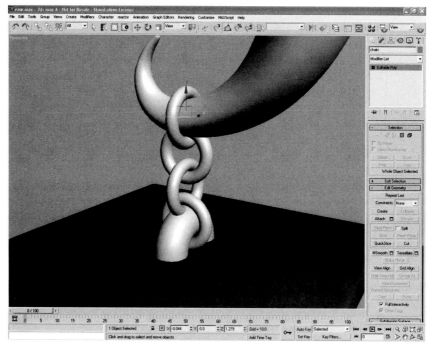

FIGURE 1.8 Because the chain portion of the vase was selected, clicking the Zoom Selected icon zooms the active view to tighten around the chain only.

15. Click and drag an x located on the trackball to constrain the view to either horizontal or vertical rotation.

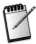

In addition to the general Arc Rotate tool, the Arc Rotate flyout menu includes two other options for arc rotating, rotating around the selected object and Sub-Object selection.

16. With the base of the vase selected, click and hold the Arc Rotate icon. Drag down the flyout menu to select the white Arc Rotate option, which enables rotation around the selected object. Notice how the view pivots off of the base object as opposed to the center of the scene, as it does when the default Arc Rotate tool is used.

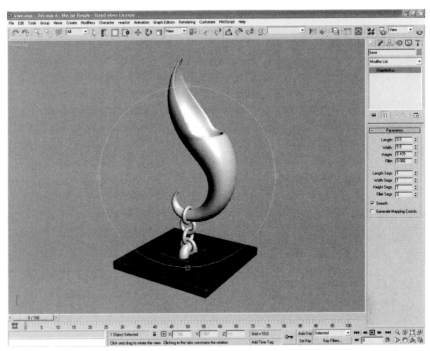

FIGURE 1.9 When the Arc Rotate tool is activated, a trackball overlay is placed in the active view. This overlay becomes an interactive tool from which the view can be rotated in any direction, either by clicking in the center, outside the trackball, or on the handles.

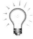

Leaving the Arc Rotate tool in Sub-Object mode works like Selected Object mode when a sub-object selection isn't made. This gives you the benefit of rotating the scene around the selection, whether it is an object or a sub-object.

THE MAIN TOOLBAR

Found at the top of the 3ds max interface, the Main Toolbar, shown in Figure 1.10, was designed to provide quick access to many tools common to the typical modeling process. Included on the Main Toolbar are tools for selection, transformation, alignment, Undo/Redo, and rendering. These and additional tools can also be found in the text menu located above the Main Toolbar. Each of these tools will be discussed throughout the book.

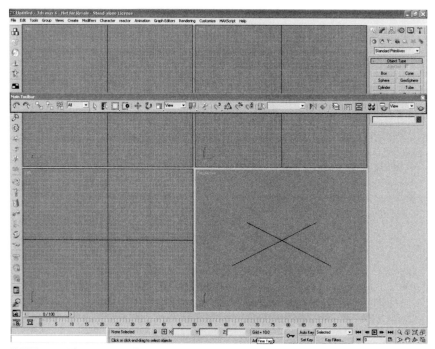

FIGURE 1.10 The Main Toolbar provides quick access to many common tools. In this example, the Main Toolbar is floating in the interface. This is accomplished by clicking and dragging the toolbar away from its attached position.

THE COMMAND PANEL

The Command Panel is the control center for nearly every operation in 3ds max. All of the creation and modification tools are found in the Command Panel, which is divided into six sections with tabs across the top of the Command Panel, as shown in Figure 1.11.

As you progress through the tutorials in this book, you will use the Command Panel extensively. For now, become familiar where it is and how to access the different panels, which are described in the following list:

Create Tab: Builds objects and adds lights, cameras, and other helper objects. The Create Panel contains seven other tabs for object creation. Those tabs also contain other classes of objects and more than 150 objects, including geometric primitives, helpers, cameras, and other tools to create 3D art.

FIGURE 1.11 The Command Panel is the control center for most modeling and animation activity.

Modify Tab: Contains the Modifier Stack, which is used to modify objects through the use of modifiers and geometry manipulation tools.

Hierarchy Tab: Manipulates components in a hierarchical structure. Used extensively during animation, this panel controls Pivot, IK, and Link parameters.

Motion Tab: Adds animation key frames and adds or changes animation controllers.

Display Tab: Turns object types off to make the scene less cluttered during the modeling and animation phases. Most controls in the Display tab do not affect the final rendering.

Utility Tab: Contains a wide variety of extra tools, including the MaxScript utility and color clipboard.

At times, the Command Panel can contain many parameters and sections, depending on what type of tool is being used or what modifier is applied. When using the Command Panel, it is advantageous to have dual monitors, using one monitor for the modeling window and the other for the Command Panel. The Command Panel can be detached and used like a floater, as shown in Figure 1.12. Click in the gray area above the tabs and drag the Command Panel to the center of the screen.

The Command Panel can also be docked on either side of the interface by right-clicking in the title bar of the new floating window, as shown in Figure 1.13.

In addition to being docked on either side of the interface, the Command Panel can also be expanded to reveal more components by clicking and dragging the left edge of the panel. When dealing with objects with complex modifiers, expanding the Command Panel enables you to view

FIGURE 1.12 The Command Panel can be detached and used as a floating window.

FIGURE 1.13 The Command Panel can be docked using the shortcut menu found by right-clicking in the title bar.

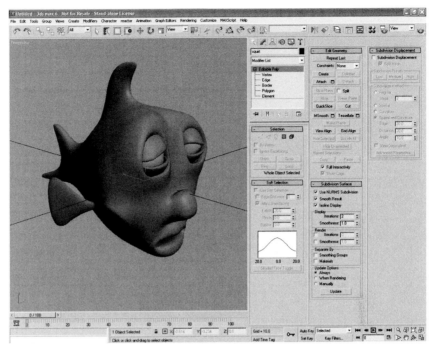

FIGURE 1.14 The Command Panel can be expanded by clicking the left edge and dragging to pull out the panels.

many of the components quickly, as shown in Figure 1.14. If you work with complex modifiers, having dual monitors will help you work more efficiently. To restore the Command Panel to a single frame, drag the left edge toward the right side of the screen until the panel collapses.

QUAD MENUS

One of the most convenient additions to 3ds max 6 is the Quad menu. Quads, as they are sometimes called, are context-sensitive popup menus invoked by right-clicking in a view. Figure 1.15 shows a typical Quad menu.

Quad menus contain a variety of tools and commands that are context sensitive. As you select different objects, the menu options change. If a menu option isn't available, be sure that you have the correct object selected. Figure 1.16 shows examples of different Quad menus, based on different selected objects.

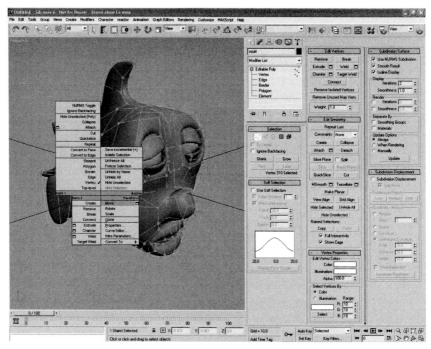

FIGURE 1.15 Quad menus provide quick access to many tools, without having to move the mouse. You can customize these menus using the Customize/Customize User Interface option.

FIGURE 1.16 This sample of Quad menus shows different options because different objects are selected.

ROLLOUTS, INPUTS, SPINNERS, AND FLYOUT MENUS

3ds max presents a parametric environment, meaning most operations are handled through the use of parameters. By using parameters, object properties can be changed in a nondestructive way. Object properties will be discussed in subsequent chapters. For now, let's look at the different methods for controlling parameters.

Rollouts

Rollouts are not so much parameter controls as they are interface controls. Rollouts are used to hide or collapse groups of related parameters. Because 3ds max has so many controls, rollouts provide a means of reducing the clutter. A rollout, as shown in Figure 1.17, consists of a title and a + (plus sign) or a – (minus sign). Click the title of the rollout to collapse or expand its contents.

To move between rollouts quickly, right-click in gray space in the Modify Panel. All of the rollouts for that object or modifier are displayed. When you select from the list, you are instantly transported to that rollout in the Modify Panel.

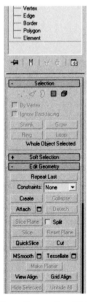

FIGURE 1.17 A rollout is used to hide related parameters. In this image, the Selection rollout is expanded and the Soft Selection rollout is collapsed. Clicking the title expands the rollout when a + is shown. A – is displayed when the rollout is open.

Inputs

An input can be either numeric or textual. An example of a text input is an object name box, whereas values, such as the radius of a sphere, are numeric. Value inputs are labeled to indicate what the value represents. Figure 1.18 illustrates some value inputs. Every numeric value input contains a spinner control.

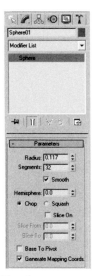

FIGURE 1.18 Most inputs are numeric, such as the radius and segments parameters shown here.

Spinners

Spinners, which enable you to quickly change numeric values, consist of an up and down arrow control that changes the value positively or negatively, depending on which arrow you click. The increment amount is based on preprogrammed values in 3ds max and varies for different input types. For example, the segments parameter is an integer and increments by one each time the up arrow is clicked, whereas the radius value of a sphere increments by a percentage of the current radius each time the up arrow is clicked.

The spinner controls can be clicked on and dragged up or down to change the value, instead of clicking each time you want the value changed. For example, click and drag up on a spinner and the value is increased. With the mouse button still held down, drag the mouse down and the value is decreased.

Flyout Menus

A flyout menu is a miniature menu that "flies out" or pops up from an icon. Many tools within 3ds max have flyout menus that contain relevant options for the selected tool. The Select and Scale tool has a flyout menu containing different scale tools. A tool's flyout menu is indicated with a small white triangle in the lower-right corner, as shown in Figure 1.19. You activate a flyout menu by clicking and holding the icon, then dragging to the desired tool choice. The scale tool's flyout menu is shown in Figure 1.20.

FIGURE 1.19 A tool's flyout menu is indicated with a small white triangle in the lower-right corner of the tool's icon.

FIGURE 1.20 Clicking a tool with a flyout menu reveals multiple, related tools.

SUMMARY

Some of the basic interface components were discussed in this chapter. Becoming familiar with the 3ds max interface is a vital part of efficient modeling. In this chapter, you learned about:

- The different views
- The Main Toolbar
- Quad menus
- Rollouts, spinners, inputs, and flyout menus

This chapter introduced you to some of the types of interface components that you will encounter and become more familiar with as you work through the tutorials in this book. During the tutorials, additional tips for manipulating controls are revealed. Before continuing to the next chapter, be sure you understand where each of the major control centers are within 3ds max, because they are referenced extensively throughout this book.

THE 3DS MAX
PRODUCTION PIPELINE

In this chapter

- Planning for Animation
- Bidding on a Project
- The Production Pipeline

As with any project, planning is the key to success. The saying "Those who fail to plan, plan to fail" holds especially true in the world of graphic production. For 3D artists, planning can mean the difference between making a deadline, or making a profit, or not. Creating 3D imagery is expensive because of the complexity of the art form. Clients who commit large budgets to a production expect to see their investment pay off. By having a production pipeline in place, you can ensure that you and your client know what to expect during the entire product lifecycle.

PROJECT PLANNING

All projects begin with one thing: an idea. The idea may stem from a need to solve a problem or to deliver a message. To address those needs, solutions are contemplated and debated. At some point a decision is made and production begins. As a 3D artist, you may be brought in at any point during a project, though in many cases, it is late in the game. Having a production pipeline in place prior to production is always a good idea, regardless of when you are brought onto the project. To be effective, you need to assert yourself in obtaining the information required to complete the job efficiently. Planning and visualization is of utmost importance to ensure that the final deliverable is exactly what is expected and agreed to. This chapter outlines a 12-step program to make the entire process of delivering a 3D project as painless as possible.

Each of the successive steps is designed to continually break down the problem until no ambiguity remains. When the problem is broken

THE IMPORTANCE OF PLANNING

My attitude may lean toward expecting problems, but the reality is that without planning, minor problems can become severe. Years ago, I was a peon for a company to which a client refused to pay for more than $40,000 of animation services because the final product wasn't exactly what they said they wanted. There was no plan and no storyboards, just a lot of lawyers interjecting their ideas over several months of intense, last-minute production. Ultimately, changes made by one person were overwritten by another until no one was sure what the deliverable was.

down to the very steps required to solve it, there is less chance of error along the way. Errors caught in the planning stages are easier to fix than those discovered at the eleventh hour. The following 12 steps are discussed in detail in the following sections:

1. Assessing the Problem
2. Bidding and Billing
3. Signing Copyright, Non-Disclosure, and Non-Compete Agreements
4. Getting Approvals
5. Creating Storyboards and Model Sheets
6. Creating Mock-ups and Animatics
7. Starting Full-Scale Production
8. Delivering Preliminary Content
9. Delivering Final Content
10. Billing the Client
11. Ending the Contract
12. Giving Recognition

ASSESSING THE PROBLEM

The crux of any project is correctly assessing the problem. Too often, details are incomplete or left out entirely. Depending on how a contract is negotiated, someone will lose if details are omitted. If you bid on a fixed-price project, you may lose if you bid too low. If you're billing time and materials, the client can get annoyed at budget overruns and refuse to pay. Either way, when neither of you is happy with the outcome, chances are you will not be working together any time soon.

To prevent problems from escalating, address concerns immediately. Problems occur on all sides of the equation. "Is their concept correct?" and "Do I have the hardware to deliver what they want?" are the types of question that you need to ask yourself prior to accepting a project. To that end, spend the time to assess the problem by asking yourself these questions:

What is the purpose of the animation? What message is to be conveyed?

Who is the audience? Be sure that the audience will appreciate or even be interested in an animated sequence.

What is the budget? Finding out the budget of the project is important not only for the client but also for you. If the budget is too low, it may be impossible for you to deliver a product and be profitable. Many

clients ask for bids and award the project to the lowest bidder. A word of caution: bidding too low may get you the job, but it may not pay the bills. Being tied to a project that isn't making you money is a bad situation. Clients who are always looking for the cheapest solution also tend to expect the most in return and are loyal to their wallets. If your intent is to bid low to "get in the door," chances are you will be "in" as long as you are the lowest bidder. Unless you're in business to lose money, bid on projects with an honest profit in mind. Everyone deserves to be paid for his services; just don't be greedy, or on the other side, don't give it away.

How do I make a bid? When you are asked to bid on a project, consider every detail you can think of, including length of animation, complexity of models and animation, materials, rendering time, required meetings, travel time, hotel expenses, catering, delivery medium, rental equipment, research, props, additional hardware (hard drives, monitors, computers), software plug-ins, models, actors, voice talent, sound clips, copyrighted material, and, of course, how many work hours you expect the animation will take to create.

Is the delivery time frame realistic? I have had clients ask for a 120-second forensic animation on Monday and expect a final product on Wednesday. In some cases it's possible, and in others, it's not. You need to be assertive and honest about whether you can make the deadline. If the job requires more machinery, remember that when developing the budget. Keep in mind other projects and commitments when estimating a time frame, and allow a cushion of 10 to 15 percent for unexpected problems, such as computer crashes.

Who has approval signature authority? Getting approval can be difficult but is worth the effort in the end. Find out who has authority to approve concepts and get written signatures on storyboards, voice-over copy, preliminary images, and so on. Having an appropriate approval process in line helps the production workflow.

What is your role? Do you have any creative input or are you to be an order taker?

Do you have the talent? This question is probably the hardest to answer objectively. You may need the work or feel the project is way cool, but if you've never done it before and aren't confident you'll be able to solve the problems within the deadlines, you are asking for trouble. Clients aren't very understanding about missed deadlines, especially when you're the one missing the deadline. Remember the golden rule: "He with the gold, rules." It's true.

What is the delivery platform? Creating animation for the Internet is not the same as creating a feature film. Resolution, quality, and

length are important details when considering an animation project. Can you deliver on the required platform? If they want a DVD, can you burn a DVD or author the DVD interface and links?

What are you to deliver? Do they want a series of images that they will composite? Do you need to deliver everything soup to nuts, or just a portion of the final product? Can you handle the delivery requirements? Do you have the equipment? Can you rent equipment that you need but don't have? Do they have in-house equipment or an in-house post-production facility that you can use?

Is animation necessary? No one likes to turn down work, but your client will appreciate your honesty and generally will respect you more if you ask them why they want animation. If they tell you they want it just because it's cool, they may not realize the true cost or they may be disappointed in the end if it doesn't live up to the hype they've given it. If they don't need it and don't have the budget for it, then offer other solutions, such as 3D or 2D stills that you could create on a smaller budget.

BIDDING AND BILLING

After assessing the client's problem, you now must assess the budget accurately. This step is the make-or-break point for many artists. The fallout of not accurately assessing the budgetary needs can be devastating. Bid too low and you may find yourself losing money, even paying to cover the cost of items that were not negotiated; bid too high and you may not win the award in the first place. As mentioned earlier, bidding requires experience and research. Make a checklist of all the components required to complete the task, including cost of time, talent, hardware, and software.

Bidding Fixed Price

When discussing the project with the potential client, be sure to ask if they would prefer a fixed-price bid or a time and materials estimate. If a fixed-priced bid is preferred, be sure that there are no hidden costs and that a baseline project is established prior to signing any agreement. The biggest threat in a fixed-price bid is having the client say, "We just need one more thing," and expect to slip that into the project after the bid has been made. If a baseline project is approved and all of the parameters are spelled out explicitly, you will have less chance of being "nickel and dimed" to death. You also are under no legal obligation to provide more than you signed for in your initial bid.

Time and Materials

With a time and materials bid, you still must give the client an estimate of what you expect the project to cost, but you have the flexibility to continue to bill if the client continues to request work, even after the initial estimate has been exceeded. This type of bid requires that you give the client an hourly rate and that you've made provisions for everything that you would in a fixed-price bid. The positive side is that you can bill for every hour that you work, and you may make more than was originally bid. The downside is that the project can be cut short and you may have passed on other projects only to find that the huge project you thought you had has dried up unexpectedly. Additionally, it's difficult to staff for projects that are open ended because of the fluctuating demand.

Determining the Billing Process

Before you sign a contract or agreement to do any work, be sure you understand how you are going to be paid. Having a lawyer look over your documents can be worth the price. Regardless of whether your project is fixed price or time and materials, many options for billing are available, and it is up to you to determine which will work best for you and the client. You can bill biweekly, monthly, or in incremental percentages based on deliverables. Keep in mind that there is a big difference between getting paid on a regular basis or getting paid a percentage up front and the rest upon delivery. If you are getting paid based on deliverable percentages, be sure to set a time limit for the final payment, just in case the project is extended by the client. You could find yourself with a cash flow problem if the project is extended and funds aren't released due to contractual agreements based on delivery.

SIGNING COPYRIGHT, NON-DISCLOSURE, AND NON-COMPETE AGREEMENTS

When signing any copyright, non-disclosure, or non-compete agreement, be sure to have a lawyer review the document first. Once you sign a document, you are legally bound to its terms, so be sure you know what you are signing. There are many interpretations of what is copyrightable and how to protect yourself, but unless you have a lawyer review your contracts you are at risk. Even if you design and create a piece, it is possible the client may hold the copyright to the work.

A non-disclosure agreement precludes you from discussing or showing any work that you produce for a project unless the information is

deemed no longer classified or proprietary by the owner of that material. Find out if and when any of the work you're creating can be shown on demo reels, CDs, DVDs, Web sites, or marketing brochures.

A non-compete agreement takes many forms and in some states is not enforceable. Basically, these agreements say that you will not do any similar work for a competitor for a specified period of time. My opinion on this matter is to *never* sign one of these. Even if it is the last job on earth (which it won't be, unless you sign), don't sign a non-compete agreement. Again, check with a lawyer before signing or not signing anything, but signing a non-compete agreement could mean that you have to find a job in a different occupation until the non-compete agreement expires.

GETTING APPROVALS

During the production process, getting approvals is essential for keeping production on schedule. By having an approval process in place, you enable completed work to move through the appropriate channels and be taken off of the production schedule. When an approval process is not in place, tasks may be overlooked or reworked unnecessarily. Each level of the process should have someone who takes responsibility. Animators sign out storyboards and sign in when the storyboards are delivered to an art director. The art director signs off, as does the producer, and then the storyboards are off to the client for final review. Each step of the way, a signature helps track where the product has been. The most important signature is the client's. Once work is signed off by the client, leave it alone. Any tweaking after a client has signed off is not billable and may put at risk whether a client approves the changes. Don't seek approval until the work is complete.

CREATING STORYBOARDS

Storyboards are graphic renditions of a script or story. When storyboards are done properly, an animator can easily understand what is supposed to happen in the animation. Storyboards are typically hand drawn, but they also may be done using vector art, 3D art, or even photos. Unfortunately, as important as storyboards are, some clients toss out storyboards when budgets get tight. This "cost-cutting" measure may only exacerbate the problem and most often actually leads to budget overruns. An example of a storyboard is shown in Figure 2.1.

FIGURE 2.1 Storyboards come in many varieties, though all should convey a sequence of events.

Storyboards most often convey the following information:

- Composition of scene (position of characters, framing, stage settings)
- Camera position, angle, and movement
- Scene action
- Sequence of events (the story)

Model Sheets

Model sheets are blueprints for the models and props created in 3D. Like storyboards, model sheets can vary greatly. The premise of a model sheet is to have the object design approved prior to spending the time and money building it in 3D. Changes made on paper are much less costly than those done in 3D. Model sheets should show the object or character from multiple sides and describe the characteristics of the look and surfaces of the model. In some cases, models may be built from concept sketches.

CREATING MOCK-UPS AND ANIMATICS

After getting approval on storyboards and models, the production of the 3D content begins. As objects and scenes are created, mock-ups and ani-

matics are created for review. Mock-ups can be practical models (sculptures or built models), sketches, or rendered images. By placing models in environments, the client or producer can get early previews of what some of the shots will look like. Mock-ups are generally done before the animation begins and are intended to convey a general look and feel of the imagery.

Animatics

An animatic is a low-resolution animation meant to preview the action and scene composition. Materials and final lighting usually are not present in an animatic. You create an animatic so that the client can request changes to the animation prior to time being spent on the details, such as color, lighting, and extensive materials. This method saves a lot of time, especially if the direction of the project is changed due to an original concept not working.

STARTING FULL-SCALE PRODUCTION

Once many of the approvals have been given, the arduous task of creating all of the environments, characters, props, and materials begins. Production can take many forms. Each studio has its own way of streamlining the workflow. By having a workflow in place at the beginning of the project, many organizational problems can be avoided or recognized early. Some questions to ask when assessing the production effort include:

- What is the personnel requirement?
- What is the estimate, in hours, for the entire production effort?
- Is new technology required, or is this a tried-and-true animation job? If the job involves unproven technologies, production effort may be greater than anticipated.
- What are the equipment requirements (workstations, hard drives, rendering nodes, servers, cabling, hubs, CD and DVD writers, video equipment, and so on)?
- What is the software requirement (applications, plug-ins, post-production tools)?
- Can you make payroll? Adding extra talent costs money. Can you pay your talent before the client pays you? Not being able to fund production in-house may require additional funding up front by the client.

DELIVERING PRELIMINARY CONTENT

Preliminary content is as close to a finished product as can be, without going to final resolution. Depending on the type of production effort and client, this deliverable comes in several forms. One method is to upload small-scale, low-resolution animation files in the form of Windows media files or QuickTime movies to a secure ftp server for the client to approve. In other cases, animation is reviewed daily (called "dailies") to keep production on track. Whatever is required, be sure that your preliminary content doesn't become a production bottleneck. In these previews, all elements should be included so there is no ambiguity on deliverables. To reduce the time required to create preliminary content, reduce the rendering output size and turn off anti-aliasing. Once a preliminary item is approved, production of the final deliverable should just be a matter of rendering at full resolution.

DELIVERING FINAL CONTENT

Once preliminary content has been approved, delivering the final content is a no-brainer. Final content should not deviate from the preliminary content except in the following areas:

- Clarity of the image (less, or no, compression) is correct
- Smooth anti-aliasing is turned on
- Output resolution matches delivery medium, such as film or video

The big problem with the delivery of final content is tying it all together. This may involve post-production, such as compositing, burning CDs or DVDs, or shooting to film.

Regardless of your final delivery method, this step is where the client gets what they paid for. It is also your chance to shine or crash and burn. If your delivery goes smoothly and the client is happy, you've done your job. If the client isn't happy, you become a negotiator aimed at finding out why they aren't happy and what is required to make them happy. Don't be a pushover. If you've satisfied all of the requirements of your contract, there shouldn't be a problem. If there is, pull out the contract and remind the client of what was agreed upon. In either case, keep communications open and calm. Upsetting your client is not a good idea.

BILLING THE CLIENT

Here's where your ability to make the client feel comfortable with the deliverables is most beneficial. There are as many billing options as there are projects. Be realistic when assessing what financial needs are required to keep production going. If you and the client can't come to an agreement, it may not be the right project for you. Being unable to pay your production staff is fatal to any project. "Production grows where cash flows." If you lose your production staff because of nonpayment, you could lose your project or company entirely. As such, you need to bill your clients on a regular basis. Consider the following tips concerning billing:

- Put billing terms in the initial contract.
- Track all project-associated time, regardless of whether the time is billable or the project is fixed-price. Keeping track of all the time associated with the project provides statistics for accurately estimating future projects or when disputing bills from clients.
- Bill accurately. When clients start disputing bills, a certain level of trust and client satisfaction is at risk.
- Send out invoices as agreed. Don't deviate from the billing plan.
- Expect regular payment. When payment isn't received, discuss alternatives with the client and have the consequences written into the contract, including penalties or loss of production.

Remember, you are in business to make money. Be fair. Be generous. Be honest. Make every project one that you can be proud of. Don't be greedy and you will flourish. Too many companies have gone south because the principals in the company were greedy.

ENDING THE CONTRACT

"All good things must come to an end." Nowhere is this adage more true than in a production environment. Regardless of how fun the project was in the beginning, eventually everyone wants it to end. The client, however, may have other ideas.

In some cases, the project has ended, the product was delivered, and the invoices are paid. Other times, there are outstanding issues, or the client has requested changes that were not part of the contract. If there is some ongoing work required, write up a new contract. Establish an estimate and timeline for the deliverables, as was done with the original project. Otherwise, you can end up with a project that won't go away. Projects that don't end can clog up your production environment and

jeopardize future projects. You must determine if staff needs to be reduced or if production can move on to the next project.

GIVING RECOGNITION

Hardly ever considered when bidding on a project, but equally important, is employee or talent recognition. When all deadlines have been made and all deliverables have been shipped, treat your production staff to some sort of closing party, luncheon, or formal recognition for those who made the difference in the project's outcome. By providing some sort of closure for the project, those who spent many late nights and weekends away from their families will feel as though their efforts have been recognized.

To be sure that this event is incorporated into every project, determine a cost estimate and what appropriate recognition for the project should be. If it's merely a lunch party, plan the cost of that in the bid. If you intend to give plaques, awards, prizes (animators love toys), or bonuses, be sure that those have been considered when you bid on a project. You do not want to give away all the profits, but you need to recognize those who made the project possible. Treating production staff well comes back in loyalty and higher production quality. People will care about you only as much as you care about them.

THE PRODUCTION PIPELINE

Bidding on a project includes putting together a production pipeline. The production pipeline defines what type of work is going to be required and needs to be addressed to make an accurate estimate. A typical production pipeline includes all or most of the following steps:

- Writing the story/script
- Creating the models
- Designing and implementing the materials
- Creating the animation
- Creating the lighting
- Planning and implementing the shot composition/staging. (All shots should be staged during the storyboard phase, then implemented in production by a director in charge of the camera lens, position, and action.)
- Post-production of special effects, compositing live action, compositing 3D, adjusting lighting, colors, and so on.

SUMMARY

Creating a 3D animation requires a lot of planning and talented personnel. Watch the credits of any animated feature film and you will count hundreds of people. Therefore, planning is essential to the success of a production. Although the production pipeline may change in its implementation, the major steps are always the same. Bidding on a project also requires an understanding of a production pipeline to have a successful bid that ends with happy clients and a fair profit.

3

STARTING SIMPLE: CREATING SHAPES AND PRIMITIVES

In this chapter

- Creating Shapes
- Creating Primitives
- Editing Parameters

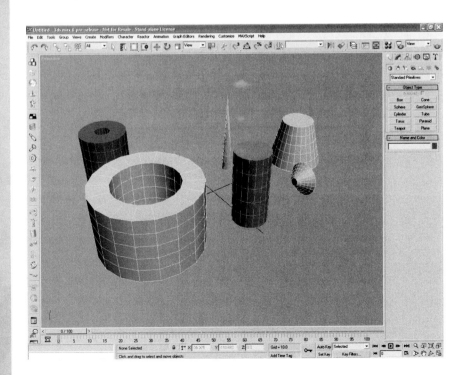

Ａs a wise man once said, "The biggest man was once just a baby." We too must learn to crawl before we can walk. As such, this chapter shows you how to create basic primitives, such as a sphere, box, or cylinder. First, you learn how to create basic shapes, such as lines and circles.

CREATING SHAPES

In 3ds max, shapes are two-dimensional objects created from one or more curved or straight lines. The exception is the helix, which is created in three dimensions. Examples of shapes, including circles, rectangles, text, and a variety of free-form lines, are shown in Figure 3.1.

If you've used a vector-based drawing program, such as Adobe® Illustrator®, you are familiar with creating shapes. With exception of the line shape, all shapes have parameters that let you adjust their dimensions. The following exercise demonstrates creating some basic shapes.

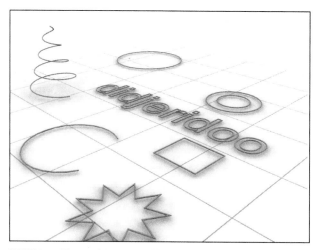

FIGURE 3.1 These objects are all shapes. Clockwise from the upper left are helix, circle, doughnut, text, rectangle, starburst, and arc.

TUTORIAL ## CREATING BASIC SHAPES

1. Open 3ds max 6 and click the Create Tab on the Command Panel.
2. Click the Shapes icon (the second icon from the left), shown in Figure 3.2, to access the Shape creation tools.

FIGURE 3.2 The Shapes icon provides access to all of the Shape creation tools.

3. Click the Circle tool to activate it.
 In the Top view, click in the center of the view and drag in any direction to create a circle. Drag the pointer so that the circle fills most of the Top view. Release the mouse button.
 Right-click to exit Create mode.

You've just created a parametric circle shape. You will adjust the parameters later. Next you'll create a rectangle.

4. Click the Rectangle tool to activate it.
5. Click and drag a rectangle in the Top view. Notice the rectangle is created with one corner where you first clicked with the length and width determined by the direction in which you drag the pointer. Drag so the rectangle fills most of the Top view.
 Release the mouse button to finish the rectangle.
6. Right-click to exit Create mode.
7. Now click the Text button.
8. Click anywhere in the Top view. Because the Text tool is a single-click creation object, right-click to exit Create mode.

The results of the previous exercise are shown in Figure 3.3.

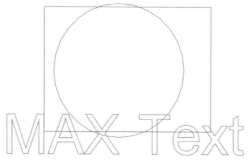

FIGURE 3.3 By default, shapes are non-renderable spline objects. This image includes a text shape, a circle shape, and a rectangle shape.

Building a Line

Although a line seems to be a simple creation, the Line tool within 3ds max offers many possibilities. A line comprises two or more points called vertices. Each vertex has its own properties, such as position and point type (Smooth, Corner, Bezier, Bezier corner). The point type dictates how the line will look. By changing the point type and its location in 3D space, you control the line's appearance. Several line shapes are shown in Figure 3.4.

Building a line or free-form shape is just a matter of creating points in space. The following tutorial shows how to create a line.

FIGURE 3.4 All of these shapes are lines. Each is made of the same components: vertices, segments, and splines.

BUILDING A LINE

1. Click the Shapes button on the Create Panel.
2. Click the Line button to activate the Line tool. The Create Panel (shown in Figure 3.5) now shows vertex types in the Creation Method rollout.
3. Click in the upper-right portion of the Top view to create the first vertex. As you move the pointer, a line segment connects the new vertex to the pointer. The line segment end follows, awaiting the next click to create another vertex.

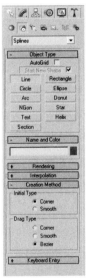

FIGURE 3.5 The Create Panel with the Line tool active. The Creation Method rollout shows the vertex types used when creating a line.

4. Click the mouse in the middle-left portion of the Top view. The result is a straight line segment between the first and second vertices, as shown in Figure 3.6.

When creating a line shape, clicking creates corner vertices. Corner vertices are used to create straight line segments.

5. Create a third vertex by clicking and dragging in the lower-right portion of the Top view. Release the mouse button after the line becomes curved. The result is a Bezier vertex. The resulting line is shown in Figure 3.7.

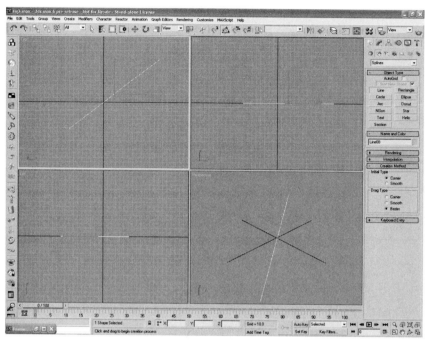

FIGURE 3.6 A straight line is created between the first and second vertices because the vertex types are corners.

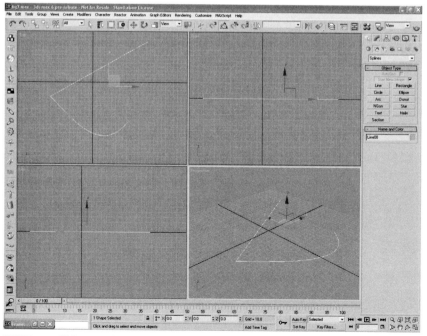

FIGURE 3.7 Clicking and dragging during vertex creation creates a Bezier vertex. Bezier vertices have handles that allow you to control the appearance of the curve.

 Click and drag during vertex creation to create a Bezier vertex. This action creates handles that you can manipulate to create complex curves.

6. Create a fourth vertex anywhere below the second vertex in the Top view. Use the click-only method for creating this vertex. You should notice that even though you just click the fourth vertex, the result is still a smooth curve (as shown in Figure 3.8) between the third and fourth vertices, due to the Bezier curve created with the third vertex.

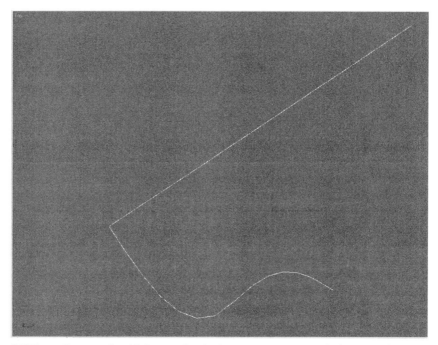

FIGURE 3.8 Because the third vertex is a Bezier vertex, a curve results between the second and fourth vertices.

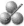

Creating Primitives

Now you have created some simple two-dimensional shapes. Next you move on to the third dimension and create some primitives. Primitives are geometric objects that are pre-programmed in 3ds max 6. The geometry is optimized and can be created with the selection of a button and a few mouse clicks. These objects include spheres, boxes, and cylinders.

TUTORIAL CREATING A SPHERE

Creating boxes and spheres isn't an exciting aspect of 3D, but consider how difficult this art used to be. During the making of the movie *Tron* in 1983, a sphere similar to the one shown in Figure 3.9 took many pages of handwritten computer code to create and more than 16 minutes to generate a similar image.

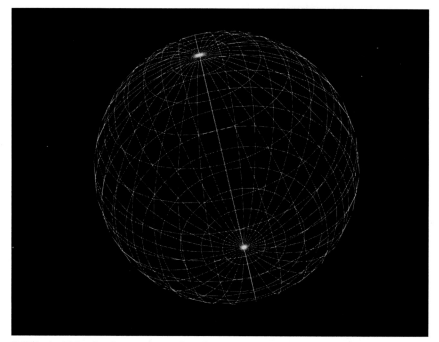

FIGURE 3.9 This wire-frame image of a sphere is generated in real-time in 3ds max 6. During the creation of the movie *Tron*, this same image would have taken more than 16 minutes to generate.

1. Open 3ds max. If it is already open, reset it to the default settings by clicking the File menu and choosing Reset so you have a fresh scene file with which to work.
2. In the Create Panel on the right side of the 3ds max interface, the Geometry section (see Figure 3.10) is open by default. Click the Sphere button. You are now in Create mode and ready to create some spheres.

 Before you begin creating a sphere, notice that the sphere's parameters are visible in the Create Panel. Though they are visible, changing the

FIGURE 3.10 Clicking the Sphere button doesn't automatically create a sphere; it activates Create mode. Notice the sphere's parameters are visible.

parameters doesn't create a sphere. The default mode is Interactive mode, so you must click and drag.

3. In the Top view, click in the center of the view. Drag the pointer to the lower-right corner and watch as the sphere gets larger. The Radius parameter is visible in the Create Panel.
4. Release the mouse button when you reach the desired Radius parameter. Releasing the mouse button sets the Radius parameter for the sphere.
5. Click and drag a few more times in the Top view. Each time you click and drag, you create another sphere. Create spheres with different Radius parameter values.
6. Right-click to exit Create mode.

You have just created several spheres, such as those shown in Figure 3.11. This step was not difficult, and the rest of the process is just as easy. It's just a matter of understanding the 3D world. Once you understand the fundamentals in 3ds max 6, you can move on to bigger and more complex model building.

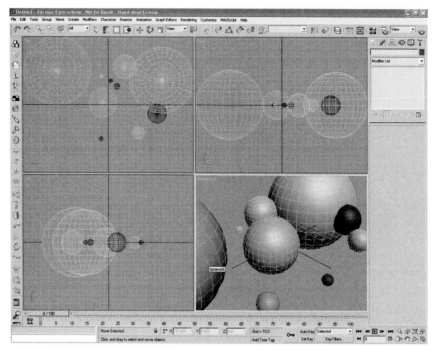

FIGURE 3.11 Clicking and dragging creates a sphere. The Radius parameter is set by the distance the pointer is dragged after the initial click.

TUTORIAL REVIEW

A few aspects of the previous tutorials may need additional explanation:

Creating the sphere in the Top view: You start in the Top view to ensure the orientation of the sphere's pivot point. Pivot points orient objects in 3D space—this will be discussed later in this chapter. For now, notice the lines of latitude and longitude on the sphere.

Exiting Create mode: 3ds max doesn't exit Create mode automatically when you are finished creating a primitive. Therefore, you can create many spheres (or other primitives) by clicking and dragging multiple times.

Object color: Every primitive and shape created in 3ds max is randomly assigned a color. The colors are for identification only and not considered surface materials for that object. Materials are covered in Chapter 12, Material Basics.

 Don't get stressed if you can't drag an exact sphere radius. In Interactive mode, it can be impossible to achieve an exact value. Just create the object close to what you want, then open the Modify Panel and adjust the parameters directly. That's the beauty of parametric modeling.

TUTORIAL

CREATING A BOX

Now that you've successfully created a sphere, you can graduate to creating boxes.

1. Reset 3ds max and open the Create Panel.
2. Click the Box button in the Create Panel. In the Top view, click and drag a rectangle, just as you did when creating the rectangle shape. Release the mouse button when the desired length and width is achieved.
3. Release the mouse button to set the Length and Width parameters, then drag to control the Height parameter of the box. Drag up until the Height parameter is set at 25.0 (or close to it). Click to set the height. The result is shown in Figure 3.12.

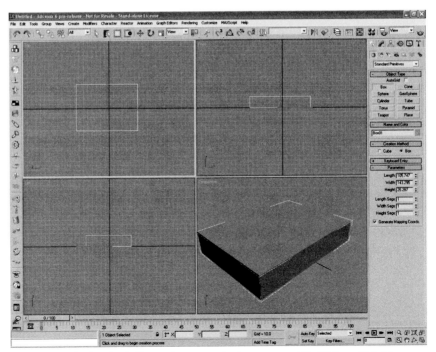

FIGURE 3.12 The box is similar to the rectangle shape, except that it has a Height parameter to give it a third dimension.

4. Create additional boxes with varying parameter values. This exercise is great practice because boxes are used often in more complex modeling.

5. Right-click to exit Create mode.

Right-clicking prior to clicking to set the Height parameter results cancels the object creation. If your box disappears, chances are, you right-clicked before you set the Height parameter.

TUTORIAL REVIEW

The box object, like other primitives, requires multiple clicks to set the initial values for several parameters.

Height parameters can be positive or negative. The only difference is the direction in which the height extends from the initial rectangle.

Building Cylinders, Cones, and Tubes

Cylinders, cones, and tubes are similar in their basic construction. Examples of each can be seen in Figure 3.13. All are essentially a two-dimensional circle that has been extended along the z axis to some height. Cones are cylinders with one radius smaller than the other, and tubes are a hollow cylinder. All three objects require a combination of actions that you've used when building the box and the sphere.

The following tutorial describes how to create a cylinder, a cone, and a tube.

TUTORIAL

CREATING A CYLINDER, CONE, AND TUBE

1. Reset 3ds max and activate the Cylinder tool in the Geometry section of the Create Tab.

2. In the Top view, click and hold the mouse button to set the center point of the cylinder.

3. Drag the pointer away from the center point to change the Radius parameter. Release the mouse button when a desired Radius parameter is achieved.

4. When you release the mouse button, the Radius parameter is set and the Height parameter becomes active. Drag up or down, then click to set the Height parameter.

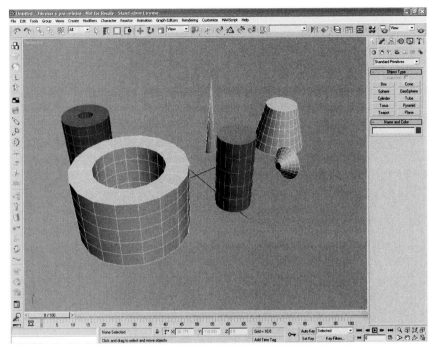

FIGURE 3.13 These objects were created using the Cylinder, Tube, and Cone tools. All are similar in that they have a Radius and Height parameter.

5. Right-click to deactivate Create mode.
6. Activate the Cone tool. The cone requires three clicks to create, because it is composed of two Radius parameters and a Height parameter. In the Top view, click and drag to set the first Radius parameter (as you did when creating the cylinder).
7. Release the mouse button when the desired Radius parameter is reached, then drag up or down (as you did when creating the cylinder) to change the Height parameter. Click when the desired Height parameter is achieved.
8. Set the second Radius parameter by dragging toward or away from the center of the cone and clicking. Dragging toward the center of the cone creates a radius that is smaller than the first radius. Dragging away from the center creates a larger Radius parameter.
9. Right-click to exit Create mode.
10. Activate the Tube tool. Like the cone, the tube has two Radius parameters and a Height parameter. Unlike the cone, both Radius parameters are set before the Height parameter.

11. In the Top view, click to set the center point of the tube. Before releasing the mouse button, drag to adjust the first Radius parameter, then release the mouse button.

12. The second Radius parameter can be larger or smaller than the first. Dragging toward the center of the first radius creates a second radius that is smaller; dragging away from the center of the first radius creates a second radius that is larger. Click when the desired Radius parameter is achieved.

13. After the first and second Radius parameters have been set, dragging up or down sets the Height parameter, as it did with the cylinder and the cone. The Height parameter can be either negative or positive. Click to set the Height parameter.

14. Right-click to exit Create mode. The result of this exercise is shown in Figure 3.14.

Height parameters can be either positive or negative. A negative Height parameter indicates that the height is in the negative direction along the z axis.

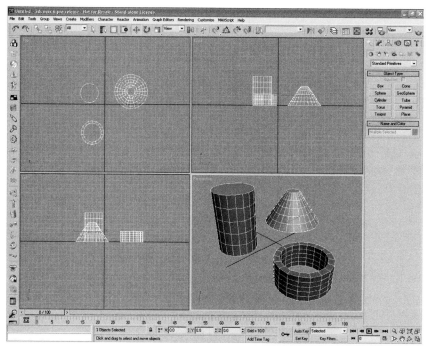

FIGURE 3.14 A cylinder is basically a circle with height or thickness.

SEGMENTS AND SIDES

Polygonal objects are created with flat polygons, so when you create curved objects, they can be blocky if you don't use enough segments or sides. Figure 3.15 shows objects with different side and segment settings.

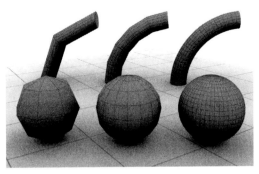

FIGURE 3.15 Changing the segments and sides affects the smoothness of an object. From left to right, the spheres and cylinders have an increasing number of segments.

You may have noticed that all of the primitives had parameters for either segments or sides, or both. Some examples of Segment and Side parameters are shown in Figure 3.16. The Segments or Sides parameters are used to control the number of divisions along a curve. In the case of the sphere, the segments parameter changes how many divisions exist around the circumference of the sphere.

FIGURE 3.16 Some examples of Segment and Side parameters.

EDITING THE SEGMENT AND SIZE PARAMETERS

Although Segment and Side parameters can be changed, they shouldn't be changed randomly. The number of segments and sides should be well thought out. The following tutorial shows when to use more or fewer segments and sides.

1. Create a cylinder in the Top view.
2. Right-click to exit Create mode and open the Modify Panel.
3. Set the Sides parameter to 5. Notice how the cylinder changes shape dramatically.
4. Increase the value of the Sides parameter slowly until a final value of 48 is reached. Notice the change in the cylinder as the number of sides increases. Figure 3.17 shows the cylinder with different Side parameter values.

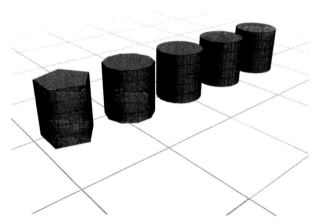

FIGURE 3.17 The same cylinder with different Side parameter values.

5. Set the Sides parameter to 32 (the default setting).
6. Change the Height Segments from 5 to 1. Observe the shape of the cylinder along its height.
7. Set the Height Segments parameter to 50. Observe the shape of the cylinder, then change the Height Segments to 1.

Notice that along straight edges, such as the height of the cylinder, no change is visible, regardless of the number of height segments used. In this case, specifying a large number of height segments would generate excessive

polygons, which could ultimately slow down your computer during the rendering process.

A side with no curves needs no additional sides or segments. Increasing the number of divisions along a straight edge does not change how the object looks.

Try changing the segment parameters for a box and a sphere to see how these objects are affected. Although all Segment parameters divide a component of the object, each object's shape is affected differently. In the case of the box, the shape does not change at all, no matter how many segments are added.

The sphere has only a Segments parameter (and no Sides parameter). The Segments parameter controls the divisions both around the circumference and vertically. The value used in the Segments parameter determines precisely the number of divisions around the circumference of the sphere. The vertical divisions are one half of the value used in the Segments parameter.

EDITING PRIMITIVES AND SHAPE PARAMETERS

Now that you've built a few primitives and shapes, youl probably want to edit their parameters at some point. Essentially, you have two options. Primitives can be edited when first created, prior to exiting Create mode (right-clicking) while their parameters are still accessible, or through the Modify Panel at some later time. Notice, however, that once Create mode has been exited by right-clicking or by choosing another tool, selecting an object no longer reveals its parameters in the Create Tab.

The Modify Panel

To modify a primitive or shape's parameters after it has been created, you must select the object and open the Modify Panel. The Modify Panel, shown in Figure 3.18, is located next to the Create Tab on the Command Panel. When no object is selected, the Modify Panel displays no parameters.

With an object selected and the Modify Tab open, all of an object's parameters, as well as the Modifier List and the Modifier Stack (with some associated Modifier Stack tools), are accessible. Figure 3.19 depicts the parameters of an existing sphere. From the Modify Panel, you can adjust any of the sphere's parameters.

FIGURE 3.18 The Modify Panel contains no parameters of its own. It is used to control the parameters of existing objects.

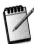 *Object parameters are not available when multiple objects are selected. The Modify Panel indicates that multiple objects are selected and shows no parameters. To modify parameters through the Modify Panel, select a single object, open the Modify Panel, and adjust parameters as desired.*

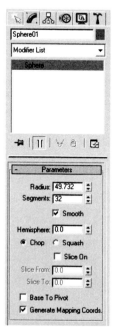

FIGURE 3.19 The Modify Panel contains parameters of the selected object. Here, the parameters of a sphere are shown and can be edited.

SUMMARY

In this chapter you learned how to create some of the most common primitives and how to access their parameters. In this chapter, you learned about:

- Creating primitives
- Creating shapes
- Accessing parameters in the Modify Panel
- Adjusting segments and sides

Practice building other primitives and shapes, because they are all an essential part of 3D modeling. As you become more familiar with the different objects, you will be able to model more complex objects by combining primitives and shapes into single geometric forms.

MANAGING AND MANIPULATING 3D SPACE

In this chapter

- Transform Axis
- Transformation Tools
- Coordinate Systems

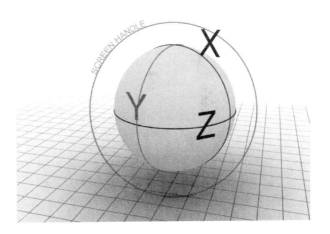

n previous chapters, you built some primitives and shape objects. Now you're going to learn how to manipulate those objects in 3D space. *Transformation* is the manipulation of 3D objects. A *transform* is defined as a change in position, rotation, or scale of an object. As simple as this may sound, it takes a bit of getting used to. Object manipulation is crucial for building and animating objects effectively. Having a thorough understanding of transforms is essential for the 3D artist.

TRANSFORM AXIS

The 3D world inside computers works on a three-axis system. This system of three axes is used to identify an artificial position in 3D space based on the object's horizontal, vertical, and depth values, or *coordinates*. The coordinates are used to identify a value for each of the three axes and are represented in the form of (x, y, z). Figure 4.1 shows the three-axis orientation. Positioning and coordinates are discussed later in this chapter.

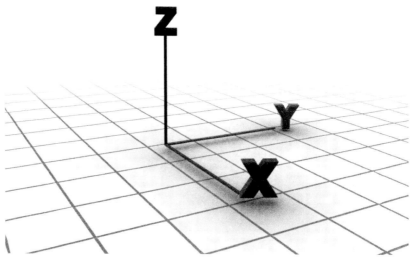

FIGURE 4.1 The three axis orientation.

TRANSFORMATION TOOLS

To accommodate all three transform modes, 3ds max provides three transform gizmos. Each transform gizmo facilitates transforming an object along any of the three axes for a single type of transform. In other

words, the Position transform gizmo can't be used to rotate or scale an object. The different transform gizmos are shown in Figure 4.2.

FIGURE 4.2 From left to right, the Position, Rotate, and Scale transform gizmos.

In addition to the transform gizmos, 3ds max also provides a Transform Type-In dialog box for exact object placement. The following sections explain how each of these 3D tools works.

The Pivot Point

The pivot point (shown in Figure 4.3) is a control that is inherent in every object in a 3ds max scene. It is used as a point of self-reference for the geometry of the object in which it is contained. Every piece of geometry has a pivot point associated with it. The pivot point is created automatically when the object is created. By default, the transform gizmo is centered on that pivot point. The position of the pivot point can be altered—this topic will be covered later. For now, know that the pivot point exists and that the transform gizmo is positioned at the same location as the pivot point.

Transform Gizmos

Whereas the pivot point of each object identifies a place of reference for the geometry of the object, the transform gizmo positions the entire object. By default, the transform gizmo is located in precisely the same position as the pivot point. Each transform and its gizmos are different in

FIGURE 4.3 The pivot point of each object. Notice that their positions relative to the geometry aren't always the same.

appearance and role, but the workings of each gizmo is similar. Each works with a set of three axis controllers—one each for the x, y, and z axes. By clicking any of the axis controls, you can manipulate an object in 3D space interactively, as if the object were real.

Positional Transforms

Positional transforms are preformed using the Select and Move tool located on the Main Toolbar, shown in Figure 4.4. Positional transforms move an object from point A to point B. There is nothing fancy about a positional transform; they exist solely to put an object in 3D space. Understanding 3D space is the tricky part. A lengthier discussion about 3D space can be found in the Coordinate Systems Overview section, later in this chapter.

The following tutorial demonstrates how to transform a sphere and a box using the Select and Move tool.

FIGURE 4.4 The Select and Move tool is found on the Main Toolbar.

 TUTORIAL **TRANSFORMING WITH THE SELECT AND MOVE TOOL**

1. Reset 3ds max, and in the Top view, create a sphere with a radius of 50.
2. Select the sphere, if it isn't already selected, and activate the Select and Move tool.
3. In the Front view, click anywhere on the sphere geometry (but not the transform gizmo) and move the sphere around. Notice how it moves up and down and left and right.
4. In the Front view, click the red arrow of the transform gizmo and drag in all directions. The sphere now moves only in a horizontal direction. This limitation is known as the x-axis constraint. Be sure that when you click the x-axis, only the stem of the x-axis arrow is yellow.

 The transform gizmo constraints are sticky. Clicking a specific axis constraint locks that constraint. The next time you want to transform, you can click anywhere on the object to constrain it to the last axis constraint used, without having to click the transform gizmo handle.

5. Again in the Front view, click the green arrow of the y-axis and drag in all directions. You will notice that the sphere only moves in a vertical direction.

6. In the Front view, click and drag the yellow transparent box of the transform gizmo between the x and y axes. The sphere, again, moves in all directions.

The previous exercise demonstrated the ability of the transform gizmo to constrain movement of an object along any of two axes. Using axis constraints is extremely useful for moving objects around while keeping them aligned.

If you want to constrain an axis without clicking that arrow, use the F5, F6, and F7 hot keys to constrain the x, y, and z axes, respectively. Using the F8 key toggles between dual axis constraints xy, yz, and xz.

Transform Type-In Dialog Box

Transforming an object is great, but you need to have a purpose. For the most part, transforms are not random. Transforms are precisely calculated to get the desired effect of creating a complex model or creating complex animation. That's where the Transform Type-In dialog box comes into play.

At the bottom of the 3ds max interface are three input boxes, as shown in Figure 4.5. These input boxes allow you to type in the exact values for the transformation of an object. When the Select and Move tool is selected, the input in the Transform Type-In dialog box refers to position. When the Select and Rotate tool or Select and Scale tool is selected, the input refers to the rotational or scale values, respectively.

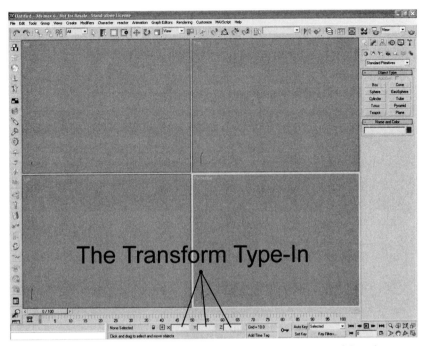

FIGURE 4.5 The Transform Type-In dialog box is found at the bottom of the 3ds max interface. The inputs reflect the currently active transform tool and are used for precise input values.

USING THE TRANSFORM TYPE-IN DIALOG BOX

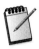

1. Create a sphere, or use the one used in the previous exercise.
2. Activate the Front view by right-clicking in it. The view now has a yellow border to indicate that it is the active view.
3. With the sphere selected, click the Select and Move tool. Some values are displayed in the Transform Type-In dialog box.
4. In each of the Transform Type-In text boxes, type the number 0. The object moves to the center of the grid, called the origin. The sphere positioned at the origin is shown in Figure 4.6.

The origin is the center of any 3D scene, where coordinate values for all axes are set to 0.0.

5. Type a value of 50 into the X text box. In the Front view, the sphere moves to the right 50 units. This movement corresponds to the direction of the transform gizmo's red x-axis arrow.
6. In the Y text box, type a value of 50. The sphere does not move along the y-axis, as you may have expected.

FIGURE 4.6 The sphere has been repositioned at the origin. The origin has a value of 0.0 on all three axes.

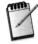

When transforming for now, check what's happening in the other views, so that you can become accustomed to what the transforms mean in terms of actual object location and transformation.

Instead of moving along the y-axis of the transform gizmo, the sphere moves farther away, along the z-axis. The Transform Type-In dialog box uses the World Coordinate System, which is constant. All coordinate systems in 3ds max are based on this coordinate system.

The Transform Type-In dialog box is based on the World Coordinate System, but the transform gizmo is based on the chosen coordinate system, which is view dependent by default. Though this arrangement may seem confusing at first, its logic will become clearer as you become more familiar with 3D space.

When using the Transform Type-In dialog box, use the small axis tripod located in the lower corner of each view to determine in which direction an object will move. Like the Transform Type-In text boxes, this tripod represents the World Coordinate System.

7. Type a value of 0 in the y-axis Transform Type-In dialog box.
8. In the Front view, click and drag on the y-axis transform gizmo handle until the y-axis value in the Transform Type-In dialog box equals 50.
9. Release the mouse button. Notice that even though the value showed 50 in the y-axis, once you released the mouse button, the z value retained the value shown in the y-axis when interacting with the transform gizmo.

 The Transform Type-In dialog box displays current axis values while interacting with the transform gizmo but then reverts to a World Coordinate System readout when you release the mouse button from the transform gizmo.

By typing values directly into the Transform Type-In dialog box, you can instantly position an object anywhere in 3D space, from inches from one object or miles away from another.

Use the Tab key when moving between each of the Transform Type-In text boxes.

Using the Quad Menu

In addition to using the Transform Type-In text boxes located on the 3ds max interface, you can access another version of the Transform Type-In dialog box through the Quad menu. As seen in Figure 4.7, when you right-click to open the Quad menu, a Transform Type-In settings dialog box opens next to the Move tool option.

The advantage of having the Transform Type-In dialog box is that you can input numeric values for both the World Coordinate System, or Absolute World values, (on the left side) and relative values (on the right) in the Offset Screen set of inputs. The Absolute World values work exactly like the inputs found at the base of the 3ds max interface. The Offset Screen values move the selected object relative to its current position based on the current transform gizmo in the active view. This means two things. First, typing a value, such as 5.0, moves the object 5 units from its current position along the specified axis. Second, the x, y, and z axes are based on the current view, so inputting a y-axis value with the Front view active moves the object differently than when the Perspective view is open.

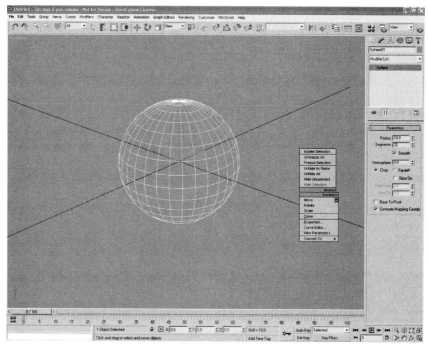

FIGURE 4.7 Right-click anywhere in the view to access the Quad menu. The Transform Type-In Settings dialog box is located next to the Move tool.

TUTORIAL

USING THE TRANSFORM TYPE-IN DIALOG BOX

1. Create a sphere in the Top view, and right-click to exit Create mode.
2. Right-click in the Front view to activate it, then right-click again to open the Quad menu.
3. In the Offset Screen area, type (0,0,0). The sphere doesn't move because these values indicate the distance an object is to be moved from its present position.
4. In the Absolute World area, type the values (0,0,0) for the x,y, and z coordinates. The sphere moves to the origin, which is located at (0,0,0).
5. With the Front view still active, in the Offset Screen area, type 5 in the y-axis text box. The object moves upward because the y-axis is pointing up.
6. Keeping the Transform Type-In settings dialog box open, activate the Perspective view.
7. In the Perspective view, notice now that the y-axis is pointing away from the view. Type a value of 5.0 in the y-axis text box of the Offset Screen area. Now the sphere moves away instead of upward.

The Transform Type-In dialog box can be a little confusing because the axis seems to move around. Keep in mind the two modes (Absolute and Offset) are meant to act differently. By typing values in the Absolute World text boxes, you are indicating a precise position in 3D space. In the Offset Screen area, you are indicating how far to move an object relative to its current position.

 All of the transform gizmos are color coded for quick identification of each of the axes. The color coding is red, green, blue (R,G,B) for (x,y,z).

Rotational Transforms

Just as every object has a position, each object also has a rotational value, even if that value is 0. The Select and Rotate tool, shown in Figure 4.8, is used to interactively set the rotational transform values of an object.

The Rotate gizmo, shown in Figure 4.9, uses a virtual trackball to give the tactile feel of actually rotating a real-world object. Using this virtual trackball, you can rotate an object in one or more directions with a single click, depending on whether you click an axis handle or select free rotation.

 Rotation works by moving around the selected axis, as if the object were tethered to a pole. When determining which axis to choose for a desired rotation, imagine that the axis runs through the center of the rotation and choose that axis constraint.

FIGURE 4.8 The Select and Rotate Tool is found on the Main Toolbar.

FIGURE 4.9 The Rotate gizmo. By using a virtual trackball, you can get the feel of rotating in a real-world environment.

Using the Rotate Transform Gizmo

The Rotate transform gizmo has three modes: Axis Constraint, Free Rotation, and Parallel View rotation. The different modes are chosen by clicking and dragging different portions of the Rotate transform gizmo.

Axis Constraint rotation: Click and drag any of the x, y, or z-axis handles shown in red, green, or blue, respectively. Rotation is constrained to the selected axis only.

Free rotation: Click between the axis handles on the transparent sphere to move the mouse and rotate on multiple axes simultaneously.

View Parallel rotation: Click the handle that encircles the entire Rotate transform gizmo to rotate the object parallel to the active view.

The Rotate transform gizmo provides feedback through the use of a visual angle indicator and a numeric feedback field. Figure 4.10 shows an example of the feedback of the visual and numeric angle indicators.

FIGURE 4.10 The angle indicators aid in determining rotation angles.

Scale Transforms

Unlike the other transform gizmos, the Scale tool set consists of three different scale tools: the Uniform scale, the Non-Uniform scale, and the Stretch and Squash tool. You can access each of the tools by clicking and holding the mouse button on the Select and Scale tool (shown in Figure 4.11), located on the Main Toolbar.

A breakdown of how each scale option works follows:

Uniform scale: Scales an object on all axes equally.

Non-Uniform scale: Scales an object on one or more axes simultaneously but with each scale amount independent from other axes.

Stretch and Squash tool: Scales two axes simultaneously, scaling one axis larger and the other axis smaller.

The Scale transform gizmo, shown in Figure 4.12, changes shape to reflect the transform being applied. As an axis is being scaled, that axis on the gizmo also changes size.

FIGURE 4.11 The Select and Scale tool has three options in its flyout menu.

FIGURE 4.12 The Scale transform gizmo enables you to scale along a single axis or multiple axes, independent of each other.

COORDINATE SYSTEMS OVERVIEW

A coordinate system is a means of positioning objects in 3D space using the three-axis system discussed earlier in the chapter. Seven predefined coordinate systems, accessible through the drop-down list on the Main Toolbar, are available in 3ds max 6. These coordinate systems are shown in Figure 4.13.

FIGURE 4.13 The Coordinate Systems drop-down list provides several coordinate systems to aid in object manipulation.

Each of the alternate coordinate systems uses the World Coordinate System internally as a reference. In other words, the World Coordinate System is the only true coordinate system. The others are tools intended to ease manipulation of geometry under a variety of circumstances. A brief description of each of the coordinate systems follows:

The World Coordinate System: A fixed-axis system. The z-axis points up.

The View Coordinate System: The axis tripod changes with each view so that the x-axis moves an object horizontally and the y-axis moves an object vertically in that view. The exception is in the Perspective view, in which case the View Coordinate System uses the World Coordinate System.

Screen Coordinate System: The axis tripod changes to match the orientation of the active view.

Local Coordinate System: The axis tripod is attached to the object and reflects the orientation of the object. This system is useful during rotation and animation.

Parent Coordinate System: The coordinate system of the parent object is used. If the object is not the child of another object, the World Coordinate System is used.

Gimbal Coordinate System: The Euler XYZ rotational controllers are applied to the object. Although this system is similar to the Local Coordinate System, the orientation of each axis is not necessarily orthogonal.

Grid Coordinate System: The Coordinate System of the active grid is used.

SUMMARY

In this chapter you learned about transforms and some of the tools associated with them. Understanding transforms and coordinate systems is vital for every aspect of 3D modeling and animation. Study the coordinate systems and how each axis works with the coordinate systems. Through experience and the tutorials throughout this book, you will become more proficient in working with these tools.

BUILDING WITH SUB-OBJECTS

In this chapter

- Sub-Objects
- Modifiers Overview
- Modifiers: EditMesh, Extrude
- Tools: Extrude, Bevel, Fillet, Divide, Chamfer

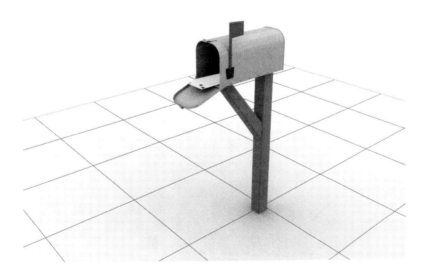

Many of the chapters in this book approach each task as a separate project. This approach is intended to mimic the real world, in that modeling, animating, and lighting tasks are given out as projects. Artists in various departments frequently collaborate, and as such the tutorial layout in this book should be considered an introduction into the studio workflow.

Starting with this chapter, this project, and each subsequent project, begins with a Project Directive, followed by Project Assessments, one for each of the modeling tasks. The Project Directive is similar to the instructions given by an art director or client. The Project Assessment is an analysis of the processes required to undertake the task and is followed by a tutorial for building the model.

SUB-OBJECTS

Before you begin the project, you need to learn about sub-objects. Sub-objects are lower-level components of an object. Most objects and modifiers have sub-objects. The sub-objects control lower-level components independently of the overall object. Primitives are made up of vertices, edges, faces, polygons, and elements. The sub-object modes are available only in editable objects, such as the Editable Poly, Editable Mesh, and Editable Spline. The Sub-Object mode icons, which are found in the Modify Panel, are pictured in Figure 5.1. The breakdown of a typical geometric mesh object follows:

Element: A mesh object or group of contiguous faces. A geometric object may have any number of elements.

Polygon: By definition, three or more vertices connected by edges to form a surface. A polygon can be made up of one or more faces. In the Editable Mesh object, most polygons consist of two faces, with an invisible edge between them.

Face: The smallest renderable surface of a mesh object. A face has three and only three vertices connected by three and only three edges.

Edge: Objects by connecting two vertices. Each edge has a vertex on either end. Edges are connected to create faces and polygons. Edges don't render but can be visible or invisible. Visible edges influence subdivision surface smoothing whereas invisible edges do not.

Vertex: A single point in 3D space. The plural form is vertices. Vertices do not render but are the smallest component of every geometric ob-

FIGURE 5.1 The Sub-Object mode icons for an
Editable Mesh object.

ject. Vertices are used to create edges, which create faces, which create polygons, which ultimately are used to create fantastic models.

Although all of the sub-objects are necessary to build geometric objects, they are not accessible from a primitive's parameters. To access the sub-object parameters, the primitive must either be converted to a different class of geometry, such as the Editable Mesh or the Editable Poly object, or a modifier must be applied for access to the sub-object components. You will work with the modifier version here and move to the Edit Poly object in subsequent exercises.

Project Directive: Build a Traditional Suburban Mailbox. Build a traditional suburban mailbox with a working door and outgoing mail flag, such as the one shown in Figure 5.2. Materials and lighting are not required at this time.

Project Assessment: The post of the 3D mailbox (shown in Figure 5.3) is created from a single box, even though in the real world it would be created with multiple pieces of wood. To construct this item from a single box object, an EditMesh modifier must be applied.

Modifiers: Because this exercise requires a box and a box is a primitive, you must apply a modifier to adjust the geometry to something other than a box. You can select modifiers from the Modifier List found in

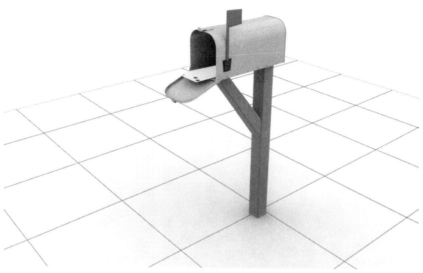

FIGURE 5.2 The model for the mailbox project.

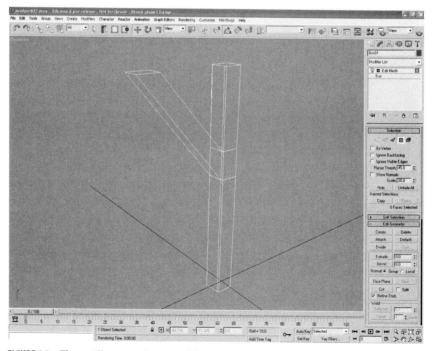

FIGURE 5.3 The mailbox post is created from a single box object using some of the geometry tools found in an Editable Mesh object.

the Modify Panel. The following tutorial introduces you to the Modify Panel and modifiers.

ADDING AN EDITMESH MODIFIER

1. Open or reset 3ds max 6.
2. In the Top view, create a box with the following dimensions: Length = 4, Width = 4, Height = 48, Height Segments = 3. Leave all other parameters at default values.
3. Click the second tab of the Command Panel to open the Modify Panel, shown in Figure 5.4. Be sure the box object is selected when opening the Modify Panel.
4. Click the Modifier List to view a list of applicable geometric modifiers.
5. Scroll through the list and locate the EditMesh modifier, found about one-third of the way down the list under the Object-Space Modifiers section.
6. Click the EditMesh modifier to apply it to the box object. All of the sub-objects levels of an Editable Mesh object are visible in the Modify Panel after you apply the EditMesh modifier. The Modify Panel showing the applied EditMesh modifier is shown in Figure 5.5.

FIGURE 5.4 The Modify Panel is the second tab from the left. You will spend most of your modeling time in this panel.

FIGURE 5.5 The result of applying an
EditMesh modifier to the box.

Now that an EditMesh modifier has been applied, what do you do with it? Applying an EditMesh modifier enables access to the object's vertices, edges, faces, polygons, and elements, also known as sub-objects. Now that you can access the sub-objects, this geometric object has the potential to become anything you can imagine, including a simple mailbox post.

TUTORIAL

TRANSFORMING SUB-OBJECTS

The first task is to move the vertices of the box so they are positioned where you need them for the support beam. You will transform vertices for this task using the Select and Move tool.

1. Click the Vertex Sub-Object icon (shown in Figure 5.6), found in the Selection rollout of the EditMesh modifier in the Modify Panel. In Vertex sub-object mode, you can select vertices only of the selected object.

FIGURE 5.6 The Modify Panel showing an active Vertex sub-object mode.

FIGURE 5.7 Drag a selection region around the second set of vertices from the bottom.

2. In the Front view, drag a selection region around the second set of vertices from the bottom, as illustrated in Figure 5.7.
3. Using the Select and Move tool in the Front view, drag the selection of vertices upward 10 units along the view's y-axis. Use the y-axis constraint handle on the transform gizmo to keep the vertices aligned. The newly positioned vertices are shown in Figure 5.8.

Now that the vertices have been repositioned, the support beam needs to be constructed. This beam will be created from the polygon that is created by the vertices in the center of the beam.

Switching between the different sub-object modes is easy. Type the number of the desired sub-object level to change to that level. The lowest level starts at 1, such as vertex level, and the highest is 5, for element. Though the types and number of levels of sub-object change with different objects, the hot keys are universal for sub-object levels.

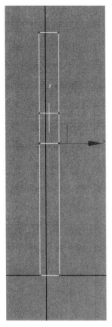

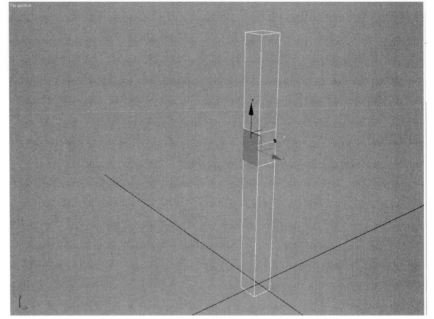

FIGURE 5.8 The vertices after moving 10 units along the y-axis.

FIGURE 5.9 Click to select the inside polygon. A support beam will be constructed from this polygon.

4. Switch to Polygon mode by clicking the Polygon icon in the Selection roll-out.
5. In the Perspective view, click the polygon in the inside left of the interface, as shown in Figure 5.9.
6. Using the transform gizmo, click and drag the y-axis handle. The polygon moves, bringing the connecting edges with it. You do not want this object for the support beam, so click the Undo icon or press CTRL + Z to undo the polygon transform.

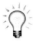

Instead of using the CTRL + Z command or clicking the Undo icon to undo a mouse operation, right-click while still pressing the left mouse button. This action cancels the prior operation and enables you to continue working with the current tool without reactivating it.

What you need is to create additional geometry from an existing polygon, essentially extending it outward. The Edit Geometry tools (shown in Figure 5.10) are used for modifying geometry at the sub-object level. In this case, you will use the Extrude tool, which extends a polygon, creating new edges at its original position.

FIGURE 5.10 The Edit Geometry tools are used to edit, build, or remove geometry from an object.

FIGURE 5.11 After clicking all of the outside edges, you can edit them simultaneously.

Prior to using the Extrude tool, you must modify the edges of the box so they are not so sharp. To do that, you chamfer the edges so they have a slight bevel. This bevel gives the edges a more realistic look—most real-world objects do not have very sharp edges.

7. Because you are going to change the shape of edges, click the Edge sub-object mode (or press the 2 key).

8. Select a corner edge and click each outside edge while holding the CTRL key. The CTRL key allows you to select multiple objects. When you are done, you should have 12 edges selected, as indicated at the bottom of the Selection rollout, shown in Figure 5.11.

Holding the CTRL key while clicking objects or sub-objects adds to the current selection; holding the ALT key subtracts from the current selection.

9. With the 12 edges selected, scroll through the Edit Geometry rollout to find the Chamfer tool. In the text box, type 0.25. All of the edges are chamfered one-quarter unit. The result is shown in Figure 5.12.

FIGURE 5.12 The edges after applying a chamfer.

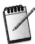

The Chamfer tool can be used interactively by clicking the Chamfer button, then clicking and dragging an edge. In the Interactive mode, it is more difficult to achieve an exact value. When a precise value is required, typing the value is faster.

Now that the edges have been chamfered, you can build the support arm from a polygon on the post.

10. Switch to Polygon sub-object mode, and click the Extrude tool button in the Edit Geometry rollout.
11. In the Perspective view, click and drag upward on the small inside polygon until the Extrude value is at 15.0. It may be difficult to get to 15.0 exactly, so just get it close. The polygon extends outward from the post and new edges are created, connecting the polygon to the rest of the geometry, as shown in Figure 5.13.

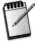

When using the Edit Geometry tools, such as the Extrude, Bevel, or Chamfer tools, the value always returns to 0 after the tool has been applied. The value is reset because the tool is active and ready for use on another sub-object.

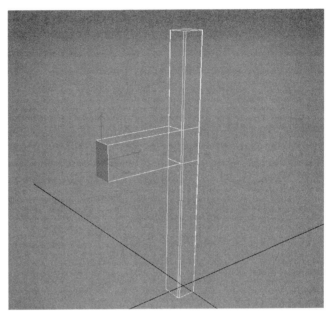

FIGURE 5.13 The polygon after applying the Extrude tool. New geometry is created to connect the polygon to the rest of the geometry.

You now must adjust the support arm geometry. This operation includes rotating, positioning, and scaling a polygon.

12. While still in Polygon sub-object mode, use the Select and Rotate tool to rotate the polygon –>90 degrees along the x-axis. You may want to use the Angle Snap toggle for more exact rotation.

13. You must now position the polygon now at the top of the post, so in the Transform Type-In text boxes at the base of the 3ds max interface, type 48. This value sets the height of this polygon equal to the height of the top polygon on the post.

After rotating and positioning the polygon, your post should look like the one shown in Figure 5.14.

14. Switch to the Select and Scale tool. In the Top view, click and drag the y-axis constraint to scale the polygon to 60 percent along the y-axis only. This action makes the polygon square again.

15. Switch to Edge sub-object mode. Select the four newly created edges of the support arm and type a value of .25 in the Chamfer text box. Your support arm and post should like the one shown in Figure 5.15.

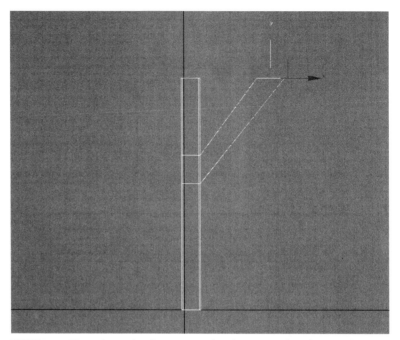

FIGURE 5.14 The polygon has been rotated and positioned at the top of the post.

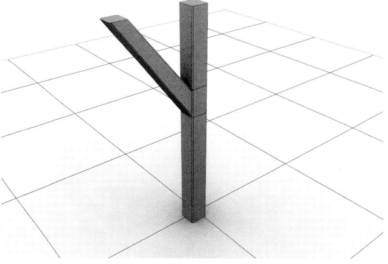

FIGURE 5.15 The completed model of the mailbox post.

The previous step completes the mailbox post modeling exercise. Before moving on to other modeling exercises, name the box object by clicking in the name text field and typing an appropriate name, such as *mailbox post*.

Naming objects as they are created is a good habit to learn. Doing so alleviates the problem of figuring out what everything is later, when you may have hundreds of objects in your scene. For example, mailbox post *is more descriptive than* box01.

BUILDING THE MAILBOX BODY

The body of the mailbox is constructed from a rectangle shape and an Extrude modifier. In this tutorial, you will learn how to clone objects and sub-objects and how to use the Align tool.

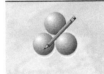

TUTORIAL ## BUILDING THE MAILBOX BODY

1. In the Front view, use the Rectangle tool to create a rectangle with both the Length and Width parameters set to 10.
2. With the rectangle selected, right-click in the active view and choose Convert to Editable Spline from the Quad menu, shown in Figure 5.16.

FIGURE 5.16 The Convert to Editable Spline option from the Quad menu.

By converting the rectangle to an Editable Spline, you can access the sub-objects without adding an additional modifier, as was done earlier with the EditMesh modifier.

3. Activate the Vertex sub-object mode and select the top row of vertices.
4. Activate the Fillet tool found in the Geometry tab, and click and drag up the top row of vertices. The vertices split in two, and the sharp corner creates a smooth curve. Release the mouse button when the curve amount is at 3.275. Your rectangle should look like the one shown in Figure 5.17.

FIGURE 5.17 After you apply the Fillet tool, the sharp corners become rounded.

5. In the Front view, click and drag the top four vertices one unit along the y-axis to give the rectangle a shape that is longer than it is wide.
6. Activate the Spline sub-object mode and select the rectangle. In the Geometry Tools rollout, select the Outline tool and type a value of 0.125. The Outline tool duplicates the selected spline to create the interior wall.
7. Turn off the sub-object mode, open the Modifier List, and apply an Extrude Modifier to the spline.
8. Set the Extrude amount to 24. This action creates the body of the mailbox and makes it 2 feet long. So far, the mailbox should look like the one shown in Figure 5.18.
9. In the Name field, change the name of the rectangle to *mailbox body*.

Whenever a spline is "nested" inside another spline, the interior spline creates a hole in the geometry. Each subsequently nested spline toggles between adding and removing geometry. The splines of the mailbox were nested on purpose to create the thin-walled construction required for this object.

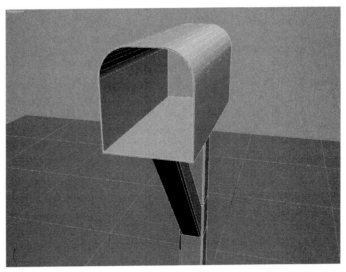

FIGURE 5.18 The mailbox body after applying the Extrude modifier and setting the extrude amount to 24.

To create the back of the mailbox, you will clone the mailbox body object and adjust the spline and the modifier.

10. In the Left view, press the SHIFT key and drag the mailbox body object –>0.125 units along the x-axis. The Clone Object dialog box shown in Figure 5.19 opens. Choose Copy and rename the object as *mailbox back*, then press OK.

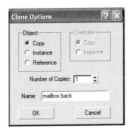

FIGURE 5.19 The Clone Object dialog box.

11. Select the mailbox back object. In the Modify Panel, set the Amount parameter of the Extrude modifier to 0.125. This amount matches the distance the object was moved so that it is aligned to the back of the mailbox body.
12. In the Modifier Stack, select the Editable Spline entry and click + (plus sign) to show the sub-object options. As shown in Figure 5.20, the Spline sub-object level is activated.

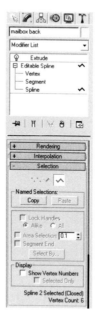

FIGURE 5.20 Click + (plus sign) to open the sub-object levels for an object. From here you can activate any of the sub-object levels.

13. Notice that, like the mailbox body, the object is hollow. In the Front view, click the interior spline and press the Delete key to delete that spline. Click the Shown End Result icon (shown in Figure 5.21) to see that the object now becomes a solid object (because the interior spline was removed).

FIGURE 5.21 The Show End Result icon is used to view the effects of modifiers that occur higher in the Modifier Stack.

The Show End Result icon is used to view object modifications that occur within the Modifier Stack. The Modifier Stack is order dependent. Modifiers are applied to the original object (at the base of the stack) from the bottom up. When modifying a modifier in the middle of the stack, the modifiers that are higher in the stack are not visible unless Show End Result is turned on.

14. In the Front view, select the spline and type –>0.125 in the Outline Tool field to make the spline larger. By making the spline larger, a lip is created at the back of the mailbox. Delete the original interior spline so the object becomes solid again. The results are shown in Figure 5.22.

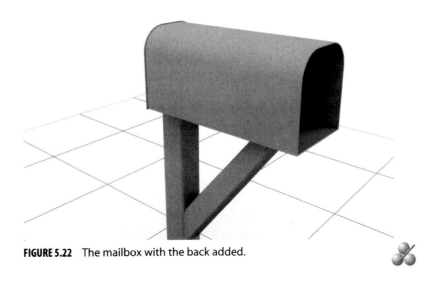

FIGURE 5.22 The mailbox with the back added.

TUTORIAL ## CREATING THE DOOR USING AN EDITABLE POLY OBJECT

The shape of the door of the mailbox presents some interesting problems. Because of the complexity of the shape, it is more difficult to create using the Editable Mesh object than some other tools. For this exercise, you will use the Editable Poly object.

1. Holding the SHIFT key, click and drag the *mailbox back* object along the x-axis in the Left view until it reaches the front of the mailbox body. Choose Copy as the clone option and rename the object *mailbox door*.

2. In the Modifier Stack, click the Editable Spline and activate the Segment sub-object mode.
3. In the Front view, select the two long segments that make up the sides.
4. In the Geometry rollout, find the Divide tool (as shown in Figure 5.23) and set the Divide field to 1, then click the Divide button. The edges are divided one time, creating new vertices, which can be repositioned, as shown in Figure 5.24.

FIGURE 5.23 The Divide tool splits a segment into equal parts.

FIGURE 5.24 The new vertices are created using the Divide tool.

5. Switch to Vertex sub-object mode, select the two new vertices, and use the shortcut menu to change the vertex types to corner vertices, as shown in Figure 5.25.

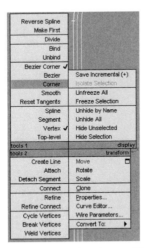

FIGURE 5.25 Vertex types can be changed by right-clicking the vertex and choosing the vertex type from the Quad menu.

6. Reposition the new vertices so that they are closer to the bottom. These vertices are used to create the hinge. Also, reposition the bottom vertices lower than the mailbox so that the hinge extends below the mailbox, as shown in Figure 5.26.

FIGURE 5.26 The new vertices and the vertices on the bottom have been repositioned to create the hinge.

7. In the Modifier Stack, go back to the Extrude modifier and set the Amount parameter to –0.75. This action creates the sides of the door.
8. To aid with creating the hinge, create a circle shape and position it where the hinge should be. This circle acts as a guide and can be seen in Figure 5.27.

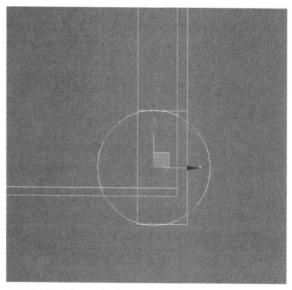

FIGURE 5.27 The circle shape is used as a guide when you create the hinge.

9. To make it easier to see what's going on, hide the mailbox body by selecting it and choosing Hide Selection from the Quad menu, pictured in Figure 5.28.

FIGURE 5.28 The Hide Selection option on the Quad menu makes seeing other objects easier.

10. Select the mailbox door and choose Convert to Editable Poly, shown in Figure 5.29. This action changes the object class and offers more powerful tools than the Editable Mesh object does.

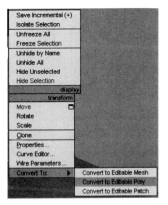

FIGURE 5.29 The Convert to Editable Poly option changes the selected object's object class, providing more powerful tools for editing geometry.

11. Activate Polygon sub-object mode and choose the large polygon that makes up the back side of the door.

12. In the Edit Polygons rollout, open the Bevel dialog box by clicking the Settings icon. Both the dialog box and the Settings icon are shown in Figure 5.30.

FIGURE 5.30 The Bevel dialog box (left) is accessed through the Settings icon (right).

13. In the Bevel dialog box, set the Height parameter to 0.0 and the Bevel parameter to –>0.125, then click the Apply button. These settings create the thickness of the sides of the door.

14. To create the walls themselves, the selected polygon must be extruded into the door. Set the Height parameter to –>0.7 and the Bevel parameter to 0.0. The result is shown in Figure 5.31.

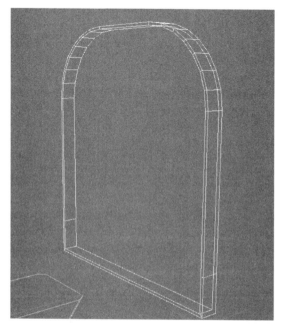

FIGURE 5.31 The door after the Bevel and Extrusion tools are used on the back face.

15. In the Perspective view, select the two smaller polygons where the hinges are to be placed and click the Extrude Settings icon, located just above the Bevel icon.

16. Set the Height parameter to 0.14 and click the Apply button five times, then click OK to create six new segments, as shown in Figure 5.32.

17. Using the Scale tool in the Left view, select the vertical set of vertices closest to the front of the mailbox and scale along the y-axis until the vertices lie on the circle guide.

18. Continue with each of the six sets of vertices until the vertices form a rounded shape, as shown in Figure 5.33.

FIGURE 5.32 The result of extruding the selected polygons six times.

FIGURE 5.33 After scaling the vertices of the hinge, the geometry becomes more rounded, due to the extra segments.

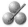

Although the door is complete, some accessory components must be created. Using the tools described in this chapter, you should be able to create the door clasps (made with an Editable Spline and Extrude modifier) and the flag (made with an Editable Poly or Editable Mesh). The completed mailbox is shown in Figure 5.34.

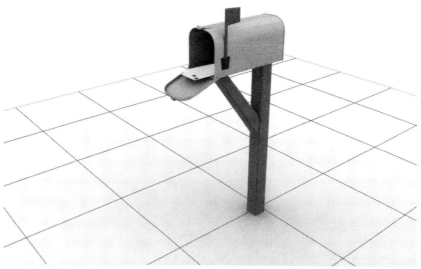

FIGURE 5.34 The completed mailbox, with working door and flag.

SUMMARY

This chapter showed you that even creating something simple, such as a mailbox, can be quite involved. These tutorials are the start of working with more complex models and sub-object manipulation. In this chapter you learned about:

- Working with vertices, edges, and polygons
- Cloning objects and repurposing them for other components
- Using some of the Edit Geometry and Edit Poly tools

Use this example to build on. Try to complete the mailbox on your own by creating the other components, including the flag, rivets, and as much detail as you can. Remember, it is the subtle detail that makes the greatest impact on whether an image is memorable.

BUILDING THE WATER TOWER

In this chapter

- Lathe Modifier
- The Array Tool
- Edge Chamfer Tool

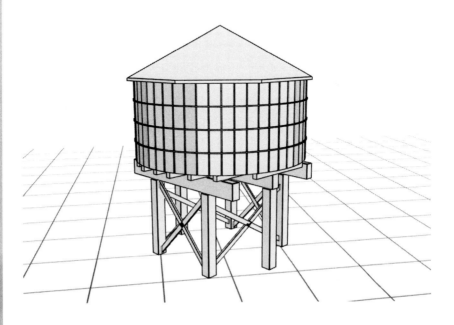

n this project, you will build a water tower. The water tower is a focal point in the animation, in that it connects the gag of where the commercial water is coming from. The water tower should look dilapidated and grimy.

Project Assessment:

- Build a complete water tower for the focal point for the final animation.
- Use reference images and concept sketches for an old-fashioned water tower. The final look is intended to be a dilapidated yet functioning water tower. The construction of the tower is based on the tower shown in Figure 6.1.

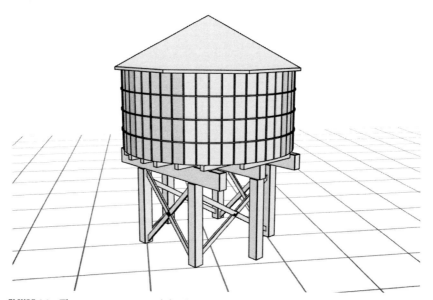

FIGURE 6.1 The water tower model reference.

Modifiers:

- Lathe

Tools:

- Editable Poly tools
- Array tool
- Align tool

BUILDING THE TOWER CAP

The cap of the water tower is built from a spline with a Lathe modifier applied. The Lathe modifier gives the object its three-dimensional shape, and the spline defines the profile of the object. The following tutorial shows how to build the tower cap.

1. In the Front view, create a rectangle, and set the Length parameter to 40 and the Width parameter to 72. This object is the guide for the next step.
2. Also in the Front view, use the Line tool to create the shape shown in Figure 6.2. Create this shape so that it fits within the guide rectangle created in step 1. Name the new line shape *tower cap*. If you are unfamiliar with the Line tool, refer to Chapter 3 "Starting Simple: Creating Shapes and Primitives" for tutorials on using the Line tool.

FIGURE 6.2 The profile of the tower cap is created using the Line tool.

3. Delete the rectangle guide shape, because it is no longer needed.
4. With the *tower cap* shape selected, open the Modify Panel and select the Lathe modifier from the Modifier List. Apply the Lathe modifier to the spline. The result looks similar to that shown in Figure 6.3.

FIGURE 6.3 After applying the Lathe modifier, prior to making any parameter adjustments.

After applying the Lathe modifier, you must make some adjustments. As with most modifiers, the Lathe modifier has parameters with which to customize its effect.

 The Lathe modifier takes a two-dimensional spline and rotates it around an axis, creating new geometry as it goes. A brief explanation of the most used parameters follows:

> **Degrees**: *Determine how far around the Lathe modifier is applied. Values are from 0 to 360 degrees.*
>
> **Weld Core**: *Welds vertices that lie along the lathe axis. This parameter corrects unusual smoothing effects due to coincident vertices.*
>
> **Flip Normals**: *Toggles the normals' direction. Depending on the direction in which the vertices of the original spline were created, the normals can be facing in or out. Normals—perpendicular vectors attached to every polygon—are used when calculating surface lighting, smoothing, and other surface attributes. Normals that face in give the mesh an inverted look when rendered.*

Direction: *Determines the direction of the lathe axis.*

Align: *Aligns the lathe axis to a perpendicular axis. Its position is based on the Min, Center, or Max buttons.*

5. In the Modify Panel, find the Align section. Click the Min button to move the Lathe axis to the minimum position along the spline's x-axis. Also, set the Lathe Segments parameter to 8. Your tower cap should look like the object shown in Figure 6.4.

FIGURE 6.4 The complete tower cap.

6. For proper position, the pivot point must be centered to the geometry after the application of the Lathe modifier. To reposition the pivot point, click the Hierarchy Tab (shown in Figure 6.5), select Affect Pivot Only, then click the Center to Object button. The pivot point is centered on the geometry instead of on the original line shape.

7. In the Transform Type-In dialog box, type the following World Coordinate values: (0,0,80)

8. The last step is to rotate the entire tower cap object 22.5 degrees so that its flat edge is at the top and the bottom (when viewed from the Top view). Figure 6.6 shows the position of the tower cap after rotation.

FIGURE 6.5 The Hierarchy Tab.

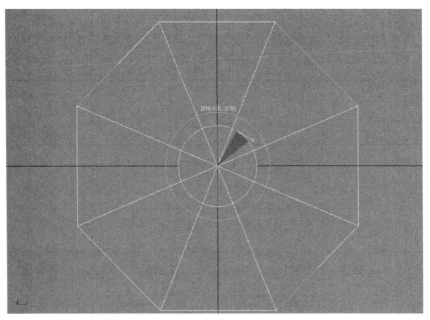

FIGURE 6.6 The tower cap after rotation.

9. Right-click in the active view to reveal the Quad menu. From the upper-right quad, choose the Hide Selected option (as shown in Figure 6.7) to hide the tower cap. By hiding this geometry, you can work on new geometry without it getting in the way.

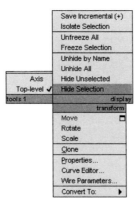

FIGURE 6.7 The Hide Selection option is found on the Quad menu.

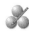

TUTORIAL BUILDING THE TOWER BODY

The tower body is created from a box object that is converted to an Editable Poly object. The box creates a single section of the body of the tower, which is then duplicated many times to create the rest of the tower. This method allows for greater manipulation later of the geometry, such as animating the tower falling apart.

1. In the Top view, create a box with the following dimensions: Length = 1.5, Width = 8, Height = 60. All Segment parameters are set to 1.
2. Convert the box to an Editable Poly object and name the box *tower panel01*.
3. Switch to Edge sub-object mode and drag a selection rectangle to select all four long edges, as shown in Figure 6.8.
4. Activate the Chamfer Settings dialog box, located under the Edit Edges rollout, set the Chamfer parameter to 0.15, then click OK. This action takes the sharp edges off of the panel. The dialog box and result are shown in Figure 6.9.

FIGURE 6.8 The interior edges of the tower panel box.

FIGURE 6.9 The tower panel after applying the chamfer. The Chamfer settings dialog box is also shown for comparison.

5. Switch to Polygon mode and click the polygon on the end of the panel. Using the Quad menu, select Convert to Edge from the Tools 1 menu (as shown in Figure 6.10). This action converts the selection from the selected polygon to the edges that make up the selection.

6. Using the Chamfer settings dialog box again, set the Chamfer parameter to 0.05. Repeat this and the previous step on the opposite end of the panel. Exit sub-object mode by clicking the currently active sub-object icon.

7. On the Quad menu, choose Unhide by Name and choose the tower cap object when the dialog box appears.

8. In the Top view, select the tower panel object and click the Align tool icon, found on the Main Toolbar and shown in Figure 6.11. After activating the Align tool, click the tower cap object. The tower cap becomes the align target. Because the tower panel was selected before the Align tool was activated, it becomes the current object.

FIGURE 6.10 By using the Convert to Edge option, you can quickly group a set of related edges by selecting a common polygon.

9. In the Align Selection dialog box, click in Y Position to activate alignment for that axis. In the Current Object and Target Object sections, select Minimum. This option aligns the minimum y value of the current object to the minimum y value of the target object. The results are shown immediately and can be seen in Figure 6.12. Click OK to keep this alignment configuration.

The intent is to now clone the panel so that it forms the tank itself. To make this operation easier, the panel first needs to have its pivot point aligned to the center of the tank cap.

FIGURE 6.11 The Align tool icon is found in the Main Toolbar.

10. In the Top view, select the tower panel object and open the Hierarchy Panel, then activate Affect Pivot Only.

FIGURE 6.12 The Align Selection dialog box can be used to align a pivot point, as well as an object or group of objects.

11. Click the Align tool icon (as was done earlier), then click on the *tower cap* object. In the Align Selection dialog box, activate the y-axis and set the current object to Pivot Point and the Target Object to Center, as shown in Figure 6.13, then click OK.
12. Turn off Affect Pivot Only by clicking its button.

 The pivot point was aligned to the center of the tower cap so that the panel object can be easily cloned to fit into position under the cap. By cloning along the rotational axis of the panel's pivot point, new panels can be created all the way around to create the body of the tower. The next step illustrates that point.

13. With the Top view activated, select the Array tool, found under the Tools menu (and shown in Figure 6.14).
14. In the Array dialog box (shown in Figure 6.15), set the Z Rotate value to 7.2 and the 1D count to 50. Be sure that Instance is selected as the clone option, then click OK. An array of identical panels is created in a perfect circular pattern just beneath the cap object.

The completed tower body is shown in Figure 6.16. By using the Array tool, you can create all the panels rather quickly. Because the clone option was Instance, you can change all panels simultaneously by editing any of the panels.

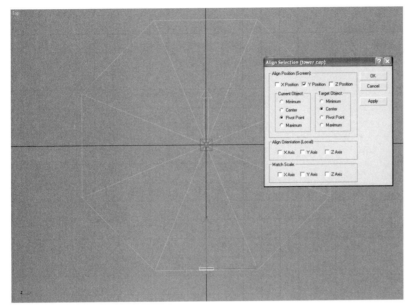

FIGURE 6.13 Aligning the pivot point of the tower panel to the tower cap.

FIGURE 6.14 The Array menu item.

15. Because 50 panels were created, grouping them enables you to interact with all the panels as one or individually. Select all of the panels and click the Group menu item under the Group menu. When prompted for a name, call the group *tower tank*.

16. Now that the panels are complete, use the Align tool to align the cap with the top of any one of the panels. Select the tower cap object first, because the panels are the target of the alignment. The tower should look like the one shown in Figure 6.17. Now is a good time to save your file.

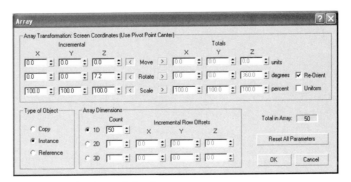

FIGURE 6.15 The Array dialog box.

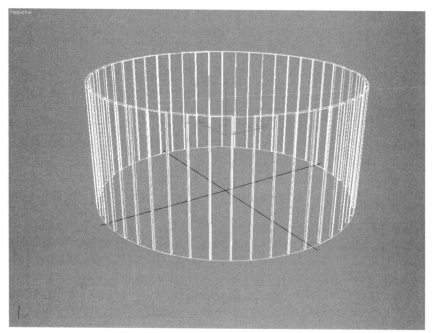

FIGURE 6.16 The complete tower body, made of 50 instanced panels using the Array tool.

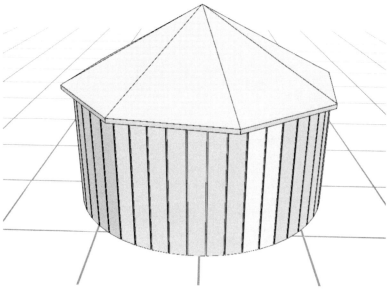

FIGURE 6.17 The tower cap and panels aligned.

TUTORIAL

CREATING THE CROSS BEAMS

The cross beams are created from a single modified box, then cloned and mirrored to create the grid of support beams.

1. In the Top view, create a box with the following dimensions: Length = 130, Width = 4, Height = 4. Name the box *4x4 cross beam01*.
2. Convert the box to an Editable Poly object, then activate Edge sub-object mode.
3. In the Perspective view, select the four edges that make up the length of the object. Be sure that only the four long edges are selected, as shown in Figure 6.18.

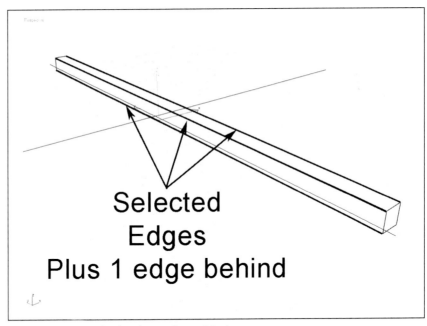

FIGURE 6.18 Select the four long edges of the beam.

4. Switch to Edge sub-object mode. Under the Edit Edges rollout, click the Chamfer settings icon and set the chamfer parameter to 0.25, then click OK.
5. Exit Edge sub-object mode by clicking the Edge sub-object icon again.
6. In the Top view, center the beam within the scene by setting its positional values to (0,0,0).

7. Activate the Array tool (found in the Tools menu), and set the Incremental X value to (–10.5) and the ID Count parameter to 5, as shown in Figure 6.19. Be sure the clone option is set to Copy, then click OK. This action creates four clones of the cross beam for a total of five beams.

FIGURE 6.19 The Array dialog box prior to cloning four cross beams.

8. In the Top view, adjust the vertices of each of the supporting beams so that their lengths corresponds to the roundness of the tank. You can do this by switching to Vertex sub-object mode and scaling the end vertices toward the center of each beam. Adjust each of the beams along the y-axis in the Top view, excluding the center beam, by the following percentages: 90, 75, 40. After adjusting the vertices, your beams should look like those in Figure 6.20.

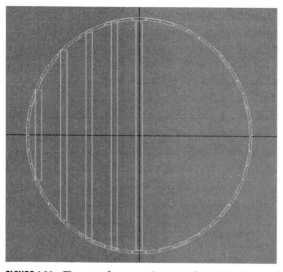 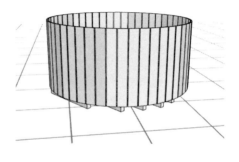

FIGURE 6.20 The set of support beams after adjusting the vertices.

9. To save time, the beams on the other side are cloned using the Mirror tool. Select the four outer beams (excluding the center beam) and set the Transform Coordinate to World and the Active Center to Transform Center. Because the rest of the model is based around the origin, using these settings guarantees that all objects are centered.

10. Click the Mirror tool icon, shown in Figure 6.21, and in the Mirror Selection dialog box, choose Copy as the clone option, then click OK.

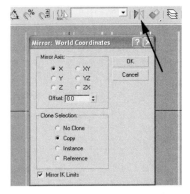

FIGURE 6.21　The Mirror Tool and icon.

11. Select all nine cross beams, and use the Align tool to align the tops of the cross beams with the underside of any of the tower tank panel objects. The result is a complete set of support beams, as shown in Figure 6.22.

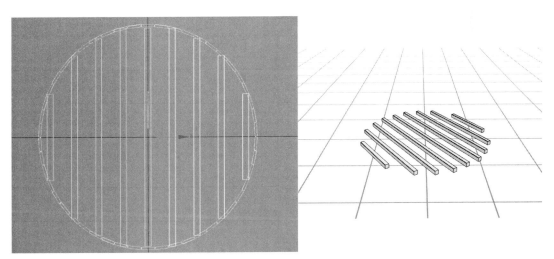

FIGURE 6.22　The complete set of support beams (with the tank panels hidden).

12. In the Leftview, create a box with the following dimensions: Length = 12, Width = 7, Height = 115. This box will be one of three additional beams. Name the box *cross beam Large01*.

13. Center the box's pivot point as you did earlier for the tower cap—click the Hierarchy Panel, then Affect Pivot Only, then Center to Object.

14. Position the beam at (0,0,0) and convert the box to an Editable Poly object.

15. Use CTRL + V to clone additional beams on both sides. Choose Instance as the clone option.

16. Use the Transform Type-In dialog box to position each beam 41 units on either side of the original beam.

17. Use the Align tool to position all three large cross beams below the smaller support beams. Chamfer the edges of the large support beams, as you did with the cross beams. Because they are instances, you need only make the adjustments to a single beam. Your beams should now look like those shown in Figure 6.23

18. Save your work as *h2o_tower01.max*.

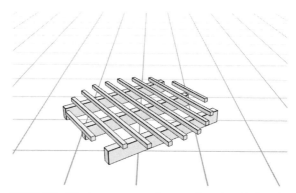

FIGURE 6.23 The large support beams after chamfering the edges.

T U T O R I A L

CREATING THE VERTICAL SUPPORT BEAMS

The legs, or vertical support beams, are created much like the cross beams. By creating a box and centering its pivot point to the tower body, you create an array of six legs. You then position the large support beams so they are directly above the legs.

1. Create a box in the Top view with the following dimensions: Length = 8, Width = 8, Height = 60. Name the box *tower vbeam01*.
2. Convert the box to an Editable Poly object.
3. In Edge mode, use the Chamfer tool to chamfer all of the long edges by 0.25, just as you did the support beams earlier.
4. Because the vertical supports were built in the Top view, the other objects in the scene must be aligned to the top of them. Select the other objects and move them so they rest in order on top of the vertical supports.
5. In the Top view, align the vertical support beam so it is centered along the y-axis on the large top cross beam. Create two additional supports on the left side so there are three vertical supports, as shown in Figure 6.24.
6. Clone the vertical beams by selecting all three, selecting the World Coordinate System, and selecting Transform Coordinate Center (as was done in the cross beam tutorial) while using the Mirror tool. Clone as Instances. The result is shown in Figure 6.25.

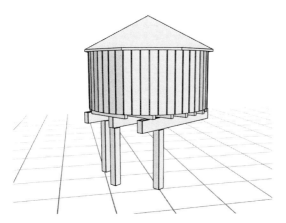

FIGURE 6.24 The vertical support beams for the left side.

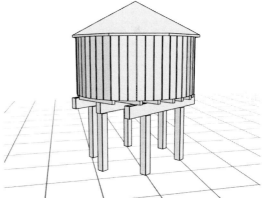

FIGURE 6.25 The support structure after cloning additional vertical supports.

TUTORIAL CREATING THE TANK FLOOR

Currently, the tank has no floor. You create the floor with a simple cylinder, though the edges should be beveled to give it a realistic appearance.

1. In the Top view, create a cylinder with the following parameters: Radius = 66.5. Height = 1.0, Height Segments = 1, Sides = 48. You may need to make adjustments if your other objects were not created with precise measurements. The tank floor should fit within the walls of the tank.
2. Rename the cylinder *tank floor* and position the cylinder at (0,0,0). Then use the Align tool in the Front view to position the floor's Min Y to the Max Y of the *4x4 cross beams* (using the View coordinate system).
3. Convert the tank floor to an Editable Poly object, and chamfer the bottom edge around the circumference of the cylinder, as you did with the panels. Set the Chamfer parameter to 0.15. The top edges need not be chamfered, because they will be inside the tank.

BUILDING BOTTOM CROSS BEAMS

Several cross beams support the leg structure of the tank. Create the cross beams on your own, using the previous tutorials as examples of how to build them. The final tank structure should look like the one shown in Figure 6.26.

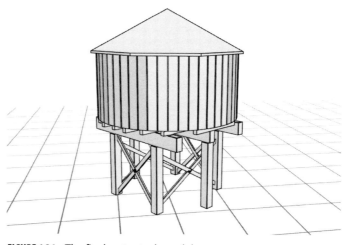

FIGURE 6.26 The final water tank model.

ACCESSORIES

Not all of the accessories are added through this tutorial series. Use the design sketches or reference material from old water tanks to get ideas on how to make the model more interesting. The key to realism is detail. Some additional items to consider:

- Windmill
- Weather vane
- Ladder
- Various piping configurations
- Metal straps for panel support

SUMMARY

This chapter provided many examples of the Editable Poly object Chamfer tool. By adding a chamfered edge to your models, you create an edge that reflects some specular light, giving a nice highlight to that edge and, ultimately, more realism.
Other tools included:

- The Clone tool
- The Array tool for creating multiple clones along one, two, or three dimensions
- The Align tool

As you can see by the tutorials in this chapter, several tools aid in creating duplicate objects. By using these tools correctly, you can quickly create complex structures.

7

BUILDING THE ELASTIC-POWERED ATMOSPHERIC TRANSPORTER

In this chapter

- Editable Poly Objects
- Sub-Object Manipulation
- Twist Modifier, Align Tool

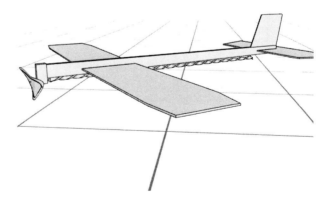

The first of the complex models is the Elastic-Powered Atmospheric Transporter, more commonly known as a rubber-band-powered balsa-wood airplane. This object is used as an animated prop in the final animation. During construction of this object, you will use the Editable Poly object and some of its tools. The Editable Poly object is a powerful alternative to other methods of modeling. It combines the ease of working with minimal sub-objects while still providing the power of creating complex geometry through the use of many powerful sub-object manipulation tools.

Project Assessment: Build a rubber-band-powered plane from the design sketches. The plane must have an animated propeller and rubber band. No other working parts are present.

Objects:

- Wing
- Tail
- Stabilizer
- Fuselage
- Propeller
- Rubber band
- Tail skid
- Propeller clip
- Cockpit

Modifiers:

- Extrude
- Twist
- Bend

Tools:

- Editable Poly tools
- Connect tool

OVERVIEW

Using the design sketch as your blueprint, you first create a box object, then convert it to an Editable Poly object. The tools built into the Editable Poly object make it superior to the tools found in an Editable Mesh object for quickly creating and manipulating complex objects.

BUILDING THE FUSELAGE

In the following tutorial you will build the fuselage from a box primitive.

1. Reset 3ds max and create a box in the Top view. Set parameters as follows: Length = 12, Width = 0.25, Height = 0.5.
2. Rename the box *fuselage*.
3. Use the Transform Type-In text boxes to set the position of the fuselage to (0,0,0).
4. From the shortcut menu, choose the Convert option, then navigate to the Editable Poly option, as shown in Figure 7.1.

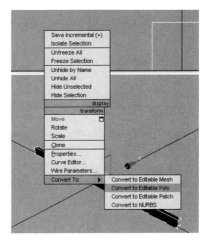

FIGURE 7.1 The Editable Poly option from the shortcut menu.

5. Switch to Vertex sub-object mode, and in the Left view, draw a rectangular selection region around the two vertices on the right side of the box. Because of the two vertices in the back, you have selected four vertices.
6. Using the Uniform Scale tool, click and drag on the y axis until the vertices have been scaled to 75 percent.

The Scale tool provides a great way to move opposing vertices along the same axis. Because vertices have no size, the Scale tool moves groups of vertices together or apart.

BUILDING THE WING

1. In the Top view, create a box with the following dimensions: Length = 2.25, Width = 14, Height = .0625. Set the Width segments to 3.
2. Convert the box to an Editable Poly object.
3. Switch to vertex mode and drag a rectangular selection region around the four center vertices. Eight vertices are selected because corresponding vertices are behind the four that are visible. The selection of vertices is shown in Figure 7.2.

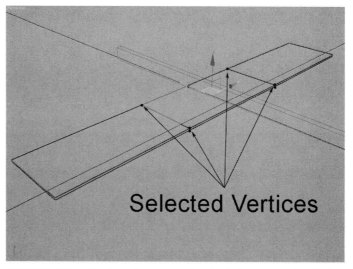

FIGURE 7.2 The selection of center vertices includes the vertices in the front and the back, even though only four vertices are visible.

4. Activate the Scale tool, set the selection mode to Selection Center, then scale the vertices by 250 percent along the x-axis. This action moves the center vertices toward the outer vertices.
5. In the Top view, select just the outer vertices (again, using the rectangular selection region to ensure that you get both the front and back vertices) on the tip of the wing, and scale them by 85 percent along the local y-axis, as shown in Figure 7.3.

FIGURE 7.3 Selecting the outer vertices and scaling them along the y-axis gives the wings more shape.

Adding some bend to the wing gives it a more realistic look. You can add additional vertices easily using the Connect tool on a selection of edges.

6. Switch to Edge sub-object mode, and in the Top view, select the long edges that run the width of the wings, as shown in Figure 7.4.

FIGURE 7.4 An additional segment is added along the long edges of the width of the wing by using the Connect tool.

7. Under the Edit Geometry rollout in the Modify Panel, click the Connect settings dialog box, shown in Figure 7.5.

8. In the Connect settings dialog box, set the Connect Edge Segments parameter to 1 and click OK. The selected edges are connected by a new set of vertices and edges, which divide each edge in two, as shown in Figure 7.6.

FIGURE 7.5 The Connect tool and its Settings icon.

FIGURE 7.6 Using the Connect tool on a set of edges to divide each edge in half.

9. Select all vertices, other than those that run along the centerline of the wing, and in the Front view, drag them 0.08 units along the y-axis. This step gives the wing a slight bend, as shown in Figure 7.7.

For now, the wing is complete. Rename this box *Wing*. You will come back to this object later for materials and positioning on the plane.

FIGURE 7.7 The wing is bent slightly by first adding another segment along the long edges using the Connect tool, and then dragging the outer edge vertices upward.

TUTORIAL

CREATING THE STABILIZER

The stabilizer is built using a box primitive. As with the wing created in the previous tutorial, this piece is created with what is known as a box-modeling method. The concept behind box modeling is to build objects with the lowest number of faces as possible, which makes controlling the mesh much easier.

1. In the Top view, create a box with the following dimensions: Length = 2, Width = 5.5, Height = 0.0625. Set all Segments parameters to 1. Rename this object *stabilizer*.
2. Convert the box to an Editable Poly object using the shortcut menu option.
3. In the Top view, select and scale the bottom corner vertices by 125 percent along the x-axis to give the stabilizer a tapered look, as shown in Figure 7.8.

FIGURE 7.8 After converting the box to an Edit Poly object, use the Scale tool to create a tapered shape.

4. Switch to Edge sub-object mode, and click the vertical edges on any of the corners. Use the Ring button (shown in Figure 7.9) to get a ring of edges around the entire stabilizer.

FIGURE 7.9 Use the Ring button to select a ring of edges around an object.

The Ring and Loop tools are used to get related edge selections on a mesh. The Ring function continues to select edges that are parallel to the selected edge. The Loop function gathers edges in both directions from the selected

edge's endpoint. Figure 7.10 illustrates the difference between a Ring selection and a Loop selection.

FIGURE 7.10 Use the Ring or Loop selection buttons to gather related edges.

5. Select any of the vertical edges that make up the height of the box, then click the Ring button. All of the vertical edges around the box are selected, as shown in Figure 7.11.
6. Now that the vertical edges have been selected, click the Chamfer settings button, shown in Figure 7.12, located in the Edit Edges rollout.
7. The Chamfer tool splits selected edges, creating a new polygon along that edge. Using the Chamfer tool, round off the edges of the stabilizer by setting the Chamfer parameter to 0.06.

FIGURE 7.11 The vertical edges of the box after clicking the Ring button.

FIGURE 7.12 The Chamfer settings button.

8. In the Top view, center the stabilizer to the fuselage along the x and z axes, and position it along the y-axis, as shown in Figure 7.13.

FIGURE 7.13 The stabilizer positioned on the fuselage.

CREATING THE RUDDER

The rudder, shown in Figure 7.14, is created somewhat differently than the other plane components. The rudder is created first with a rectangle with a modifier, then converted and adjusted. The reason for this method is primarily to show another method of object creation.

1. In the Left view, create a rectangle with the following dimensions: Length = 1.75, Width = 1.5.
2. Using the Quad menu, choose Convert To Editable Spline, then activate Vertex sub-object mode.
3. In the Left view, drag a rectangular selection area around all four vertices and right-click on one of the selected vertices. In the Quad menu, click the Corner Vertex option, as shown in Figure 7.15.
4. In the Left view, select the two vertices at the top of the rectangle and drag them 0.35 units along the x-axis.

FIGURE 7.14 The finished rudder.

FIGURE 7.15 Changing the vertex type to Corner.

5. With the same vertices selected, use the Fillet tool found in the Geometry rollout of the Editable Spline to round the top corners. Set the Fillet radius to 0.075, as shown in Figure 7.16.

FIGURE 7.16 Using the Fillet tool to round off a corner.

FIGURE 7.17 The Interpolation parameters.

 The Fillet tool is used to round off the angle of two edges by splitting a vertex and moving the split vertices along the edges while interpolating the existing angle. The larger the Fillet radius value, the larger the curve between the two segments. Once a value has been placed in the Fillet radius field and the ENTER or TAB key pressed, the value is applied and the field is cleared, showing a value of 0.0.

6. In the Interpolation rollout, shown in Figure 7.17, set the Steps parameter to 3. Leave Optimize checked and Adaptive turned off.

 Interpolation is the process of calculating the curve of line segments between existing vertices. Increasing the Steps amount creates smoother geometry by creating more steps between the existing segments and vertices.

7. Turn off the Vertex sub-object mode by clicking the Vertex icon or the Editable Spline base object in the Modifier Stack.
8. Click on the Modifier List to activate it. Find and double-click the Extrude Modifier to add it to the spline.
9. Set the Amount parameter to 0.0625 to give the rudder some thickness. Use the Extrude modifier to add depth to the two-dimensional object, as shown in Figure 7.18.

FIGURE 7.18 Close-up shot of the rudder after applying the Extrude Modifier.

Now that depth has been added to the spline, additional changes need to be made to give the rudder additional detail. For those changes, the tools of the Editable Poly object are needed. To access those tools, you must convert the object to an Editable Poly object.

10. With the rudder object selected, right-click in the active view. From the Transform menu, choose Editable Poly from the Convert To menu.

Converting an object from one class to another (such as Editable Spline to Editable Poly) results in the object being permanently collapsed, meaning that any modifiers or animated parameters that were applied are no longer accessible.

11. In the Left view, using the Select and Move tool, drag the left-lower corner vertices –0.35 units along the x-axis. Your rudder should look like the one shown in Figure 7.19.

FIGURE 7.19 The rudder after applying the Scale and Move transforms to the top row of vertices.

Now that you have given the rudder some depth and adjusted the vertices for shape, you need to bevel the edges. In the real world, all edges have some bevel. As such, adding a bevel to an edge provides a necessary highlight on the edge of the geometry, given additional realism to the geometry. Within 3ds max, polygons and faces are beveled, but edges are chamfered. The result is that the surface has an edge that is no longer infinitely thin, creating the highlight necessary to send the visual clue to the viewer. The following steps show how to access common edges through a polygon selection.

12. In the Perspective view, tighten the shot so that just the rudder is visible. Switch to Polygon mode (use the 4 hot key), and click on the large polygon, which makes up the side face of the rudder.
13. In the active view, right-click to view the Quad menu. Choose Convert to Edge from the upper-left Quad menu. This tool changes the selection from the polygon to the edges that make up the selected polygon. The result is shown in Figure 7.20.

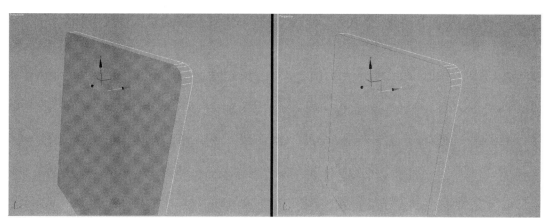

FIGURE 7.20 The rudder with the polygon selected (left) and the results of choosing Convert to Edge.

14. Now that you have a clean selection of just the edges that make up the perimeter of the rudder, click the Chamfer settings tool in the Edit Edges rollout. This action opens the settings dialog box necessary to manually set values for the Chamfer.

15. In the Chamfer dialog box, set the Amount to 0.01, then click OK.

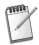

When working with a settings dialog box for the Chamfer tool (and other tools), clicking OK applies the value and closes the dialog box. If you press Apply, the parameter values are applied, then reapplied again for preview. Pressing Cancel after Apply just cancels the preview action, not the value that was applied.

16. Use the Chamfer tool on the opposite side of the rudder geometry by selecting the opposite side, converting the polygon selection to edges, then using the Chamfer settings dialog box again. You may need to use the Arc Rotate tool to select the face on the opposite side of the object. The chamfered rudder should look like the one pictured in Figure 7.21.

17. Save the file as *balsa_plane.max*.

The plane isn't complete, but now is a good time to save the work you've done up to this point. In the subsequent exercises, you'll build the propeller and linkage.

FIGURE 7.21 The chamfered rudder.

TUTORIAL

CREATING THE PROPELLER

In this exercise, you create the propeller and the linkage that holds it to the fuselage of the plane. These components look like those shown in Figure 7.22 when completed.

1. In the Front view, create a box with the following dimensions: Length = 0.75, Width = 3.5, Height = 0.625. Set the Width Segments to 5 and the Height Segments to 3.
2. Convert the box to an Editable Poly object and rename it *Propeller*.
3. Center the propeller on the box in the Front view using the Align Tool.
4. In the Front view, counting from the left side, select the second and fifth set of vertical vertices. Using the Non-Uniform Scale tool, scale the selection of vertices by 135 percent along the x-axis until they are positioned like the vertices shown in Figure 7.23.

FIGURE 7.22 The completed propeller and fuselage linkage.

FIGURE 7.23 The propeller after scaling the outer inside vertices outward.

5. Select the two outer vertical sets of vertices and scale them by 75 percent along the y-axis. This step rounds off the corners of the propeller slightly, as shown in Figure 7.24.

FIGURE 7.24 Using the Non-Uniform Scale tool to round off the outer edges of the

6. Select the inner group of vertices and use the Uniform scale tool to scale them by 50 percent along all axes, as shown in Figure 7.25.

FIGURE 7.25 Scale the center vertices of the propeller to pinch it inward.

7. In the Top view, select the corner vertices of both the left and right sides of the propeller and move them 0.08 units along the x-axis to give the propeller edges a more rounded appearance, as shown in Figure 7.26.
8. Apply a Twist modifier to the propeller and set the Amount parameter to 75. Set the Twist axis to the x-axis. Applying the Twist modifier twists the geometry of the box to look somewhat like that of a real propeller, as shown in Figure 7.27.

FIGURE 7.26 The corner vertices are moved along the x-axis in the Top view to create rounded edges on the propeller. This is a close-up view of the left side of the propeller.

FIGURE 7.27 Adding a Twist modifier to shape the propeller geometry.

 Be sure to turn off the sub-object mode when applying a modifier. Modifiers that are applied with a sub-object selection are applied only to the sub-objects, not to the entire object.

The Twist modifier twists the propeller, but the geometry doesn't bend very well because of the lack of segments. The next step uses the Subdivision Surface attributes of the Edit Poly object to fix that problem.

9. Navigate the Modifier Stack of the propeller object and open the Subdivision Surface rollout of the Editable Poly object, as shown in Figure 7.28.
10. Click the Use NURMS Subdivision to activate subdivision and set the iteration amount to 2 to smooth the geometry of the propeller, completing the look of the propeller geometry, as shown in Figure 7.29.

FIGURE 7.28 The Subdivision Surface rollout of the Editable Poly object.

FIGURE 7.29 Setting the Subdivision iteration parameter to 2 creates a smoother propeller by dividing each segment by a factor of 2.

TUTORIAL

THE LINKAGE AND POWER BAND

To create the linkage to the propeller, use a box, cylinder, and a torus primitive to create the objects shown in Figure 7.30. Because these objects are primi-

FIGURE 7.30 The propeller linkage.

tives, no explanation on how to create them is necessary. Use the Transform tools to position them correctly and align them with the propeller and the fuselage.

The final step is to create a rubber band. Simply create a box and align it along the length of the fuselage and the propeller linkage. When you animate the propeller and plane in a later chapter, you will make some changes to the rubber band. When completed, your plane should look like the one shown in Figure 7.31.

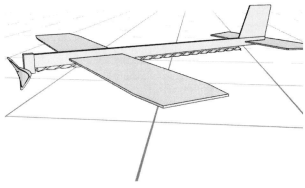

FIGURE 7.31 The finished plane.

SUMMARY

In this chapter you studied more modeling concepts with the Editable Poly object. A variety of tools were used, some in different ways, to manipulate geometry. Remember, there are many methods of creating geometry. Exploring the different methods expands your ability to solve modeling problems. Not every method is appropriate for every model or artist. Find a method that works best with your thinking and expand on it. In this chapter you learned about:

- Vertex and edge manipulation
- The Connect tool
- Collapsing the Modifier Stack

For a more realistic model, you may want to go back to all of the components modeled in this chapter and create a beveled edge, as was done during the rudder exercise. You will add materials and animate the plane's components in subsequent chapters.

COMPLEX MODELING: CREATING A SKULL

In this chapter

- A Virtual Studio Setup

- Symmetry and Shell Modifiers

- Target Weld

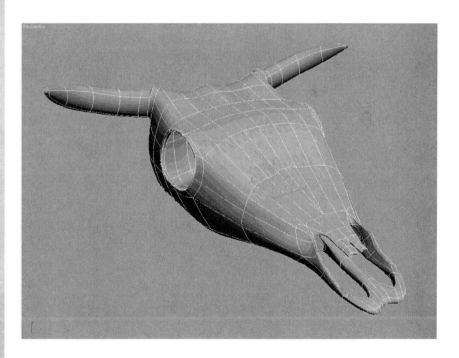

n the last chapter you created a complex model that consisted of some simple shapes. In this chapter, the geometry of the model itself is complex. Though the model is complex, your goal in this chapter is to keep the geometry as simple as possible. Creating unnecessarily complex geometry only makes the task more difficult for the modeler and doesn't necessarily produce a better model.

Project Assessment: Create a detailed steer skull from a box.
Objects: The steer skull.
Modifiers:

- Symmetry
- Shell
- MeshSmooth

Tools:

- Extrude tool
- Bevel tool
- Target Weld tool

GET TO KNOW YOUR SUBJECT

Even though this model is complex, your modeling task starts the way every modeling task should start—by analyzing the task. Unless you have some old cattle skulls lying around, you'll need some reference material. Figure 8.1 is a photo from the Internet of a typical cattle skull.

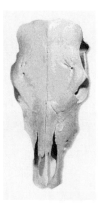

FIGURE 8.1 A cattle skull that will be used as a modeling reference.

WHERE TO START

One of the most common questions you'll have of any modeling task is "Where do I start?" Start where you are most comfortable. That being said, it is unlikely that you'll undertake a task and complete it just the way you like it in a single iteration. Most projects will find you rethinking your modeling strategy and starting over or changing direction at some point during the task. The point is, don't let change deter you when you find yourself in a corner. Start where it's most comfortable and continue from there. You can always start over.

T U T O R I A L

THE VIRTUAL STUDIO

You'll start by creating what is known as a virtual studio. This type of setup is used throughout the industry, regardless of the software package employed. A virtual studio requires multiple shots of the modeling task to be used as guides within 3ds max. You then build geometry over the guide images, which make it much easier to get the proper proportions. Figure 8.2 shows a typical virtual studio setup.

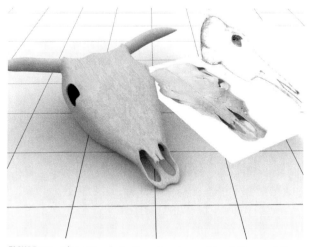

FIGURE 8.2 The virtual studio setup is used to aid in modeling complex geometry.

To create the virtual studio, images from both the front and the side of the subject are required. In some cases, a top view is also desirable, though not always necessary. Complete the following short exercise to set up a virtual studio for modeling the skull.

1. Reset 3ds max 6 or launch it, if it isn't already open.
2. Open the Materials Editor by pressing the M key or by clicking the Materials Editor icon. Both the Materials Editor and its icon are shown in Figure 8.3.

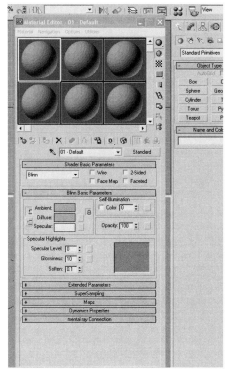

FIGURE 8.3 The Materials Editor and its icon.

 A detailed discussion of the Materials Editor is reserved for a later chapter. In this exercise, only the required elements are discussed.

By default, the first material slot is selected. Each slot represents a different material. In the Blinn Basic parameters section is a Diffuse Color swatch. Next to that is a blank square button. That button is used to place a map on the Diffuse Color attribute. Clicking that button enables you to replace the diffuse color with the reference photo.

3. Click the Diffuse Color Map button. A Material/Map browser opens (shown in Figure 8.4), offering a variety of map choices. In the browser, click the Bitmap option, which appears at the top of the list.
4. Double-click the Bitmap option. A dialog box opens, requesting that you choose the file for the bitmap image. Navigate to your directory or the companion CD-ROM and choose *skull_top.jpg* for your image file.

FIGURE 8.4 The Material/Map browser.

When selecting the image to be used as reference, take note of the dimensions of the image file. The image dimensions can be found in the status line in the Open File dialog box, as shown in Figure 8.5. What's important now is the size and ratio of the image, because you will create an object to match the ratio in the next few steps.

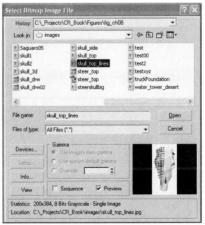

FIGURE 8.5 The Open Image dialog box displays important information about the image being loaded.

5. Click OK to choose the file and close the dialog box. The image has now been loaded into the current material's diffuse color map and will appear on the sphere in the current sample slot.

6. Click the Go to Parent icon (black arrow) to go to the top level of the material. Rename this material *skull top* by clicking in the material name field, shown in Figure 8.6.

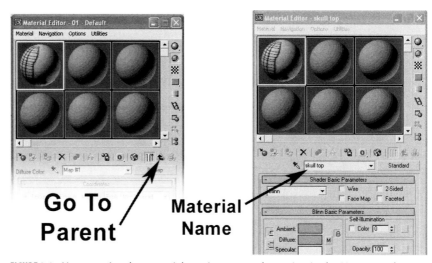

FIGURE 8.6 You can give the material a unique name by typing in the Name text box.

7. Click the second sample slot to choose the next material. Repeat the procedure from the first six steps to create a second material. The second material will be used for the side view of the skull object. Use the *skull_side.jpg image*, found on the companion CD-ROM.

ON THE CD

8. For both materials, set the Self Illumination parameter to 100. This value makes the image appear brighter on the object. The Self Illumination parameter is shown in Figure 8.7.

9. Click the Show Map in Viewport icon (shown in Figure 8.8) so that the image is displayed in the modeling view. Otherwise, the map is visible only when the image is rendered.

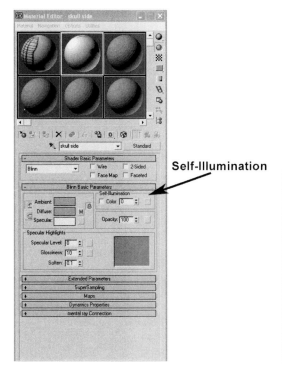

Self-Illumination

Show Map
in Viewport

FIGURE 8.7 The Self Illumination parameter.

FIGURE 8.8 The Show Map in Viewport icon is used to make a map visible in the modeling view. Otherwise, the material is visible only when the image is rendered.

APPLYING A MATERIAL

Now that the guide materials have been created, they need to be applied to Plane objects so that they can be viewed in the modeling view.

10. In the Top view, create a plane with a length of 19.7 and a width of 10.0. Rename this object *plane_top.* The plane is sized to the same aspect ratio as the images that you applied to the materials in the previous steps. By matching the aspect ratio, you ensure that the image is of proper proportions for modeling.

11. With the *plane_top* object selected, drag the material sample slot onto the plane. This action applies the material to the plane object. The image of the front of the cattle skull can be seen in the Perspective view, as shown in Figure 8.9.

FIGURE 8.9 The first plane with the material applied, as viewed in the Perspective view.

 Even though the Show Map in Viewport option is turned on, the image is shown only when the image is in Shaded mode. Wire-frame views do not show materials or maps.

12. Create another plane in the Side view and repeat the procedure with the second material created. This action creates a second view of your subject, as viewed from the side. With this step, your virtual studio is complete.

TUTORIAL **MODELING WITHIN THE VIRTUAL STUDIO**

Now that you've created a virtual studio, you can begin modeling. In this tutorial, you start with a box and learn to manipulate vertices, edges, and polygons. You also model by adding modifiers. The following steps explain the procedure:

1. In the Left view, create a box with the following dimensions: Length = 5.0, Width = 12.0, Height = 4.0. Set the Height Segments to 4.

FIGURE 8.10 The box and Top view image plane in Shaded view with Show Map in View turned on.

FIGURE 8.11 The Material Editor and color selector.

2. Maximize the Top view, press the F3 key to toggle Shaded view, and zoom in so the box and the Top view image fill most of the viewport, as shown in Figure 8.10.
3. To work on the box without it getting in the way, you create a simple wire-frame material. Press the M key or click the Material Editor icon to open the Material Editor.
4. In the third sample slot, click the Diffuse Color swatch and choose a dark color to contrast with the guide image, as shown in Figure 8.11.
5. In the Shader Basic Parameters section, click the Wire option to force the material to render as a wire-frame material. Drag the material onto the box. Notice that it appears as a wire-frame object, as shown in Figure 8.12.

A different skull image was used in this shot to avoid confusion between the contour lines and the mesh object.

6. With the box selected, use the shortcut menu to convert the object to an Editable Poly. The shortcut menu can be seen in Figure 8.13.

FIGURE 8.12 After applying the wire material to the box, the segments of the box and the image on the plane can easily be seen simultaneously.

FIGURE 8.13 Converting an object to an Editable Poly object makes the sub-objects (such as vertices, edges, polygons) accessible.

7. Press the 1 key to invoke Vertex sub-object mode. In the Top view, manipulate the vertices of the top row so they match the contour of the skull image. The top row of vertices should look like those shown in Figure 8.14.

When manipulating the vertices of a box object, use a rectangular selection region to select the vertices because the box has two sets of vertices (one above and one below). Click and drag around the vertices to select both vertices. When clicking and dragging on a vertex, only the top vertex is selected.

8. Switch to Edge mode (the 2 hot key) and select all of the vertical segments of the box, as shown in Figure 8.15.

FIGURE 8.14 Manipulate the top row of vertices (in the Top view) so that they match the contour of the image of the skull.

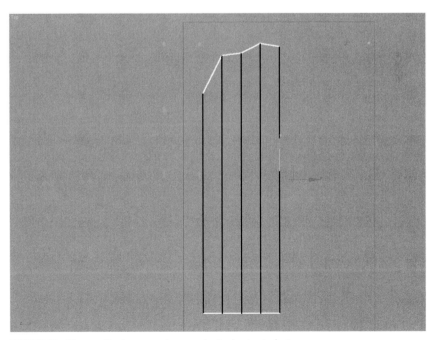

FIGURE 8.15 The vertical segments are selected prior to being connected.

9. In the Edit Edges rollout (on the Modify Panel), click the Connect settings icon, shown in Figure 8.16, to open the Connect dialog box.
10. Set the Connect Edge Segments parameter to 3 to create four new edges on the connecting polygons, as shown in Figure 8.17. Press OK to accept the Connect settings.

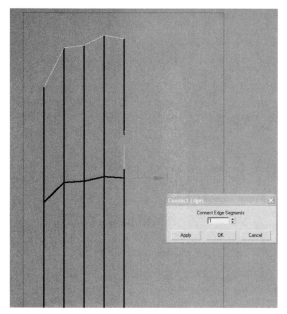

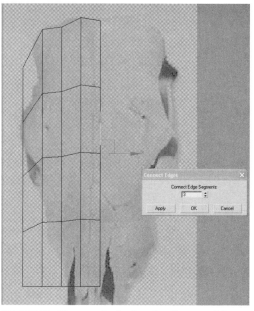

FIGURE 8.16 The Connect Edge Segments dialog box is used to divide an edge in half and connect it with the opposite edge on the same polygon.

FIGURE 8.17 The result of using the Connect Edge tool.

11. In the Top view, manipulate the vertices (press the 1 key again to get to Vertex sub-object mode) so they match the contour of the left side of the skull image, as shown in Figure 8.18. Do not change the position of any of the vertices along the right edge.
12. Switch the view to the Left view. Because only one segment is along the box's z-axis, an additional segment must be added. Select any of the vertical edges, then use the Ring tool to select all of the vertical edges. Use the Connect tool with a setting of 1 to divide and connect all of the selected edges at one time, as shown in Figure 8.19.

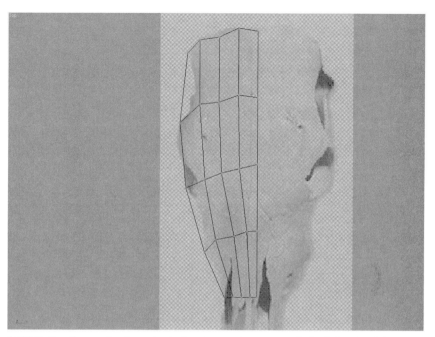

FIGURE 8.18 The result of manipulating the vertices to match the left side of the image in the Top view.

FIGURE 8.19 Because only one segment is along the height of the box, more segments and detail must be added.

13. In the Left view, manipulate the vertices along the top edge so they match the guide image loosely, as shown in Figure 8.20. For now, don't worry about exact placement. Blocking out the shape roughly is the goal here.

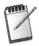 *The vertices have been enlarged to show detail. This setting can be found in the Viewport Tab on the Customize/Preferences menu. In the Viewport parameters section, be sure that Show Vertices as Dots is checked, then set the Size parameter. The range is 2 to 7.*

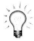 *Sometimes it's difficult to select vertices that are not perfectly aligned. To make it easier, use the Perspective view to select vertices, then use one of the orthographic views to accurately place vertices using the guide image. Although vertices can be moved in the Perspective view, it is easier to align objects in an orthographic view because of the lack of distortion due to perspective.*

14. In the Left view, position the lower vertices along the guide image. When you're done, the box should look similar to Figure 8.21.
15. Continue manipulating vertices (including the middle row) to match the guide image in the Left view. Try to manipulate groups, if possible, to

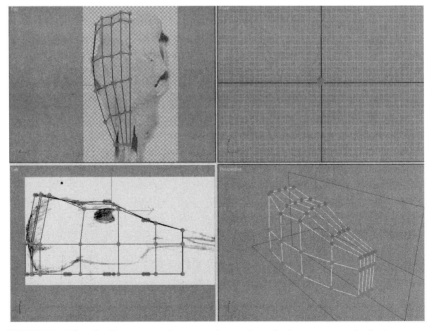

FIGURE 8.20 After the Connect tool was used on a ring of edges, a new set of edges divides the box all the way around.

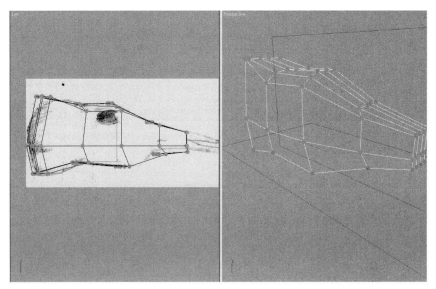

FIGURE 8.21 Position the lower row of vertices along the guide image.

avoid ending up with a cluster of unorganized vertices. Make small changes until you are comfortable with your shape. After a while, your skull should look similar to the one shown in Figure 8.22.

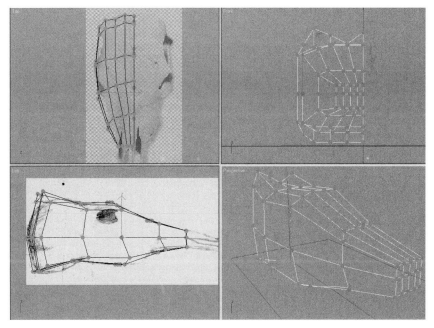

FIGURE 8.22 A blocky version of the skull after slightly manipulating the vertices.

16. To make the skull rounder, activate the Front view and pull the left-center vertices outward along the negative x-axis, as shown in Figure 8.23.

17. Save your file as *skull.max*.

FIGURE 8.23 The side of the skull, as viewed from the front, before the center vertices were moved (left), and after. By pulling the center vertices away from the rest of the mesh, the geometry becomes rounder when smoothed.

TUTORIAL REFINING THE SKULL

ON THE CD

In the previous tutorial, you learned how to shape a box that approximates the shape of an image projected on a plane. The following tutorial shows you how to refine the object using a variety of tools and parameter settings.

1. Load *skull_blocky.max* from the companion CD-ROM or work with your .max file from the previous tutorial. Select the *skull original* object.

2. Because the nasal cavity isn't developed, you need to add new geometry to the box to create the bones in that area. In the Perspective view, select the four polygons at the narrow end of the skull, as shown in Figure 8.24, and use the Extrude settings dialog box to extrude the polygons 0.5 units. Press the Apply button twice and OK once to create three new segments along the nasal cavity, as shown in Figure 8.25.

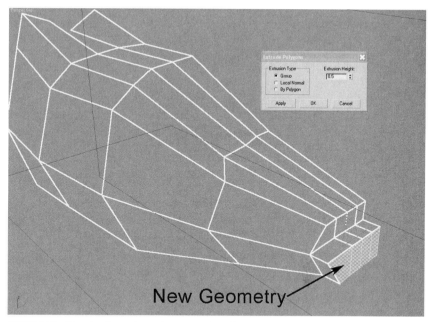

FIGURE 8.24 Use the Extrude tool to extrude polygons and add new geometry to the mesh.

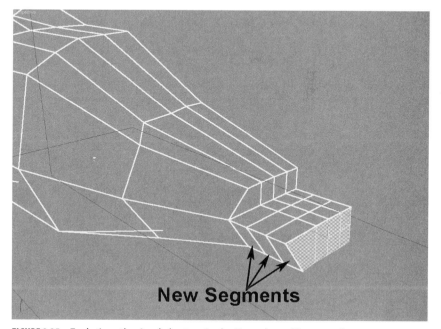

FIGURE 8.25 Each time the Apply button in the Extrude tool is pressed, a new segment is added, and a preview of the next iteration is shown. Clicking OK applies the final iteration, and clicking Cancel cancels only the last preview.

3. In the Left view, adjust the vertices of the new segments to correspond with the nasal ridge in the reference image, as shown in Figure 8.26.

FIGURE 8.26 Adjusting the vertices of the nasal ridge using the side image as a reference.

Now that the skull is beginning to take shape, it's a good time to create a mirrored instance of the skull to see how it will look as a complete skull. You use an instanced clone so that changes made to the original are also applied to the mirrored clone, thereby creating a symmetrical mesh.

Because mirroring objects can cause problems during animation, this object is temporary. The mirrored instance is for use during modeling only. Ultimately a Symmetry modifier will be added and the mirrored half will be deleted.

4. In the Front view, turn off Sub-Object mode. Click the Mirror tool, found on the Main Toolbar, and in the Mirror dialog box (shown in Figure 8.27), leave the Mirror Axis parameters to the default (x-axis and 0.0 offset value).

FIGURE 8.27 Use the Mirror tool
to create a clone of the
original skull.

Set the Clone type to Instance, set the name to *skull clone* and press OK. A
clone of the original is created.

5. Select the original skull, and in the Modify Panel, open the Subdivision Sur-
face section and turn on Use NURMS Subdivision. Set the Display Iterations
parameter to 2. This value smoothes out the skull, as shown in Figure 8.28.

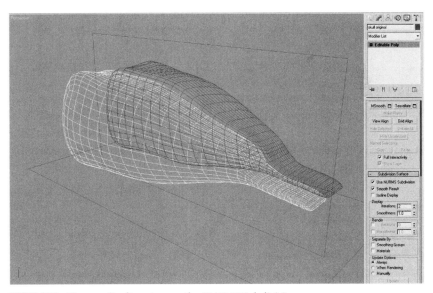

FIGURE 8.28 The result of turning on the NURMS Subdivision.

 NURMS Subdivision is a process of dividing each polygon along the visible edges. Use NURMS Subdivision to smooth out the sharp angles of geometry.

6. Although NURMS Subdivision is a great method for smoothing out geometry, it can become difficult to model because of the large number of polygons. With the skull selected, use the shortcut menu to access the NURMS toggle option, as shown in Figure 8.29. Each time this option is selected, NURMS is toggled on or off, without your having to navigate the Modify Panel.

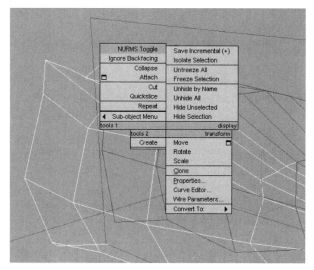

FIGURE 8.29 The NURMS toggle option is found on the shortcut menu when an Editable Poly object is selected.

 When using NURMS Subdivision and a mirrored clone to create one half of an object, the polygons that reside at the point where the two halves meet must be removed or a seam will be visible between the halves.

7. To avoid having a seam between the two halves of the model, the polygons that reside along the centerline must be removed. Figure 8.30 shows the model with and without the center polygons removed.

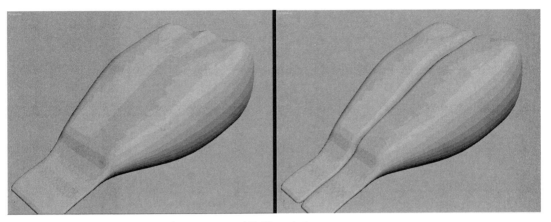

FIGURE 8.30 The polygons prior to being removed (left), and after.

8. In the Perspective view, select the faces shown in Figure 8.31, then press the Delete key to delete the selected vertices. Click Yes when asked to remove isolated vertices.

Use the NURMS toggle option to turn on Subdivision Surface to see how the model looks with the center faces removed. Save your file.

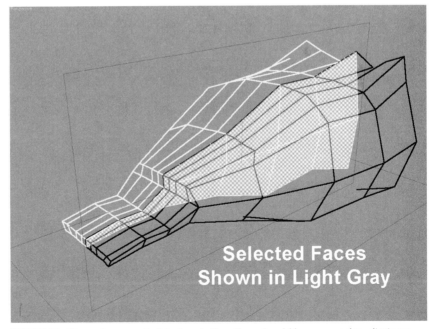

Selected Faces
Shown in Light Gray

FIGURE 8.31 These faces are inside the skull, so they should be removed to eliminate the seam that appears when two halves are merged.

TUTORIAL ## REFINING THE NASAL CAVITY

In the previous steps, you prepared the model for being one half of the completed mesh. In the following steps, you make, remove, and rebuild geometry to create the nasal structure with more detail.

ON THE CD

1. Open *skull_jaw.max* from the companion CD-ROM.

To help with the modeling process, use the View Image File option found in the File menu. Load the skull_top.jpg *file to have a constant reference window open while modeling.*

2. In the Perspective view, select the polygons shown in Figure 8.32, then press the Delete key to remove them. You may need to use the Ignore Backfacing option to select polygons on the back side of the model.
3. Rotate the view to the underside of the nasal cavity, select the polygons shown in Figure 8.33, then press the Delete key to remove these polygons.

FIGURE 8.32 The polygons of the nasal cavity that will be removed from the top and rebuilt.

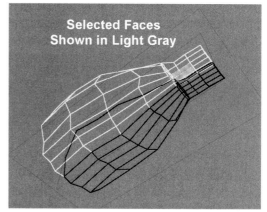

FIGURE 8.33 The polygons under the nasal cavity that will be removed and rebuilt.

You could select all of these polygons without rotating views by using the Ignore Backfacing option. Ignore Backfacing (found in the Selection rollout) enables you to control whether or not sub-objects facing away from the current view are selectable. With Ignore Backfacing on, sub-objects with surface normals facing away from the current view are not selectable until the view is rotated so those sub-objects are facing the current view.

4. After deleting the polygons of the nasal cavity, the skull should look like the one shown in Figure 8.34. Now that the polygons have been deleted, you rebuild the inside section of the nasal cavity.

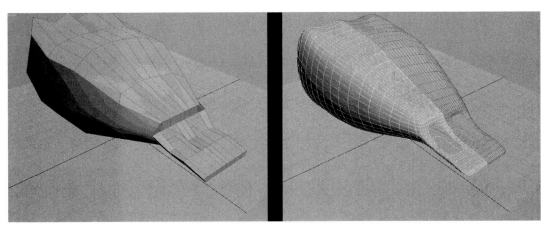

FIGURE 8.34 The nasal cavity after deleting the interior polygons with NURMS Subdivision turned off (left), and turned on.

To create the nasal cavity structure, the polygons must be rebuilt in a different configuration. Instead of rebuilding the polygons on the top surface, interior wall polygons are built surrounding the holes.

5. Activate Polygon sub-object mode. From the shortcut menu or the Edit Geometry rollout, click the Create button. Notice that the vertices of the model become visible, even though Polygon mode is still active, as shown in Figure 8.35.

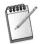

When creating a polygon from existing vertices using the Create tool, select the four adjacent vertices that make up the polygon in a counterclockwise order. Double-click the last vertex to end vertex selection and create the polygon.

6. In the Perspective view, be sure the Create tool for polygon is active, then click the four vertices that make up the center nasal ridge of the nasal cavity, as shown in Figure 8.36.
7. Create the polygon next to the first one, as shown in Figure 8.37.
8. Rotate the Perspective view so you are almost behind the skull looking forward, and create two adjacent polygons, as shown in Figure 8.38. Create each polygon separately by selecting the four vertices that make up that polygon.

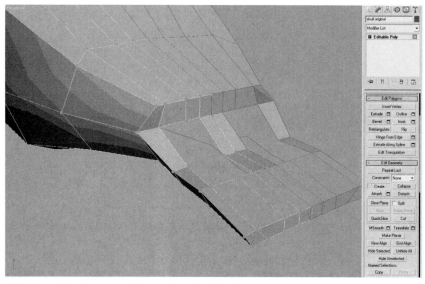

FIGURE 8.35 The Create tool is used to rebuild polygons. When in Create mode, the vertices of all polygons are visible.

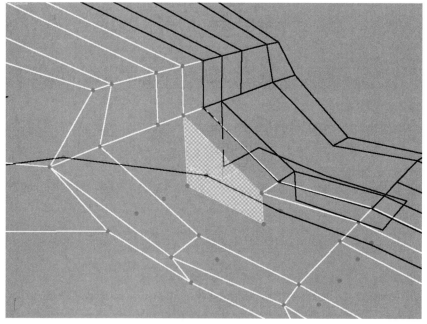

FIGURE 8.36 The first polygon created using the Create tool. This polygon will become the nasal ridge for the center of the nasal cavity.

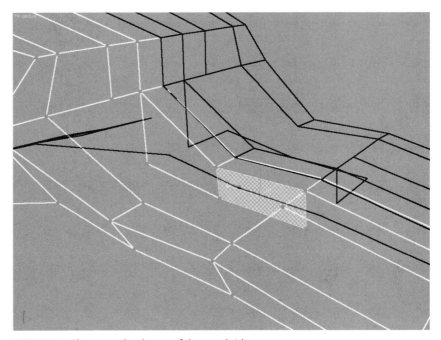

FIGURE 8.37 The second polygon of the nasal ridge.

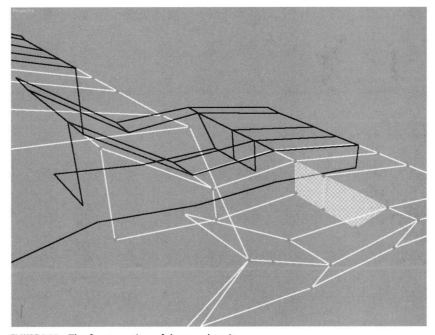

FIGURE 8.38 The front portion of the nasal cavity.

9. Rotate the view again so the right side of the inside nasal cavity can be seen, and create two polygons similar to the ones created in steps 6 and 7. The result is shown in Figure 8.39.

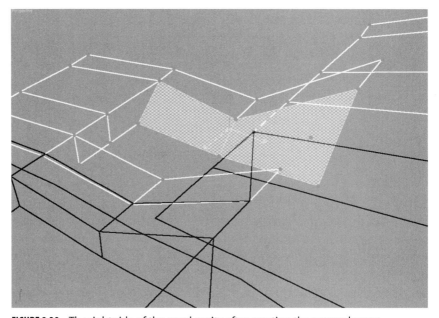

FIGURE 8.39 The right side of the nasal cavity after creating the new polygons.

10. Right-click to exit Polygon Create mode.
11. While still in Polygon sub-object mode, select and delete the two polygons of the upper nasal region, as shown in Figure 8.40. Choose Yes when asked to delete any isolated vertices.
12. Save your work.

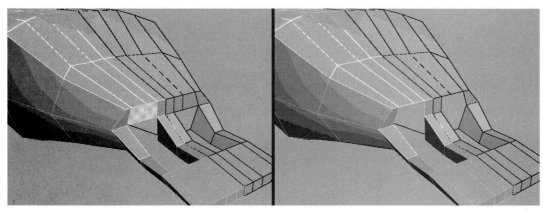

FIGURE 8.40 The upper nasal polygons should be deleted.

TUTORIAL ## CREATING MORE SKULL DETAIL

Now that the polygonal structure of the nasal cavity has been changed, you'll add some detail by manipulating edges and vertices, using the reference photo as a guide. Much of the following sequence will vary from your model because this is the artistic process and is somewhat loose in its implementation. Use the following steps and images as guides, but use your own creative mind to customize your model.

ON THE CD

1. Load *skull_jaw_refine.max* or continue from your previous model file.
2. In the Top view, turn on Shaded mode (F3). Be sure that you can see the reference image below the model mesh.
3. Manipulate each of the vertices shown in Figure 8.41 so they more closely match the reference image. It may be easier to manipulate along all axes from the Perspective view, while using the Top view as reference.

FIGURE 8.41 The vertices that make up the nasal cavity must be manipulated to give the skull more shape.

Do not edit any of the vertices along the centerline of the model (the right edge) unless constrained to the view's y-axis (in the Top view). This is where the two model halves will be joined, and if those vertices are moved away from the centerline, there will be a gap in the model.

Though only a few vertices were moved, the difference is dramatic. The edge vertices were positioned to match the curve of the bone in the reference photo. After some manipulation, your nasal cavity should look similar to the one in Figure 8.42.

4. Save your work.

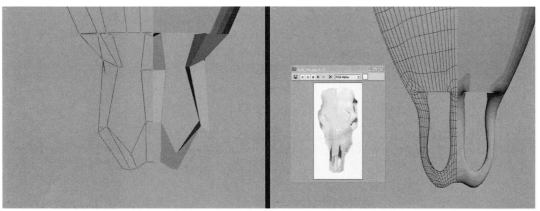

FIGURE 8.42 The revised nasal cavity with visible vertices (left) and with NURMS Subdivision turned on.

T U T O R I A L ## CREATING AN EYE SOCKET

Now that the preliminary nasal detail has been created, it's time to create the eye sockets. The eye sockets are created from a single polygon, which is extruded and beveled to create the necessary geometry. From there, the existing vertices are modified to create the shape of the eye socket. The following steps demonstrate how to create the eye socket:

ON THE CD

1. Open *skull_eye.max*, or continue with the file you've been using in the previous steps.
2. In the Perspective view, select the large polygon that resides where the eye should be, on the skull original object. Figure 8.43 illustrates which polygon to select.

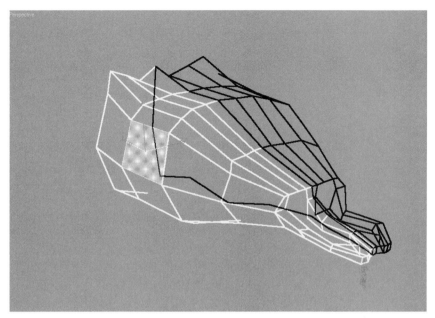

FIGURE 8.43 The eye socket is created from a single polygon (selected).

3. With Polygon sub-object mode active and the eye socket polygon se-
 lected, click the Bevel tool in the Edit Polygons rollout. The Editable Poly
 Bevel settings dialog box opens, as shown in Figure 8.44.

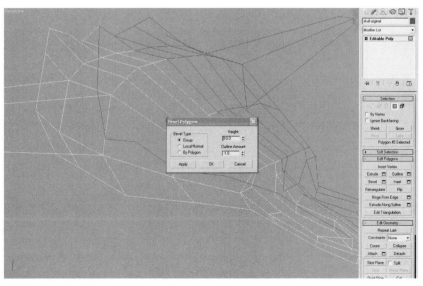

FIGURE 8.44 The Editable Poly Bevel settings dialog box.

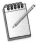 *When the settings dialog box is opened with tools such as Extrude or Bevel, the current settings shown are applied as a preview. If you click OK, the settings are applied and the tool is closed. If you click Cancel, nothing is applied and the tool is closed. If you click Apply, the settings are applied, then reapplied as a preview for another iteration of the settings. Clicking Cancel after clicking Apply does not undo the results of clicking Apply.*

The Bevel tool consists of the following parameters:

Bevel Type (Group, Local Normal, By Polygon): Determines how the selected polygons (if more than one is selected) is beveled.

Group: Polygons are beveled based on an average normal direction for a contiguous group of polygons.

Local Normal: Each polygon in the selection is beveled according to its own normal's direction.

By Polygon: The bevel operation is applied separately to each polygon, as opposed to the group, thereby creating geometry between polygons.

Height: Measures height in units that the polygon are extruded.

Outline Amount: Creates another polygon either larger or smaller than the original selection, based on a positive or negative value.

4. In the Bevel settings dialog box, use the following amounts. You do not need to select a new polygon, because the newest polygon is automatically selected each time the bevel is applied. The result can be seen in Figure 8.45.

- Height = 0.05, Bevel = 0.05, then Apply
- Height = 0.0, Bevel = –0.06, then Apply
- Height = –0.25, Bevel = 0.0, then OK.

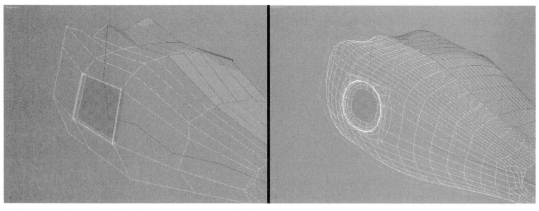

FIGURE 8.45 The result of applying the Bevel tool multiple times. The NURMS Subdivision has been turned on.

5. With the innermost polygon selected, press the Delete key to delete it. The purpose is to create a hollow skull, so the polygon in the center is no longer required. The result can be seen in Figure 8.46.

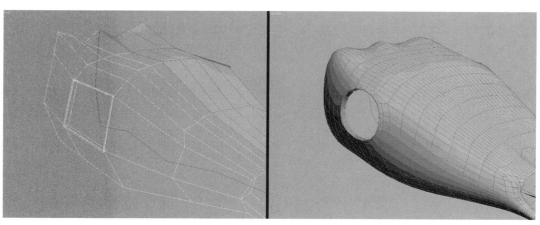

FIGURE 8.46 The eye socket after deleting the inner polygon.

TUTORIAL **ADDING THE NASAL BRIDGE**

The nasal bridge is added by editing edges and further extrusion. The following steps illustrate this procedure:

ON THE CD

1. Open *skull_nasal.max* from the companion CD-ROM, or continue with your previous model.
2. In the Perspective view, select the *skull original* object and switch to Edge mode (activated by pressing the 2 key).
3. Select the two edges at the top of the nasal cavity, as shown in Figure 8.47.
4. In the Perspective view, press the SHIFT key, and drag the selected edges along the z-axis. New edges and faces are created, as shown in Figure 8.48.
5. The new edges need to be attached to the skull for continuity. Use the Ring tool to select all vertical edges near the eye socket, being sure the ring selects all edges around the skull. You may have to use the CTRL key to select additional edges and press the Ring tool a few times (after additional edges are selected manually) to complete the ring. The edges that should be selected are shown in Figure 8.49. You should have 18 edges selected.
6. Use the Connect tool with a setting of 1 to create a new edge segment through the ring. The result is shown in Figure 8.50.

FIGURE 8.47 The edges at the top of the nasal cavity are used to create the nasal bridge.

FIGURE 8.48 New edges and faces are created by pressing the SHIFT key while dragging an edge.

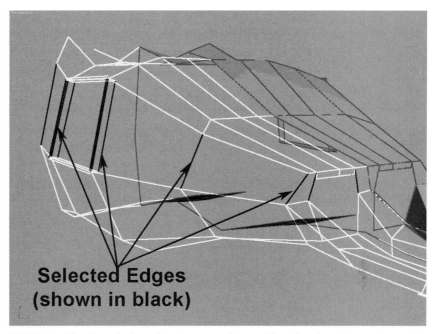

FIGURE 8.49 The ring of edges that intersects the eye. The edges have been enhanced to show detail.

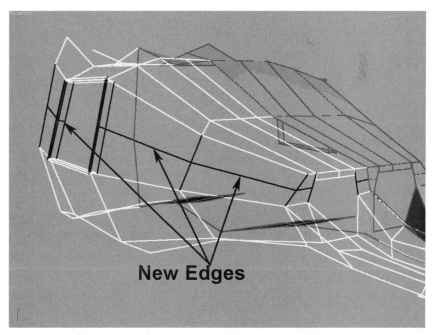

FIGURE 8.50 Adding a new edge segment with the Connect tool.

7. In the Perspective view, go back to the edges created around the nasal bridge. In Vertex sub-object mode, use the Target Weld tool (found in the Edit Vertices rollout) to weld the left nasal bridge vertex to the new segment, then the right side of the nasal bridge, as shown in Figure 8.51. Welding the vertices removes the gap between the edges.

FIGURE 8.51 The vertices before (left) and after the Target Weld operation. This procedure was done using Target Weld twice.

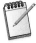 *Target Weld is used by clicking a vertex that you want to move and weld, then clicking the vertex to which you want it welded. The edge segment connected to the vertex being welded remains connected to that vertex. In Target Weld mode, only one vertex can be welded at a time.*

8. In the Perspective view, switch to Polygon mode and select the two new polygons, then open the Bevel settings dialog box, as shown in Figure 8.52.
9. In the Bevel settings dialog box, set the Extrude value to 0.5 and the Outline Amount to 0. Click the Apply button three times, then click OK to accept the fourth segment and close the dialog box. Your geometry should look like that shown in Figure 8.53.

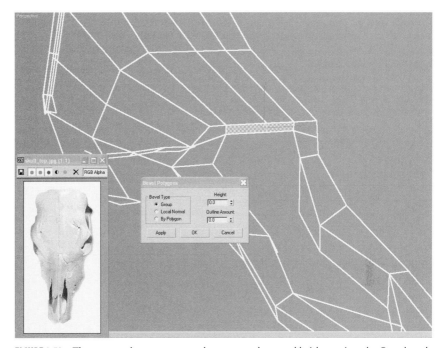

FIGURE 8.52 The new polygons are used to create the nasal bridge using the Bevel tool.

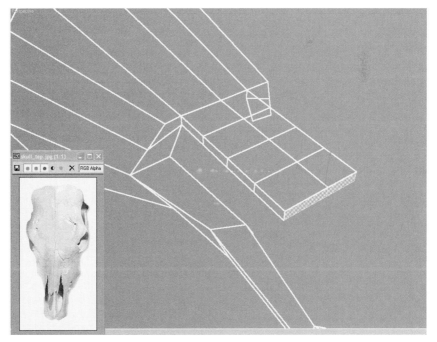

FIGURE 8.53 The result of the Bevel tool on the nasal bridge.

10. In the Top view, manipulate the nasal geometry to match the reference photo. Start by editing the left edge of the extruded polygons so that it matches the curve of the nasal bridge in the reference image. The result can be seen in Figure 8.54.

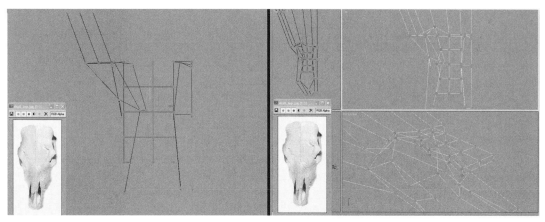

FIGURE 8.54 After editing the left edge of the nasal bridge.

11. Edit the nasal bone so that it is thinner and flows smoothly into the nasal ridge, as shown in Figure 8.55.
12. Switch to Polygon mode and select the polygons that transition from the nasal cavity to the top of the skull, as shown in Figure 8.56.
13. Use the Extrude settings dialog box to extrude the selected polygons 0.25 units, as shown in Figure 8.57.

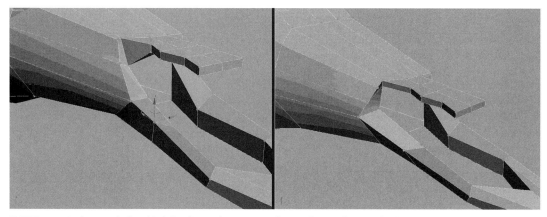

FIGURE 8.55 Before and after (right) editing the vertices that make up the nasal ridge.

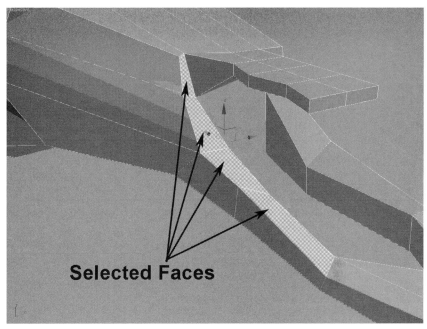

FIGURE 8.56 The polygons that make up the geometry that transitions from the upper mandible to the nasal cavity.

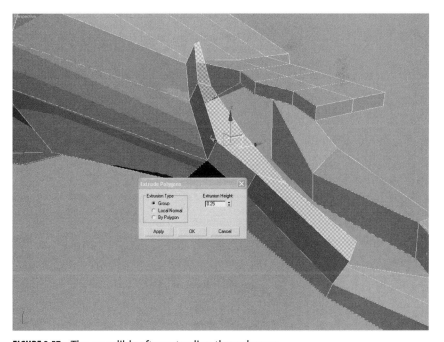

FIGURE 8.57 The mandible after extruding the polygons.

14. Edit the newly extruded polygons to create the ridge connecting the mandible and the nasal cavity, as shown in Figure 8.58.

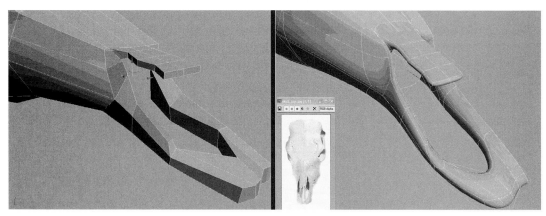

FIGURE 8.58 The new nasal ridge, before (left) and after editing the new polygons.

15. In the Top view, go back and edit the nasal ridge so that it resembles the reference image, as shown in Figure 8.59. Be sure to edit the vertices on all axes, not just the Top view.

FIGURE 8.59 Before and after editing the nasal ridge vertices.

16. If not already visible, unhide the cloned other side of the skull and notice how the nasal ridge has a gap between the ridges of both sides. To remove this gap, use the Target Weld tool to join the vertices at the beginning of the ridge, as shown in Figure 8.60.

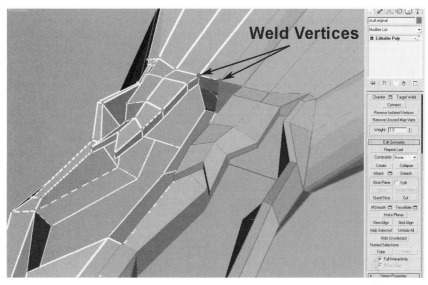

FIGURE 8.60 Use the Target Weld tool on the top vertices to close the gap.

17. Repeat the previous step on the vertices just below the previous vertices. After both have been welded, the ridge should look like the one shown in Figure 8.61

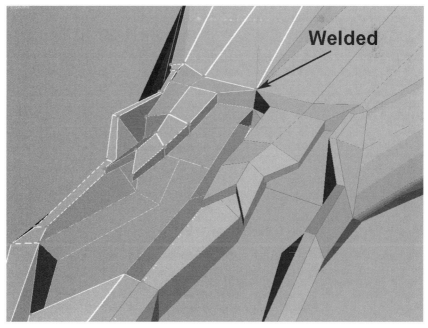

FIGURE 8.61 After all four vertices have been welded.

18. Finish the ridge by dragging all of the nasal ridge vertices closer to the point where the two halves of the model meet, as shown in Figure 8.62.
19. Save your work.

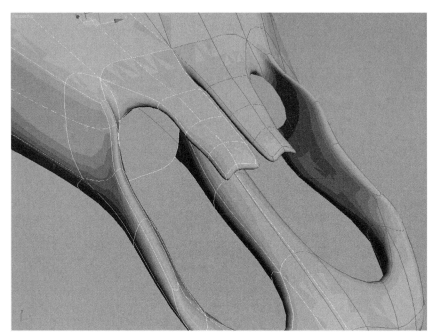

FIGURE 8.62 Position the nasal ridge vertices so they are closer to the middle of the model (where the two halves will meet).

FURTHER REFINEMENT

To add more detail to the skull, additional refinement is required. In addition to adding the horns and nasal bridge, the entire mesh needs some adjustment. In this section, you adjust the eye socket and build the horns, as well as some other minor adjustments.

TUTORIAL ## REFINING THE EYE SOCKET

1. Open *skull_refine.max* from the companion CD-ROM.
2. In Edge mode, select a horizontal edge by the eye socket, then use the Ring tool to select a ring around the skull, through the eye socket, as shown in Figure 8.63. Click the Connect tool to create a segment through the ring, as shown in Figure 8.64.

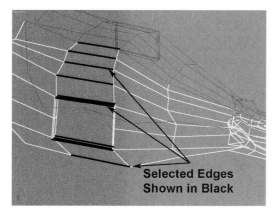

FIGURE 8.63 The edges selected using the Ring tool. The edges have been enhanced to show detail.

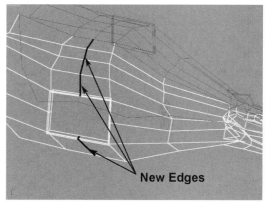

FIGURE 8.64 Using the Connect tool to create a new segment. The new edges have been enhanced to show detail.

3. Now that a new segment has been created, edit the vertices around the eye socket to make the eye more elliptical, as shown in Figure 8.65.

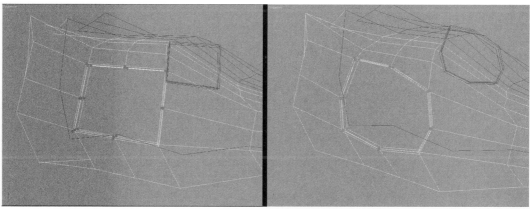

FIGURE 8.65 The vertices of the eye socket, before (left) and after editing.

TUTORIAL

BUILDING THE HORN

The skull is nearly complete, except for the horn and some refining details. In this series of steps, you create a horn using the Bevel tool on a polygon. Additionally, you use the Ring and Connect tools to add the necessary segments to the model.

ON THE CD

1. Continue with the previous model or load *skull_horn.max*.
2. In the Perspective view, create an additional segment behind the eye socket, as shown in Figure 8.66, using the Ring and Connect tools.

FIGURE 8.66 The Ring and Connect tools were used to create an additional segment behind the eye socket.

3. Rotate the Perspective view so you can see the back of the skull, and choose the polygon that creates the bump in the skull, as shown in Figure 8.67.
4. Use the following setting in the Bevel settings dialog box to create the ridge to the horn. The result can be seen in Figure 8.68.

 - Extrude = 0.24, Outline Amount = 0.09, then Apply
 - Extrude = 0.0, Outline Amount = –0.09, then Apply
 - Extrude = –0.05, Outline Amount = 0.0, then OK

FIGURE 8.67 The horn is created from this polygon using the Bevel tool.

FIGURE 8.68 After creating the horn socket.

5. Before proceeding, adjust the vertices of the horn socket so they are somewhat square. By organizing the vertices as you go, the additional vertices created with the Bevel tool will also be more in line with the final shape. Eventually a new segment will be added to make it rounder.

6. With the center polygon still selected, use the Bevel settings dialog box to set the Extrude value to 0.5 and the Outline Amount to 0.0. Click Apply. The result is shown in Figure 8.69.

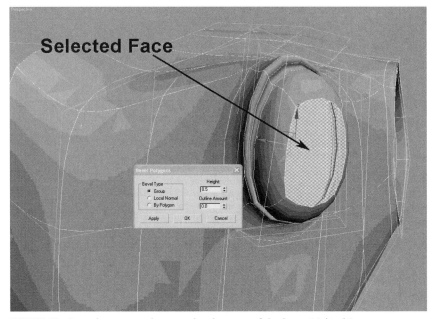

FIGURE 8.69 Extrude a new polygon to be the start of the horn. Make this segment extrude just inside the horn socket geometry.

7. Set the Extrude amount to 3.0, Outline Amount to 0.0, and click the Apply button four times to create the length of the horn, as shown in Figure 8.70.

8. Using the Scale tool, scale the polygon on the end (it should still be selected) until it brings the horn to a point, as shown in Figure 8.71.

9. In the Top view, adjust the vertices of the horn segments so there is a bend in the horn, as shown in Figure 8.72.

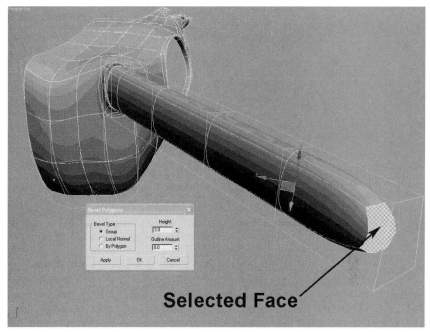

FIGURE 8.70 Creating the horn with three bevel segments so a bend can be added

FIGURE 8.71 Create a point in the horn by scaling the end polygon to be much smaller than the others.

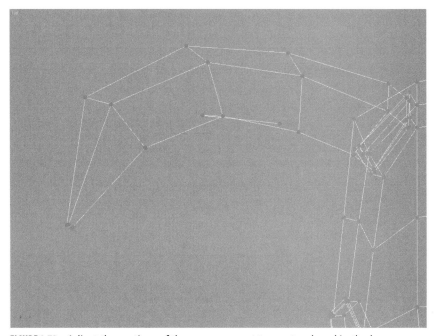

FIGURE 8.72 Adjust the vertices of the new segment to create a bend in the horn.

 When changing the direction of a polygon's vertices, using the Rotate tool to rotate the polygon retains the polygon's shape and moves the related vertices in unison.

10. After looking at the horn, you may realize that some of the vertices need to be adjusted or scaled to make the horn thicker or thinner. Make those changes, as desired, until you are happy with the shape of the horn.
11. Save your work.

TUTORIAL

THE FINAL REVISION . . . ALMOST

For the most part, the modeling of the skull is complete. You can adjust the vertices to add more detail, including adding additional segments using the Ring and Loop tools. This section teaches you how to complete the model using a couple of modifiers.

ON THE CD

1. Open *skull_shell.max* or continue with the model you've been working on.
2. Hide all geometry except the *skull original* object.
3. In the Editable Poly object, turn off NURMS Subdivision.

4. Apply a Symmetry modifier to create the other half of the skull. Set the Mirror Axis to Z, making sure that Slice Along Mirror and Weld Seam are checked. Your skull should look like the one shown in Figure 8.73.

This modifier also eliminates the seam by dynamically welding coincident vertices from both halves.

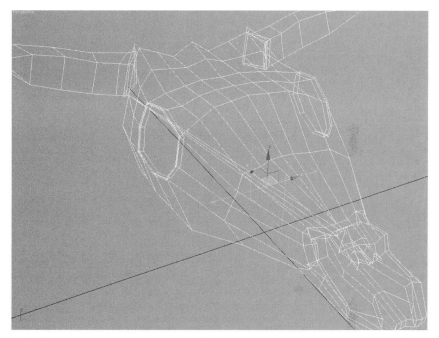

FIGURE 8.73 Adding the Symmetry modifier mirrors the geometry along the specified axis.

5. To give the skull some thickness, you must add a Shell modifier. In the Modify Panel, add a Shell modifier after the Symmetry modifier. Set the Shell Inner Amount parameter to 0.08 to give the model a thickness. Set the Outer Amount to 0.0. A before and after shot of the model can be seen in Figure 8.74.

The Shell modifier, new in 3ds max 6, is used to give a surface thickness when faces have been removed, such as in the skull model.

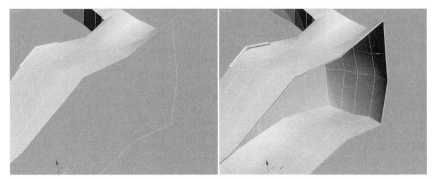

FIGURE 8.74 Before (left) and after applying the Shell modifier. The Symmetry modifier has been turned off and NURMS Subdivision has been turned on to show the effect.

6. A final step is to smooth out the entire model. To prevent the model geometry from changing during smoothing, do not use the NURMS Subdivision integrated into the Editable Poly object. Instead, in this case, add a MeshSmooth modifier after the Shell modifier. This modifier applies the smoothing last and keeps the geometry from smoothing between the two halves. Set the Subdivision Amount Iterations parameter to 2. The result can be seen in Figure 8.75.

7. Save your work.

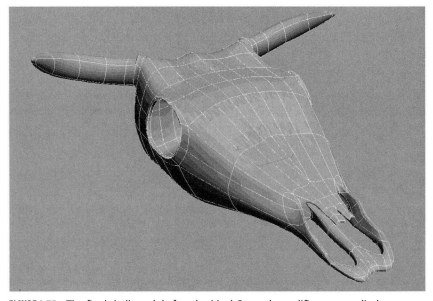

FIGURE 8.75 The final skull model after the MeshSmooth modifier was applied.

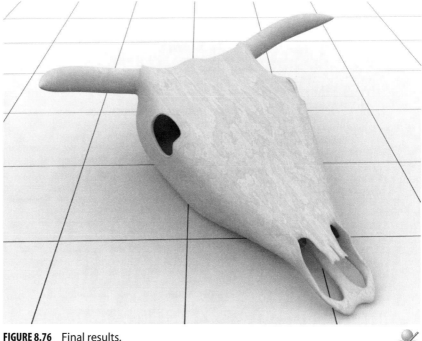

FIGURE 8.76 Final results.

SUMMARY

This chapter covered many of the basic steps involved in nearly every complex model. Use the lessons in this chapter to conquer even more complex modeling exercises. Just break down the task into the simplest modeling problems and continue doing so until the model is built. Don't be afraid to start over. Many models are built better and quicker the second time around. In this chapter you learned about:

- Creating a Virtual Studio setup
- Modeling with reference images
- Using the Extrude and Bevel tools of the Editable Poly object
- Creating new polygons from existing vertices
- Using the Target Weld tool

For additional experience, continue refining this model and adding more of the subtle detail found in a steer skull. If you can get your hands on the real thing, try modeling from life. You will have the added benefit of seeing more detail than what was provided in the exercise photos and build stronger modeling skills through experience.

BUILDING A CHARACTER

In this chapter

- More Editable Poly Fun
- Outline and Inset Tools
- Cut and Quick Slice

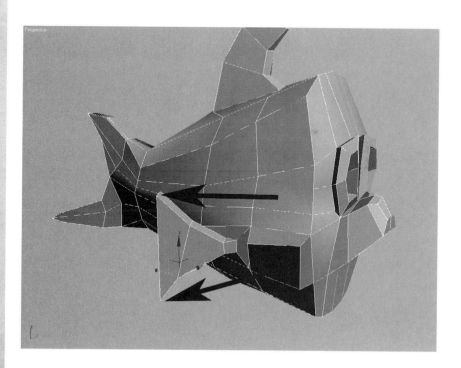

In the last chapter you built a stylized steer skull as an introduction to more complex modeling using the Editable Poly object. In this chapter you build a character that will ultimately be animated.

Project Assessment: Build a fish character for animation.
Objects: The fish
Tools:

- Ring tool
- Loop tool
- Polygon Extrude tool
- Polygon Bevel tool
- Convert to Polygon tool
- Outline tool
- QuickSlice tool
- NURMS toggle tool
- Mirror tool

BUILDING FROM A BOX—AGAIN

This tutorial builds on some of the tools and experience you gained by building the steer skull. You create a fish character (shown in Figure 9.1) that will ultimately be animated as part of the animation project. Start by building the virtual studio described in the last chapter, or load the al-

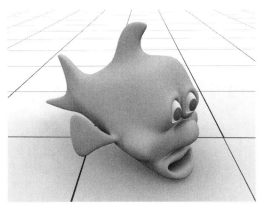

FIGURE 9.1 Squirt, the fish character built in this chapter.

ready created start file. If you create the virtual studio yourself, don't forget to check the image sizes so that the reference planes are at the right proportions.

TUTORIAL ## CREATING THE SIDE OF THE FISH

The following exercise assumes that you've gone through the previous exercises or have some experience with 3ds max 6. In this model, only the right half of the fish is created; you use the Symmetry modifier to automatically generate the left half.

ON THE CD

1. Create the virtual studio using *squirt_front.jpg* and *squirt_side.jpg* as the reference images (found on the companion CD-ROM in the Chapter 9 files). Alternatively, you can load *squirt_start.max*, which has the virtual studio already created.

2. In the Left view, create a box that matches the length of the fish sketch. Be sure that the view is set to Shaded mode (F3). Turn on Show Map in Viewport for the reference plane's material.

3. In the Material Editor, create a wire-frame material and apply it to the box. Use a dark color so it stands out against the white background of the reference image.

4. Rename the box object *Squirt*, and convert the box to an Editable Poly object.

5. In the Left view, select all of the horizontal edges, and use the Connect tool to create two additional segments, as shown in Figure 9.2.

FIGURE 9.2 Use the Connect tool to add two segments to the box.

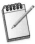 *Normally the segments are added when the box is created. For purposes of instruction, I tend to let the reader add the segments as part of the exercise. There is no difference to adding the segments before converting to an Editable Poly or after, so the choice is yours. One caveat—it's easier to add segments than to remove them, so err on the side of not enough at the start.*

6. In the Top view, adjust the vertices to create a boxy teardrop shape, as shown in Figure 9.3. This step accommodates for the taper of the fish's body as it leads into the tail section.

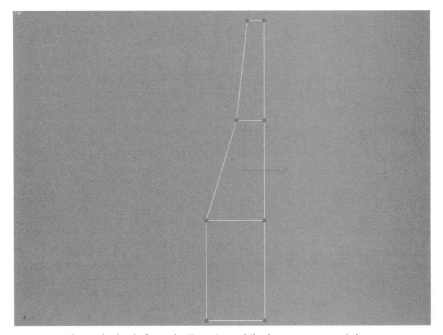

FIGURE 9.3 Shape the body from the Top view while the vertex count is low.

7. In the Perspective view, remove the three polygons that lie along the centerline of the model, as shown in Figure 9.4. Because these polygons aren't needed, remove them as early as possible.
8. Adjust the vertices of the new segments to follow the outline of the fish body, as shown in Figure 9.5. Ignore the tail for now—that will be added later with additional segments.

FIGURE 9.4 Select and remove the three inner polygons.

FIGURE 9.5 The vertices of the new segments are adjusted to match the outline of the reference image.

9. Select one of the vertical edges and use the Ring tool to select a ring around the entire model. Then use the Connect tool to add a single segment around the entire model, as shown in Figure 9.6.

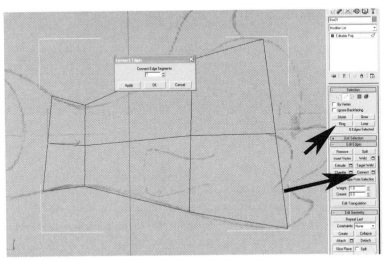

FIGURE 9.6 After using the Ring tool to select a vertical ring around the model, use the Connect tool to create an additional segment.

10. In the Left view, adjust the vertices of the new segment to coincide with other important joints in the model, such as the nose, tail, and fin, as shown in Figure 9.7.
11. Save your work.

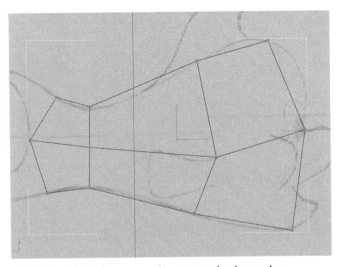

FIGURE 9.7 Adjust the new vertices to match where other geometry will be created.

TUTORIAL **BUILDING THE FISH HEAD**

Before getting too far along in shaping the side of the fish, it's a good idea to adjust the vertices of the fish from the Front view, while the vertex count is low.

1. Continue with your previous model, or load *squirt_front.max* from the companion CD-ROM.

This procedure illustrates the benefit of the Ring tool. Because the tail is thinner than the head, you may have difficulty selecting all of the horizontal edges of the model. The Ring tool selects edges based on their association, not their position, so even edges that don't lie on the same plane or axis are selected and divided at their center point.

2. In the Front view, select a horizontal edge, then use the Ring tool to select all of the horizontal segments associated with that ring. Then use the Connect tool to add one segment to the model, as shown in Figure 9.8.

FIGURE 9.8 Use the Ring and Connect tools to add a segment to the depth of the model.

3. This step is where the modeling gets tricky. Because the fish has a tapered shape, the vertices in the back won't match those in the front. To isolate just the vertices in the front of the model, switch to Polygon mode, select the four polygons that make up the front, as shown in Figure 9.9, then use

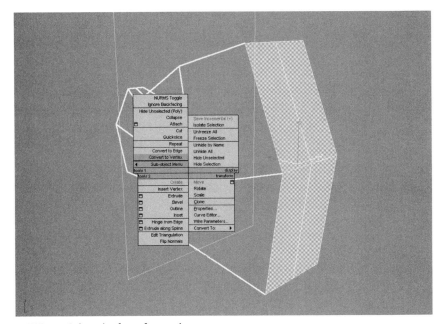

FIGURE 9.9 Select the front four polygons.

the Convert to Vertex option on the Quad menu to select the associated vertices, as shown in Figure 9.10

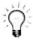

The Convert to Vertex, Convert to Edge, and Convert to Polygon options convert the selection, not the model. Though the name may be misleading, this tool is great for changing the selection based on the selection of another sub-object.

4. Now that you have selected the vertices that you want to adjust, you may find that it's impossible to adjust them all at the same time. Therefore, use the Hide Unselected button (shown in Figure 9.11) inside the Edit Geometry rollout while in Vertex sub-object mode. The result is shown in Figure 9.12.

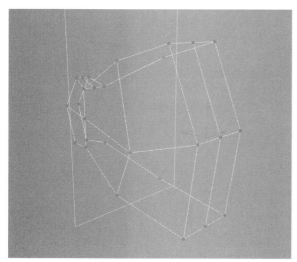

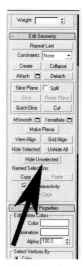

FIGURE 9.10 The vertices selected using the Convert to Vertex option.

FIGURE 9.11 The Hide Unselected button is used to hide sub-objects that aren't selected.

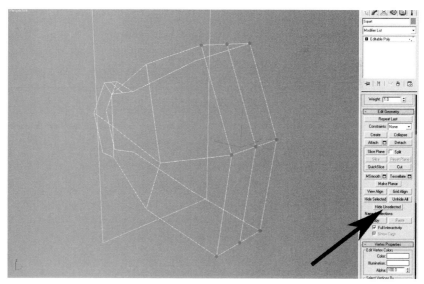

FIGURE 9.12 After clicking the Hide Unselected button, extraneous vertices are temporarily hidden. Hiding vertices does not affect the shape of the model.

5. Now that only the vertices on the front of the model are visible, adjust them to match the contour of the head, as shown in Figure 9.13. Because only the front vertices are visible, it's much easier to adjust them without the confusion of the other vertices.

FIGURE 9.13 With only the vertices on the front of the model visible, selecting and shaping the front of the head is much easier.

6. Use the Unhide All button to make all vertices visible again. In Edge mode, select an edge along the second row of vertices, and use the Loop tool to select all edges in a loop around the model. The Loop tool selects edges from end point to end point. The result is shown in Figure 9.14.

7. With the edges still selected, use the Convert to Vertex and Hide Unselected tools to select just the vertices of the second row, as shown in Figure 9.15. Unlike in the previous steps, you don't need to select polygons first. The Convert to Vertex tool can be used with an edge selection as well.

8. In the Front view, adjust the second row of vertices to follow the shape of the reference image. Though no contour lines are shown, try to anticipate where the vertices should go, based on the shape of the fish, as shown in Figure 9.16.

9. Continue with the next row of vertices, then finally the tail. Note that some adjustments are very minor. The fish shape should still be blocky and approximate, as shown in Figure 9.17.

10. Save your work.

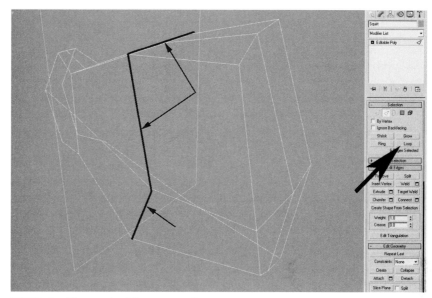

FIGURE 9.14 The result of the Loop tool.

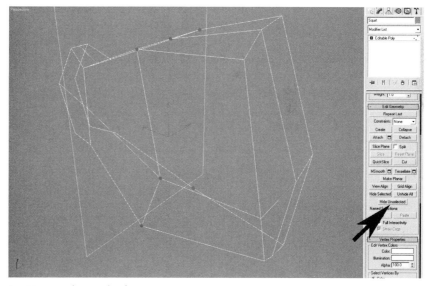

FIGURE 9.15 The result of using Loop, Convert to Vertex, and Hide Unselected tools.

FIGURE 9.16 Adjustment of the second row of vertices.

FIGURE 9.17 The result of adjusting all vertical rows of vertices. The shape is far from a likeness, but the point of these steps is to approximate the shape.

TUTORIAL **ADDING THE TAIL**

Now that you have given the body its basic shape, it's time to add more detail. In this section, you add the tail and the nose and begin adding detail for the mouth.

1. Open *squirt_tail.max* from the companion CD-ROM, or continue with your previous file.
2. In the Left view, select one of the vertical edges, and use the Ring and Connect tools to add a segment at the eye level, as shown in Figure 9.18.

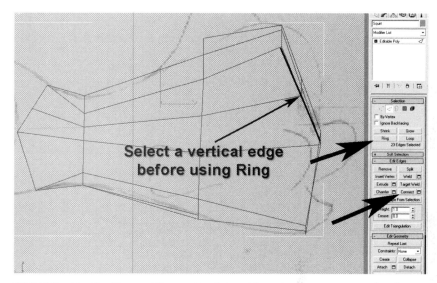

FIGURE 9.18 Use the Ring and Connect tools to add another segment at eye level.

3. In the Perspective view, select the four polygons that make up the end of the top portion of the tail. Use the Extrude tool to extend the tail 0.75 units, as shown in Figure 9.19.
4. In Vertex sub-object mode, adjust the vertices of the tail to create a pointed tip on the tail, as shown in Figure 9.20.
5. Rotate the view and remove the polygons on the inside of the tail, as shown in Figure 9.21.

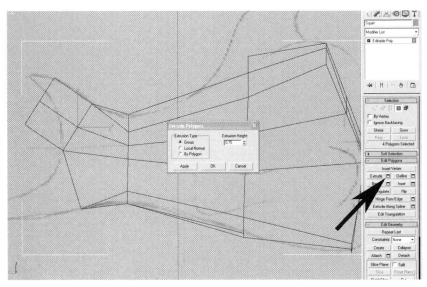

IGURE 9.19 Use the Extrude tool to extend the tail.

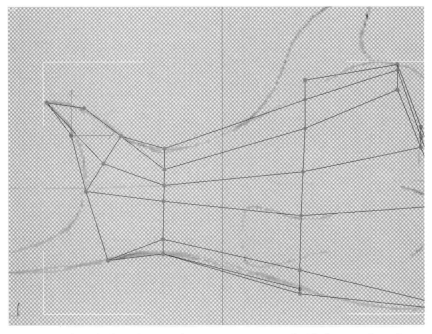

FIGURE 9.20 The tail, after adjusting the new vertices created with the Extrude tool.

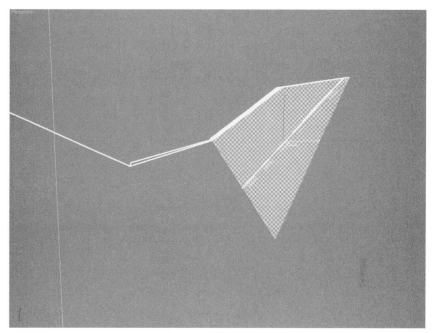

FIGURE 9.21 Remove the inner polygons of the tail.

6. Select a vertical edge in the lower portion of the tail and use the Ring and Connect tools to create a new segment along the lower part of the model, as shown in Figure 9.22.

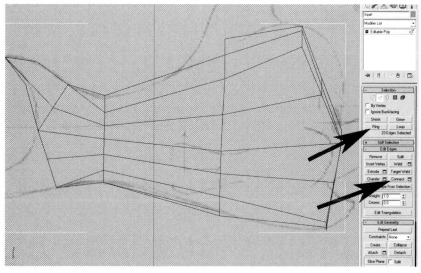

FIGURE 9.22 Adding a segment to the lower part of the model.

7. Extrude the polygons on the end of the fin of the tail, using two iterations of the Extrude tool. Adjust the vertices so the detail of the tail matches that shown in Figure 9.23.

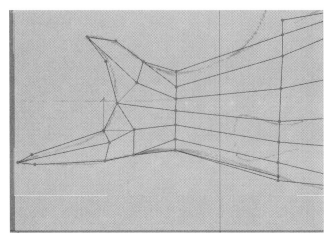

FIGURE 9.23 After adding detail to the bottom fin of the tail.

8. Remove the polygons on the inside of the tail, as you did with the top tail fin.
9. To better see the effects of adjusting the new vertices, turn on NURMS subdivision and set the iterations parameter to 1. This value rounds the geometry by smoothing the sharp angles.
10. Adjust the vertices on the head to accommodate the new vertices created by the added segments. The head becomes rounder, especially when NURMS is turned on, as shown in Figure 9.24.
11. Save your work.

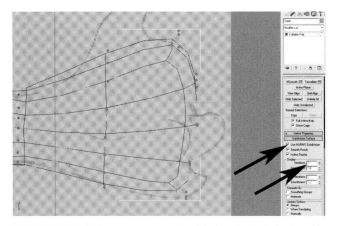

FIGURE 9.24 With the new segments added to the tail, the head has additional vertices that need to be adjusted as well.

TUTORIAL ## ADDING THE CHEEKS AND NOSE

Adding the cheeks and the nose to the fish is as simple as extruding and beveling some polygons. The process of adding detail is one of incremental refinement, only adding geometry where necessary. This method makes it easier to manipulate and creates a more optimized model.

ON THE CD

1. Open *squirt_nose.max* from the companion CD-ROM, or continue with your previous model file.
2. The model is getting to the point where having both sides of the model would make it easier to build. Using the Mirror tool, create an instanced clone of the model along the x-axis in the Front view. The result is shown in Figure 9.25.

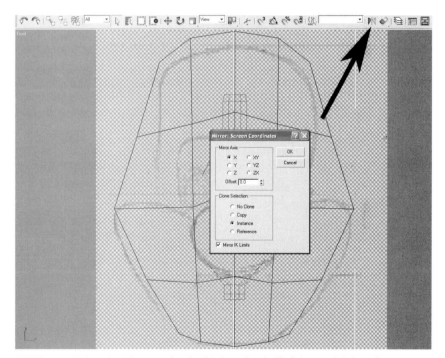

FIGURE 9.25 Using the Mirror tool to build the other half of the model, for reference only.

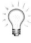

The Mirror tool is used only for reference when modeling. The Symmetry modifier will be added near the end of the modeling procedure. By creating a mirrored instance, you don't need to traverse the Modifier Stack each time you select the character.

3. Select the original half, and in the Modify panel, activate Polygon mode. Select the polygon positioned where the nose should be, as shown in Figure 9.26, then activate the Bevel settings dialog box.

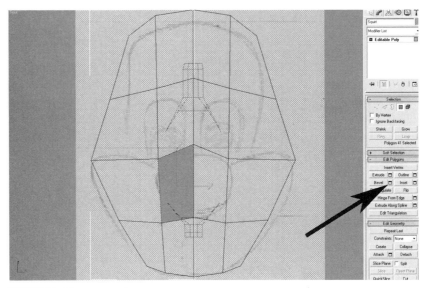

FIGURE 9.26 The nose polygon.

4. Using the Extrude settings dialog box, create three small extrusions from the nose polygon, then edit the vertices until they form the blocky shape of the nose, as shown in Figure 9.27.
5. Switch to Vertex mode, and drag the outer nose vertices slightly downward (along the z-axis in the Perspective view), to round the nose a bit.

FIGURE 9.27 A roughly shaped nose.

6. Delete the polygons that were created on the inside half of the nose because those will be inside both halves of the model. Your model should look something like the one shown in Figure 9.28.

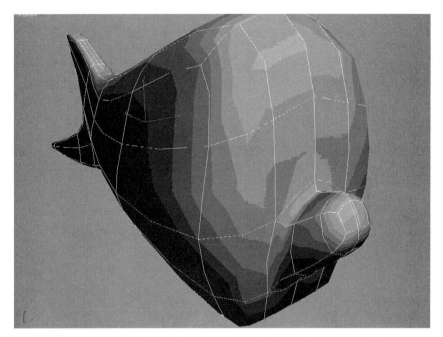

FIGURE 9.28 The nose of the fish after extruding and editing the position of the vertices. Note that a solid material was added to this image for clarity.

When working on a symmetrical model I typically use a wire material for the half of the model that I'm building. On the instanced half, I'll add a solid material so that I can have the best of both worlds during the modeling process. When I want to see how the model is shaping up, I simply rotate the view so the half with the solid material is more visible.

The cheeks are created by creating a new segment using the Ring and Connect tools.

7. In the Perspective view, click a horizontal edge behind the first row of vertices that make up the front of the head, then use the Ring and Connect tools to add one segment to the edges, as shown in Figure 9.29.

8. Next, select the vertical edge just above the cheek, and use the Ring and Connect tools to create another segment above the cheek, as shown in Figure 9.30. This segment is used to make the cheeks more pronounced.

FIGURE 9.29 Adding a segment from which to build the cheeks.

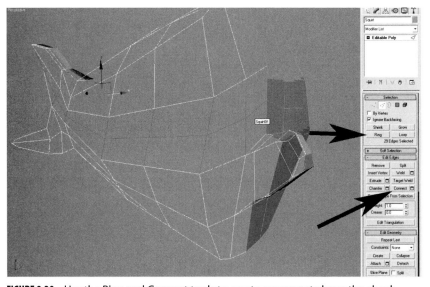

FIGURE 9.30 Use the Ring and Connect tools to create a segment above the cheek.

9. Edit the new segment so that it is closer to the cheek. Having two segments close to each other pinches the geometry slightly, as shown in Figure 9.31.
10. Select the polygon that makes up the cheek, and use the Bevel tool to create a single bevel on the cheek, as shown in Figure 9.32. This bevel adds some volume to the cheek.

FIGURE 9.31 Move the new segment downward, closer to the nose to pinch the cheeks slightly.

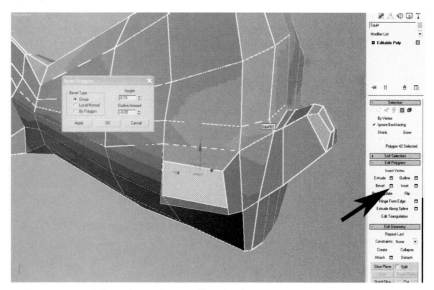

FIGURE 9.32 Bevel the polygon for a puffier cheek.

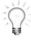

When individual vertices have been manipulated, polygons can become nonplanar, meaning that their vertices are not on a single plane. Nonplanar polygons may render incorrectly, so try to avoid them. Use the Make Planar tool in the Editable Poly object to make all selected polygons coplanar.

11. Use the Make Planar button in the Edit Geometry rollout to make the cheek polygon planar. Figure 9.33 illustrates the before and after result of using the Make Planar tool.

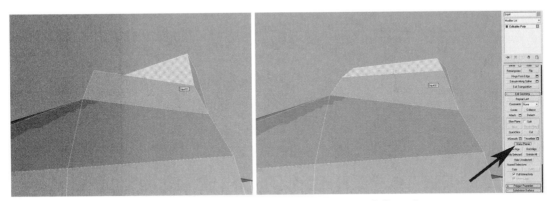

FIGURE 9.33 Use the Make Planar tool to change a polygon from nonplanar (left) to planar.

12. Save your work. The cheeks and nose will undergo further refinement, but for now your model should look something like that shown in Figure 9.34.

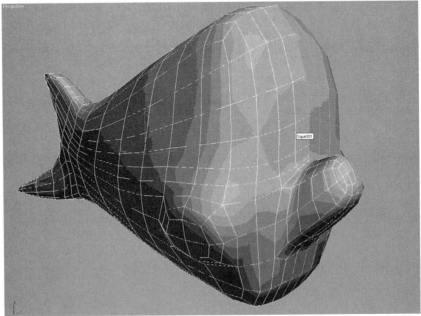

FIGURE 9.34 The fish model thus far, with a nose and little cheeks.

TUTORIAL

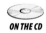

CREATING THE EYE SOCKETS

To create the eye sockets, you use some tools with which you should already be familiar, as well as a couple of new tools. By now, the reference image planes have been hidden and a solid material has been added to the model so that it's easier to see when making subtle changes. You can also use the NURMS toggle option to preview your model as you make changes.

ON THE CD

1. Open *squirt_eyes.max* from the companion CD-ROM, or continue with the model you have been working on.

 The eyes require that another segment be added along the length of the model. The new segment creates a gap between the eyes and can be used to build the dorsal fin later. Instead of using the Ring and Connect tools, the next step uses the Cut tool so that excessive segments are not created in the tail.

2. Switch to Edge mode and activate the Cut tool. The Cut tool is found in the Edit Geometry section or on the Quad menu, as shown in Figure 9.35.

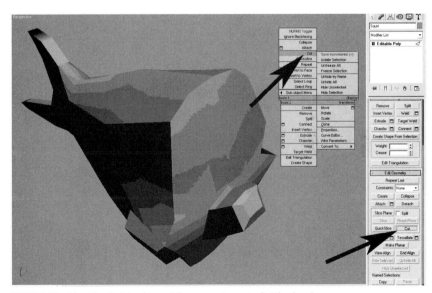

FIGURE 9.35 Use the Cut tool to add segments on individual polygons.

3. Using the Cut tool in Edge mode, make a cut from the base of the nose (by clicking that edge) down the back to just before the tail, clicking each

segment along the way. For the last edge, click the vertex of the final edge so that the polygons share that vertex. The new segment is shown in Figure 9.36.

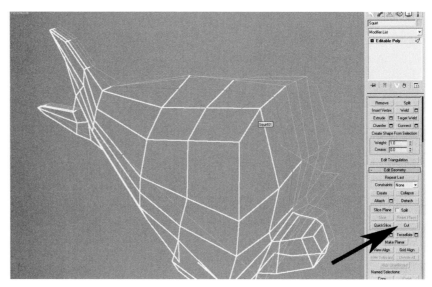

FIGURE 9.36 The result of the Cut tool.

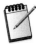
When you use the Cut tool, you don't have to select or click each edge to create the new cut. Any edge bisected by the Cut tool is cut. By clicking an edge, you can specify exactly where you'd like the cut to occur. The pointer changes when using the Cut tool to indicate whether the cut will occur at an edge or at a vertex.

4. To make the polygon that will be used for the eye wider, use the Outline tool (found next to the Extrude tool in the Edit Polygons rollout, shown in Figure 9.37), and click and drag the polygon to make its edges move outward. Drag up to grow the polygon, and drag down to shrink the size of the polygon. Like the Extrude and Bevel tools, you can also use the settings dialog box to adjust the polygon precisely.

5. To make the eye socket ridge, use the Bevel tool on the same polygon three times with the following settings:

 • Height = 0.09, Outline Amount = 0.04, then Apply
 • Height = 0.06, Outline Amount = –0.13, then Apply
 • Height = –0.25, Outline Amount = 0.0, then OK.
 • Your eyes should look like those shown in Figure 9.38.

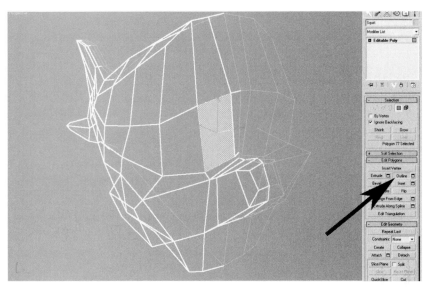

FIGURE 9.37 The Outline tool is used to grow or shrink the edges of a polygon.

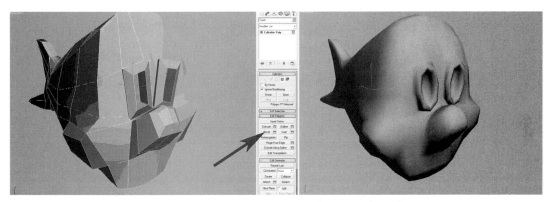

FIGURE 9.38 The eye sockets after using the Bevel tool to create the eye socket ridge.

6. Switch to Edge mode and select all of the vertical edges of the eye socket, as shown in Figure 9.39. Choose the Convert to Face option from the Quad menu.

7. With the new selection of polygons, you are automatically placed in Polygon mode. Use the QuickSlice tool to divide all of the selected polygons quickly. The result of using the QuickSlice tool is shown in Figure 9.40.

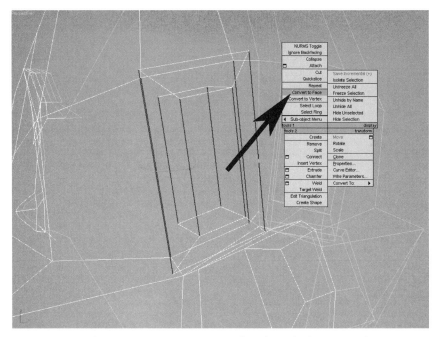

FIGURE 9.39 Use the Convert to Face option on the selected edges to get the

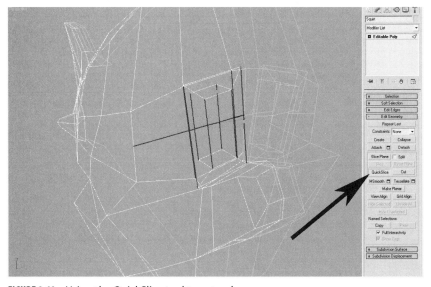

FIGURE 9.40 Using the QuickSlice tool to cut polygons.

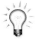

When you use the QuickSlice tool at the edge level, the slice is made through the entire object. At the polygon level, the tool only slices through the selected polygons. Unlike the Connect tool, which divides the selected edges at the center of each individual edge, the QuickSlice tool uses an imaginary plane to divide the selected edges or polygons. For this reason, the QuickSlice tool is great for making a straight cut across edges of varying sizes.

8. Switch to Vertex mode and adjust the vertices of the new edges to round the eye socket, as shown in Figure 9.41.
9. Save your work.

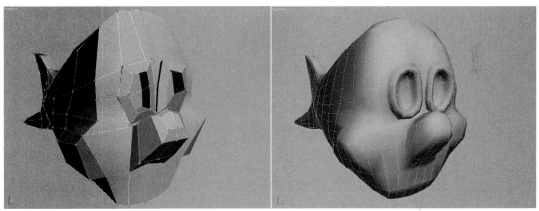

FIGURE 9.41 The eyes after the new vertices were adjusted slightly to make the eyes rounder.

TUTORIAL **ADDING FINS**

You create the dorsal fin from existing polygons using the Extrude tool. You then must manipulate the vertices to taper the fin and give it some shape.

ON THE CD

1. Open *squirt_fins.max*, or continue with your previous model.
2. In the Perspective view, select the polygon shown in Figure 9.42. Use the Extrude settings dialog box to create two new extrusions of 0.5 units each and one segment with a Height value of 0.15, resulting in the form shown in Figure 9.43.
3. In the Perspective view, you can see that the polygons have strayed from the centerline of the model. Switch to Edge mode, select each of the

edges shown in Figure 9.44 individually, and set the x-axis value to 0.0. This value places those edges back at the centerline, alleviating a gap in the geometry when the two halves of the model are merged. The result is shown in Figure 9.45.

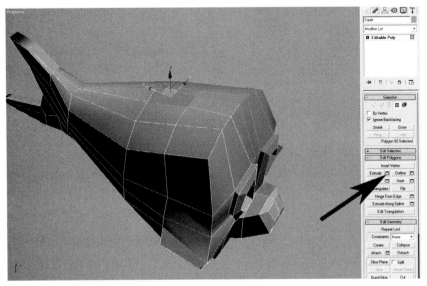

FIGURE 9.42 Select this polygon to create the dorsal fin.

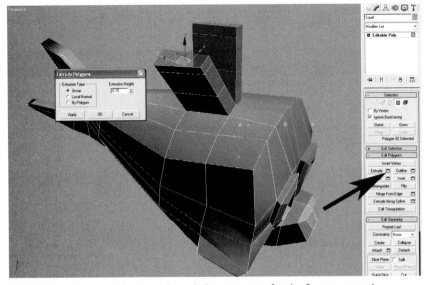

FIGURE 9.43 After using the Extrude tool, the segments for the fin are created.

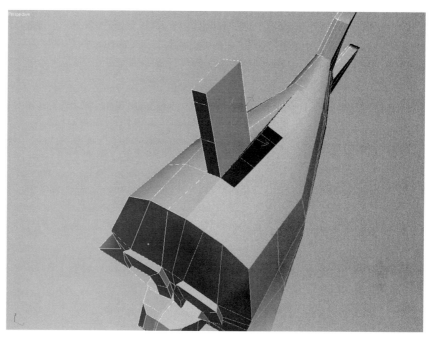

FIGURE 9.44 The edges that must be aligned to the center of the model.

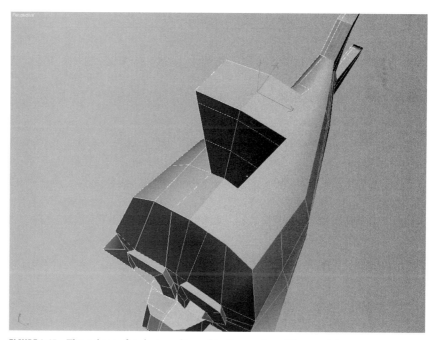

FIGURE 9.45 The edges after being aligned to the center of the model.

 When using the Transform Type-In dialog box to position edges (or any sub-object), each itme must be positioned individually. You cannot position a group of sub-objects with the Transform Type-In dialog box, because their position is based on the group rather than individual sub-objects.

4. In the Perspective view, remove the three inner polygons of the new segments, as shown in Figure 9.46. You'll need to switch to wire-frame mode (F3) to view the polygons.

FIGURE 9.46 Remove the polygons shown, because these eventually reside inside the model when the other half is added.

5. In the Left view, select the 12 vertices that make up the fin. Use the Hide Unselected tool in the Edit Geometry rollout to hide the other vertices. This step makes it easier to manipulate the geometry.
6. In the Left view, adjust the vertices so they resemble the shape of the fin, as shown in Figure 9.47.
7. In the Front or Perspective view, switch to Edge mode and edit the edges so that the fin gets progressively thinner at the top, as shown in Figure 9.48.
8. Return to Vertex mode and Unhide all vertices. Then manipulate the vertices behind the fin to smooth the transitional area where the fin meets the back, as shown in Figure 9.49.

FIGURE 9.47 The fin vertices, after adjustment.

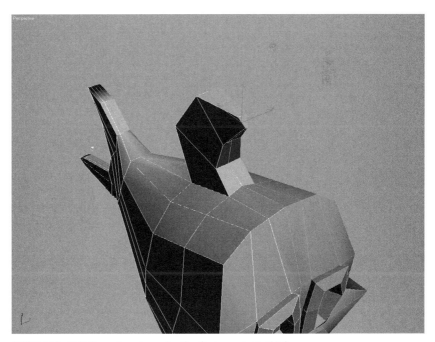

FIGURE 9.48 Edit the edges to make the fin taper in its thickness.

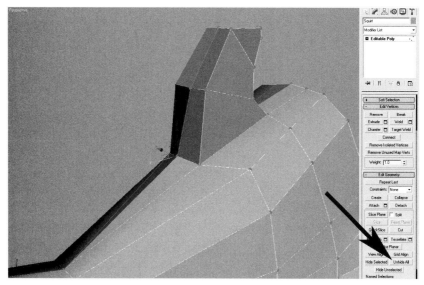

FIGURE 9.49 Adjust the vertex behind the fin so that it transitions smoothly into the back of the fish.

9. Continue manipulating the other vertices on the fin to create tapered geometry on all sides, as shown in Figure 9.50.

10. Save your work.

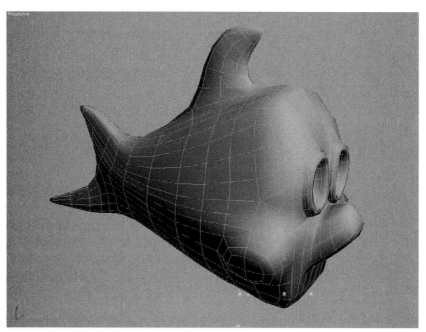

FIGURE 9.50 The fin after some initial refinements.

TUTORIAL ## CREATING A PECTORAL FIN

The pectoral fin is created slightly differently than the dorsal fin. You use another great tool specific to the Editable Poly object called as the Hinge From Edge tool. This tool enables you to pivot a polygon from an edge to create additional geometry.

ON THE CD

1. Open *squirt_dorsal.max* from the companion CD-ROM, or continue with your previous model.
2. In the Left view, select the polygon behind the extruded cheek, shown in Figure 9.51.

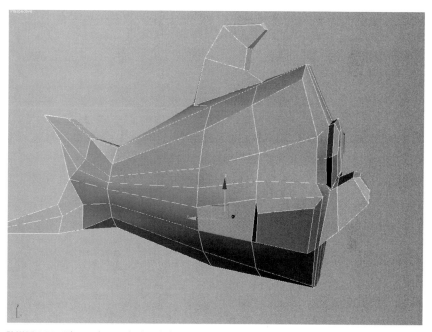

FIGURE 9.51 The polygon behind the cheek is the start of the pectoral fin.

3. In the Edit Polygons rollout, click the Inset settings button to open the dialog box. Set the Inset Amount parameter to 0.1, as shown in Figure 9.52.
4. Scale the polygon (using the Scale tool) to make the polygon very small, then adjust the vertices to make a small square, as shown in Figure 9.53. Be sure to keep the vertices in line with the rest of the body, and check the position of the vertices in all views.
5. Before moving on, use the Make Planar button to make the small polygon planar.

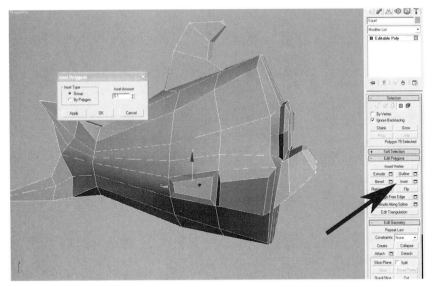

FIGURE 9.52 Use the Inset tool to create a new polygon with the selected polygon.

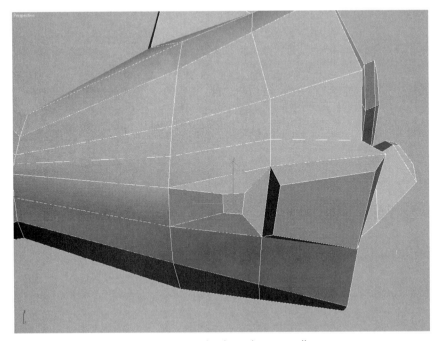

FIGURE 9.53 Adjusting the vertices to make the polygon smaller.

6. With the small polygon selected, click the settings button for the Hinge From Edge tool, found in the Edit Polygons rollout, shown in Figure 9.54.

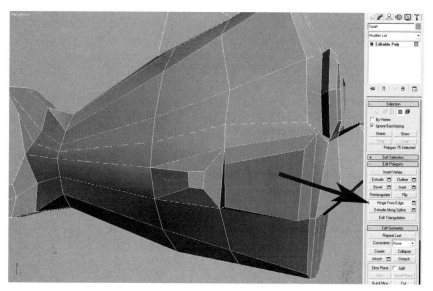

FIGURE 9.54 The Hinge From Edge tool has an interactive mode and a settings dialog box.

7. In the Hinge From Edge dialog box, click the Pick Edge button, then click the edge on the forward side of the polygon, as shown in Figure 9.55. After the edge is selected, its number is shown in the settings dialog.

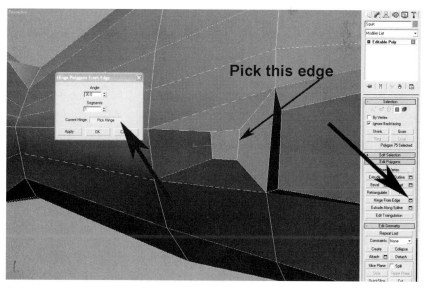

FIGURE 9.55 For the Hinge From Edge tool to work, an edge must be selected from which the new geometry will hinge.

8. Set the Hinge Angle to 45.0 to create new geometry that hinges 45 degrees from the edge selected as the hinge. Keep the segments parameter set to 1, then click OK. The result is shown in Figure 9.56.
9. Select the new polygon on the back end of the new geometry (shown in Figure 9.57), then use the Extrude tool to create two new segments, as shown in Figure 9.58.

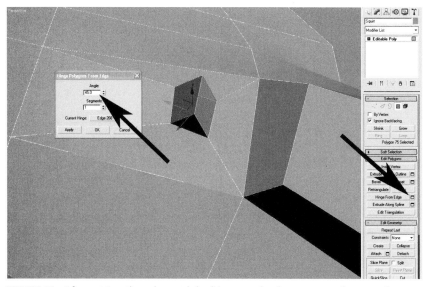

FIGURE 9.56 After setting the edge and the hinge angle, the geometry is created.

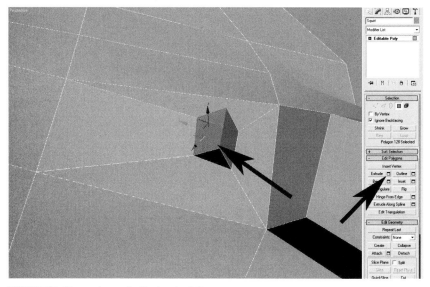

FIGURE 9.57 The polygon in the back of the new geometry.

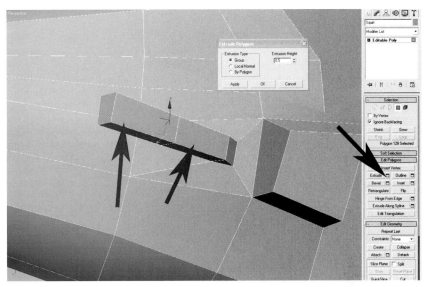

FIGURE 9.58 After extruding the selected polygon twice for two segments.

10. In Edge mode, select the edges along the top and position them so the fin becomes wider. Repeat the process on the bottom edges. The result is shown in Figure 9.59.

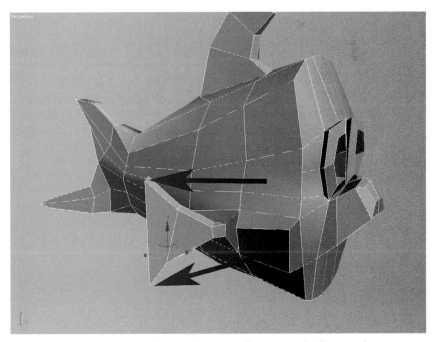

FIGURE 9.59 Adjust the two edges on the top and bottom so the fin spreads out.

11. Select the polygon on the end of the fin, then use the Extrude tool again with a Height value of 0.5. This setting creates a rounded fin when smoothing is turned on, as can be seen in Figure 9.60.
12. Save your work.

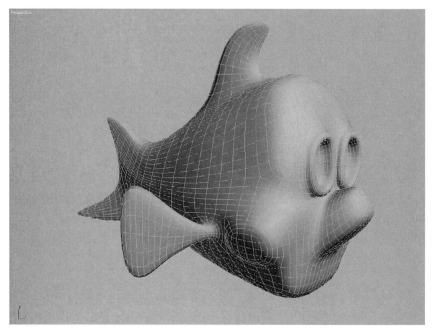

FIGURE 9.60 The completed fins.

BUILDING THE MOUTH

1. Open *squirt_mouth.max* from the companion CD-ROM, or continue with your existing model.
2. Select the two faces in the front of the fish, by the mouth, as shown in Figure 9.61, and use the Inset settings dialog box to create a starting point for the lips.
3. Select the polygon in the center of the mouth (shown in Figure 9.62) and press the Delete key to delete it.

FIGURE 9.61 The Inset tool creates a new set of polygons within the selected polygons.

FIGURE 9.62 Select and delete the center polygon from the mouth.

4. Select the two vertices that were part of the just deleted polygon, and set the x-position of each to 0. Each vertex needs to be positioned individually. This step positions the vertices at the centerline of the model, as shown in Figure 9.63.

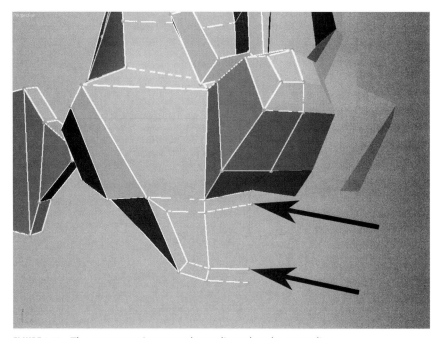

FIGURE 9.63 The center vertices must be realigned to the centerline.

5. Select the faces around the mouth and use the Extrude tool to extrude the selection 0.1. Press the Apply button, set the Extrusion Height parameter to 0.2, and press OK. The result is shown in Figure 9.64.

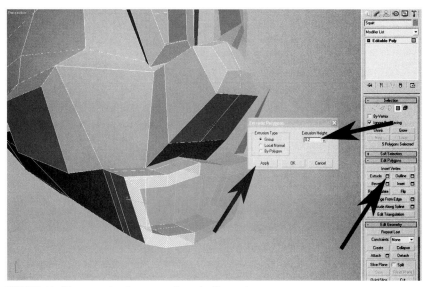

FIGURE 9.64 The mouth, after extruding the lips twice.

6. Rotate the view, and select and delete the polygons on the inside center-line, as shown in Figure 9.65.

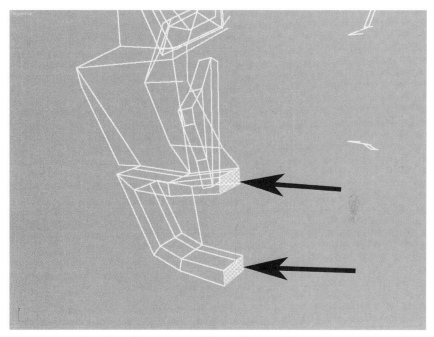

FIGURE 9.65 Delete the polygons created along the centerline, as a result of using the Extrude tool.

7. In the Perspective view, move the two sets of vertices in the center of the lower lip approximately –0.25 to –0.5 units along the y-axis, as shown in Figure 9.66.
8. Adjust the next row of vertices back (on the inside of the mouth) and bring them forward to fatten up the lips, as shown in Figure 9.67.
9. Adjust the other vertices in both the upper and lower lips until the mouth is fuller, as shown in Figure 9.68.
10. Before moving on, verify in the Top view that all vertices that belong on the centerline are on the centerline. To check, each of those vertices should be at position 0.0 on the x-axis, as shown in Figure 9.69, though the Symmetry modifier clips and welds any vertices that cross the midline (which could change the shape of your model).
11. Save your work.

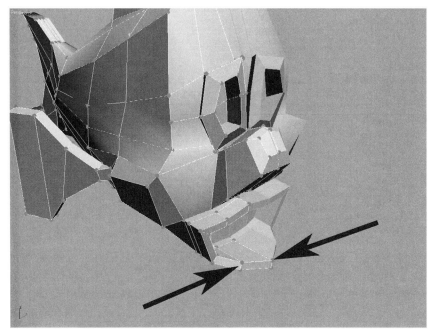

FIGURE 9.66 The lower lip is stretched outward by moving the lower vertices.

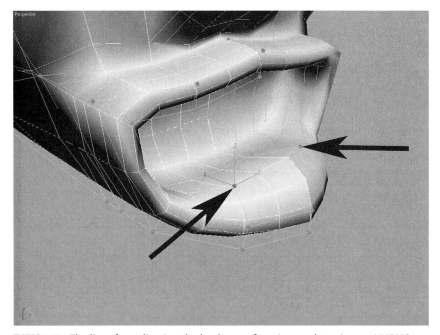

FIGURE 9.67 The lips after adjusting the back row of vertices and turning on NURMS.

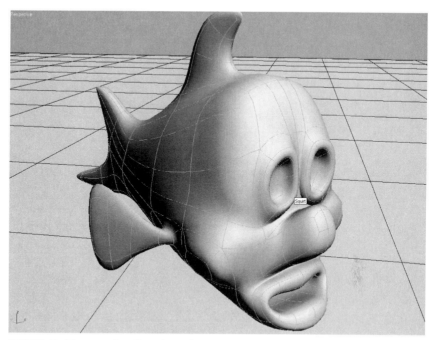

FIGURE 9.68 The complete lips after adjusting vertices in both the upper and lower lips.

FIGURE 9.69 Check the vertices in the mouth along the centerline. Each should have an x position of 0.0.

SUMMARY

This chapter contained many detailed steps. As you can see, the modeling process takes a lot of work, but by attacking each problem one at a time, you can complete the entire project without too many headaches. By now your modeling experience—and, hopefully, your confidence—has been raised a few notches. In this chapter you learned:

- More about polygonal modeling
- Editable Poly tools, such as Extrude, Bevel, Outline, Inset, and Hinge From Edge
- How to use the Cut and QuickSlice tools

Some refinement can still be done on the fish model. For one thing, add the Symmetry modifier, like you did in the skull tutorial. Also you can collapse the entire object to an Editable Poly and make adjustments so the fish isn't perfectly symmetrical. Also, you can customize the eyes and mouth to your liking. This model will be revisited in later tutorials.

10

BASIC HIERARCHIES AND PARAMETRIC ANIMATION

In this chapter

- Animating Parameters
- Hierarchical Chains

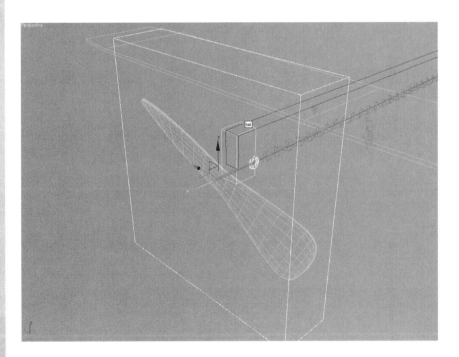

When most people think of animation, they typically think of an-
imated cartoons or the full-length feature animation of such
classics as *Toy Story*, *A Bug's Life*, or *Finding Nemo*. Aside from the
delightfully animated characters that make these animations wonderful
to watch, subtleties in animation are included in these films that make
the experience richer. Props and insignificant objects within the film may
all have motion. By animating the background objects, such as water
drops on a window, leaves on a tree, or specks in the ocean, the artists
make the environment more believable. This chapter begins the intro-
duction into animation by teaching how to animate some of the simpler
objects of your project.

Project Assessment:

- Animate the Twist parameter to make the rubber band appear to un-
wind.
- Wire the propeller's rotational values so it appears to be powered by
the rubber band.
- Create a hierarchical structure using a dummy object to control the
entire plan's position.

BASIC ANIMATION

3ds max 6 provides just about the easiest method for animation in the in-
dustry. You first set the time, then set the key frame. When you create two
or more key frames, you have animation. In the following tutorial, you ex-
perience the most basic method of animation. In subsequent tutorials, the
complexity of animation increases.

Creating Key Frames

Animation is created with a series of key frames. The term *key frame* comes
from the days of hand-drawn animation where the most important draw-
ings were called *key drawings*, or key frames. Key drawings are those that
include the most extreme poses of motion. For example, in a bouncing ball
animation, the key frames would be the frame of the ball before it fell,
when it hit the ground, and when it reached the top of its bounce arc, as
shown in Figure 10.1.

To expedite the process of creating traditional cell animation, the key
drawings were created by the senior artists in the studio, and the
younger, inexperienced artists created the frames between the key draw-
ings. Drawing the frames between the key frames was called *in between-*

FIGURE 10.1 The light-colored spheres are the key frames, whereas the darker spheres are the in-between frames.

ing, later shortened to *tweening*. Within 3ds max, key frames are created by the animator, and the tweening is accomplished by the software in a process known as interpolation.

Auto Key versus Set Key Mode

3ds max offers two modes of animation: Auto Key and Set Key. The icons for each are located in the lower portion of the 3ds max 6 interface, as shown in Figure 10.2. Depending on the type of animation being created, each has its strengths and weaknesses. Each mode is discussed in detail

FIGURE 10.2 The Time Slider is used to change the current time. By dragging the Time Slider you can "scrub" the animation, or you can use the arrows to move between frames and key frames in the active time segment.

during the appropriate tutorials, but a short list of the differences between the animation modes follows.

Auto Key:

- Creates a key frame any time something is changed.
- Keeps key frames to a minimum.

Set Key:

- Creates multiple key frames with a single click.
- Animates character linkages (such as bones).
- Creates multiple keys at once.
- Can create excessive key frames.

TUTORIAL

ON THE CD

ANIMATING PARAMETERS

You start with a simple animation task. In this task, you animate the twist in the rubber band used to power the plane.

1. Open *plane_start.max* from the companion CD-ROM.
2. Press the H key to open the Select By Name dialog box. Choose the *rubber band* object.
3. In the Modify Panel, click the Modifier List and apply a Twist Modifier to the *rubber band* object.
4. In the Twist Modifier dialog box, set the Angle amount to 7000. This value twists the geometry of the rubber band and gives it the proper look.
5. Drag the Time Slider to frame 100, then click the Auto Key icon (shown in Figure 10.3) to activate Auto Key mode.

FIGURE 10.3 The Auto Key and Set Key icons.

6. At frame 100, set the Twist amount to –720, then turn off Auto Key mode.

The rubber band is now animated. Look at the Track bar, shown in Figure 10.4, to see the two key frames created by just setting one key frame. Because animation needs at least two key frames for motion to occur, the key frame created at frame 0 is generated automatically (because Auto Key was turned on) when the key frame at 100 was created.

FIGURE 10.4 The Track bar shows the current time, the current time range, and any key frames that occur for the selected objects within the time range.

When the first key frame is created on a frame other than 0, 3ds max creates an additional key frame at frame 0. This key frame is created because 3ds max requires that at least two key frames be present to interpolate values and create the in-between frames.

TUTORIAL **WIRING PARAMETERS**

In the previous tutorial, you made the rubber band twist. In this tutorial, you make the propeller turn in unison with the rubber band. Though each object can be animated individually, that requires that each object be reanimated if you make changes in the animation or in the timing. The following tutorial guides you through the steps required to wire the parameters of one object to that of another.

ON THE CD

1. Open *plane_final.max* from the companion CD-ROM.
2. With the propeller object selected, right-click to open the shortcut menu and choose Wire Parameters from the Transform menu (as shown in Figure 10.5).

FIGURE 10.5 The Wire Parameters option lets you control the parameters of one object with the parameters of another.

3. After the Wire Parameters option is selected, another menu appears, prompting you for a parameter to wire. Because you want to control the rotation of the propeller along its y-axis, choose the y-axis option (as shown in Figure 10.6).

FIGURE 10.6 The parameter list for the first object to be wired.

4. After choosing the propeller's parameter, a dashed line extends from the pivot point of the selected object to the pointer. Click an object to wire to. Another menu appears that lists all of the parameters available to the selected object. Choose the Twist Angle parameter (found under the Modified Object menu item), as shown in Figure 10.7.

FIGURE 10.7 The menu from the second object to be wired. All of the object's available parameters, including those found in modifiers, are listed.

5. After selecting the second wired parameter, the Wire Parameter dialog box (shown in Figure 10.8) opens. Use this dialog box to choose the direction of control for wired parameters. Choose a Control Direction—in this

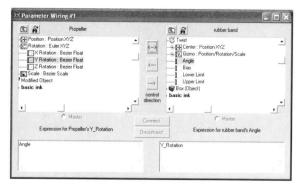

FIGURE 10.8 The Wire Parameter dialog box. From here, parameter wiring is controlled.

case, choose the one-way control from the rubber band to the propeller, as shown in Figure 10.9.

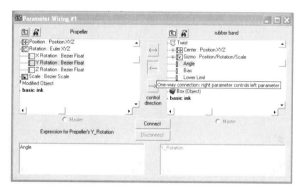

FIGURE 10.9 The direction control is used to decide which parameter (if any) is the master controller. If both directions are chosen, both parameters affect each other.

6. Before finalizing the wiring of parameters, be sure that the wired expression is appropriate for the connection. In 3ds max, rotation angle is expressed in degrees, whereas numeric values are expressed in radians. As such, you must use the Degtorad() function when wiring the rotation of an object with the value of another parameter. The new expression is added to the expression box on the side of the propeller parameters, as shown in Figure 10.10.
7. After choosing a control direction, click the Connect button in the Wire Parameters dialog box to activate the wiring choice. The Twist Angle value now controls how much the propeller spins.

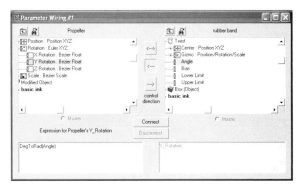

FIGURE 10.10 Adding the DegtoRad() function to the expression of the wired parameter.

8. Scrub the Time Slider to watch the propeller spin with the rubber band. Because the propeller is being controlled by the rubber band, from this point forward, do not animate the propeller directly; use the rubber band to control its rotational speed.

Drag, or scrub, the time slider back and forth to see how a sequence is animated instead of clicking the Play button. By scrubbing, you can control the playback speed, as well as isolate the playback sequence.

CREATING A HIERARCHY

To gain more control over animated objects, you create hierarchies, which are like the strings of a marionette. Hierarchies determine the order of control among related objects. The hierarchical relationship between objects let animators control objects in a variety of ways. Within a two-object hierarchy, one object serves as the parent and the other as the child. Both the parent and child objects can be animated separately, but the child object always follows the parent, regardless of its own animation. For instance, in a paddle-ball set, the ball and rubber band are child objects of the paddle, which is the parent (as illustrated in Figure 10.11). Each moves in its own way, but as the paddle moves, the rubber band and the ball follow.

FIGURE 10.11 The paddle is the parent, and both the ball and the elastic string are child objects. The ball could also be a parent object to the string, because the string is attached to the ball.

TUTORIAL

USING A DUMMY OBJECT

In the following exercise, you create a simple parent-child hierarchy. The parent object in this case is going to be a dummy object. Dummy objects are found under the Helpers Tab (shown in Figure 10.12) and are used as a parent object to control geometry. Dummy objects are rendered and appear as a wire-frame box in the scene.

FIGURE 10.12 The Helpers Tab contains several objects that are useful for animating and controlling geometry, including the dummy object.

1. Open the Helpers Tab and click the Dummy Object button. In the Top view, click and drag out a box (created in a single motion from the center out at the point of the click) to create a dummy object around the entire propeller object, as shown in Figure 10.13.

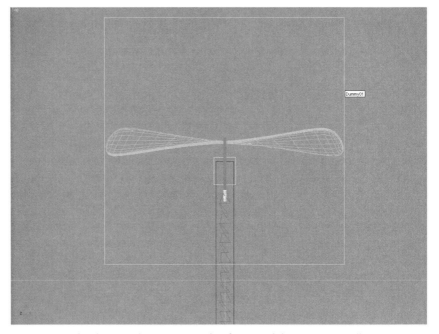

FIGURE 10.13 The dummy object is created to fit around the entire propeller.

 It is recommended that you create dummy objects in the Top view to ensure that the pivot point of the dummy object is oriented to the World Coordinate System. When hierarchical links are created, having misaligned pivot points can lead to undesirable and uncontrollable animation.

2. Though the center of gravity on a plane is around the wings' spars, place the dummy object at the propeller for this exercise. Use the Align tool to align the dummy object around the propeller. Set the alignment to be centered along the x-, y-, and z-axes.
3. Although the size of the dummy objects makes no difference when controlling other objects, use the Scale tool to make the dummy object thinner and a tighter fit around the propeller, as shown in Figure 10.14.

 When using dummy objects in hierarchies, never use the Scale tool. Using the Scale tool causes the objects lower in the hierarchy to become skewed when rotating. The scaling in this exercise is done purely for ease of example.

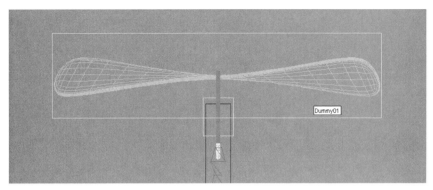

FIGURE 10.14 The dummy object has been scaled to 25 percent along the y-axis to fit better around the propeller object.

4. Now that the dummy object has been sized, position it around the propeller using the Align tool. Center the dummy object to the propeller on all three axes, as shown in Figure 10.15.

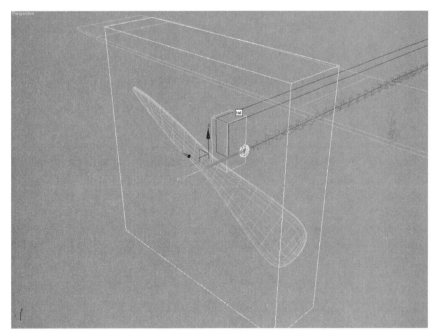

FIGURE 10.15 The dummy object has been centered on the propeller object along all three axes.

5. From the Main Toolbar, activate the Select and Link tool (shown in Figure 10.16).

FIGURE 10.16 The Select and Link tool is used to create a hierarchical chain.

6. With the Select and Link tool active, click and drag from the propeller, releasing the mouse button on the dummy object. This action links the propeller to the dummy object. After clicking the propeller, a dotted line follows the pointer, indicating the Link mode is active, as shown in Figure 10.17. When you release the mouse button on another object, that object flashes white for one second, indicating it is now the parent object.

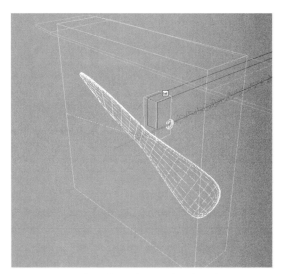

FIGURE 10.17 When the Select and Link tool is active, clicking and dragging from one object to another creates a parent-child link, where the first object selected is the child and the object over which the mouse button is released is the parent.

7. Now that you've linked the two objects, move the dummy object around to ensure that the propeller follows. Remember to Undo any movement you make (use CTRL + Z) so that you don't alter the relationship between the dummy object and the propeller.

Hierarchies can have several levels (or parents) within the hierarchical chain. Because the propeller has already been wired to the rubber band, use the propeller to control the metal pin and ring that connect it to the rubber band. Although a more logical setup may have been to wire the ring and pin to the rubber band, the propeller was used for convenience.

8. Although you can link objects individually, when multiple objects share the same parent, they can be linked at one time. Press the H key to open the Select by Name dialog box, and select both the *prop axel* and *prop band ring* objects, as shown in Figure 10.18. Click the Select button to close and select the objects.

9. With the Select and Link tool active, press the H key again to open the Link by Name dialog box. This dialog box looks similar to the Select by Name dialog box, but you can only select a single object in this dialog box, as shown in Figure 10.19. The object selected from this list becomes the parent of the original selection. Select the propeller object and click the Link button.

FIGURE 10.18 Use the Select by Name dialog box to select multiple objects.

FIGURE 10.19 When the Select and Link tool is active, pressing the H key opens the Link dialog box. Only one object can be selected from this dialog box, and it becomes the parent object to the current selection.

10. Activate the Select Only tool (Q key) and press the H key to open the Select By Name dialog box. Click the Display Subtree option and notice that the child objects are indented slightly from their parent object, as shown in Figure 10.20. Select the objects not yet linked and link them to the dummy object, as was done in steps 8 and 9.

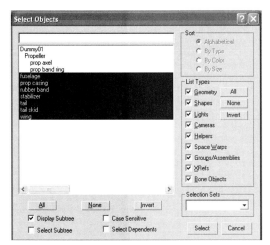

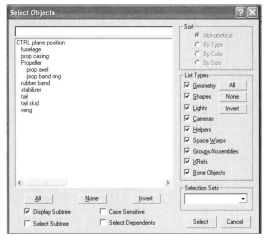

FIGURE 10.20 Parent-child relationships are shown in the Select by Name dialog box when the Display Subtree option is selected.

FIGURE 10.21 The completed plane hierarchy. The dummy object was renamed *CTRL plane position* to make it easier to identify when the entire scene is assembled.

11. Now that the entire plane has a hierarchical structure, rename the dummy object so that it is called *CTRL plane position*. Your hierarchy is now complete. The entire hierarchy is shown in Figure 10.21.

SUMMARY

In this chapter you learned about simple animation concepts and how to animate an object's parameters. You also learned about:

- Creating key frames
- Dummy objects
- Hierarchical linking

This chapter provided just the start of creating an animated structure. In subsequent chapters, you will learn about more advanced animation concepts and more complex hierarchies.

11

RIGGING AND ANIMATING

In this chapter

- Wiring Parameters
- Character Rigging
- Skinning and Envelopes

A nimation may be the most exciting aspect of computer graphics, but it is also the single most difficult aspect of computer graphics. Giving life to an inanimate object requires many skills, all of which take time to develop. To be a successful animator, you must understand emotion, gesturing, weight, and timing, just to name a few qualifications. All of these things are in addition to knowing your software of choice. In this chapter you learn the mechanics of the software.

Project Assessment: This shot consists of your character swimming around, then blowing some bubbles. This project is only a single shot in an animation.

Objects:

- Steer skull
- Squirt

SETTING UP THE CHARACTER FOR ANIMATING

The Squirt character isn't yet complete and must be rigged for animation. Rigging is the process of building controls for the components of an animated mesh. You use several different control types to create the rig for the fish. This section is divided into smaller sections for creating the eyes and eyelids, then the controls for animation.

TUTORIAL

ON THE CD

CREATING THE EYES AND EYELIDS

The following tutorial demonstrates how to set up the rigs for the eyes.

1. Open *squirt_rig_start.max* from the companion CD-ROM.
2. You first make eyes and eyelids for your character, so in the Front view, create a sphere with a radius of 0.125 and position it so that it is resting within the right eye socket of the fish, as shown in Figure 11.1. Rename this object *eye RT*.
3. Now you create the left eye. You can quickly clone it and align it to the left eye socket the same way that it is aligned to the right eye socket. Activate the Select and Move tool and set the coordinate system to World Coordinate System. Change the selection center option from Use Pivot Point Center to Transform Coordinate Center, as shown in Figure 11.2.

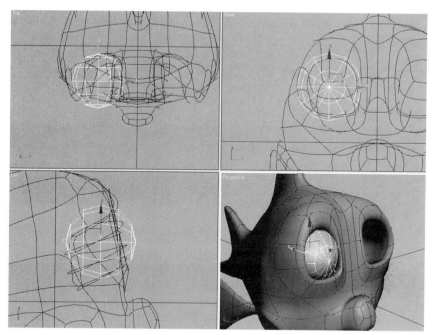

FIGURE 11.1 Create an eyeball within the eye socket.

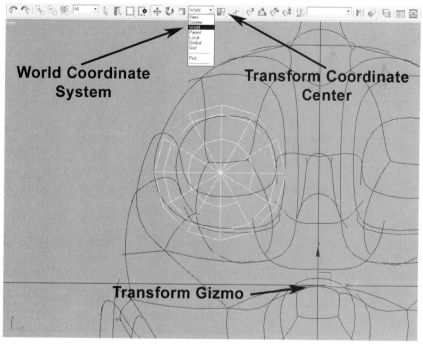

FIGURE 11.2 Changing the transform and coordinate systems changes the way objects are transformed, even when cloned.

 By switching the selection center to the Transform Coordinate Center and using the World Coordinate System, you can transform objects around the origin. This method works great when your objects are created at the origin and makes initial placement of symmetrical objects much easier.

4. Use the Mirror tool in the Front view. Mirror along the x-axis and choose Copy as the clone type. This clone type creates a second eye in the left eye socket, as shown in Figure 11.3. Rename this object *eye LFT temp*.

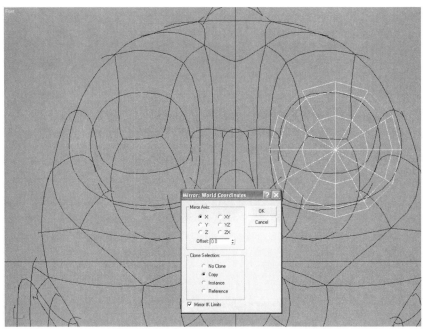

FIGURE 11.3 Use the Mirror tool to create the left eye. It is positioned based on the position of the right eye, so it aligns perfectly to the left eye socket.

5. Create a new sphere in the Front view and match the dimensions of the first (radius of 0.125). Using the Align tool, align the new sphere to *eye LFT temp* on all three axes and delete the *eye LFT temp* object.

 You used the mirrored object as a temporary object for alignment purposes only. Due to the characteristics of a mirrored object, the pivot point of the mirrored object would never match that of the other eye, potentially causing difficulty during animation.

6. Change the selection center and coordinate system back to Pivot Point Center and View Coordinate System, respectively.

Creating the Eyelids

The eyelids are created by cloning each of the eyes and modifying them to create the eyelids. The eyelids (two for each eye) are then wired and linked to a control object so that they open and close with a single control.

7. Select the right eye and press CTRL + V to create a clone of the eye. Choose Copy as the type of clone. Rename this object *eyelid RT*. Set the radius of the eyelid to 0.16.
8. In the Top view, rotate the eyelid 180 degrees along the z-axis.

This is a great time to use the Isolate Selection tool, found on the Quad menu, as shown in Figure 11.4. The Isolate Selection tool hides any object that's not selected to clear up the interface. When you exit the Isolate Selection tool, all of the objects that were hidden are returned. This process does not affect objects that were already hidden manually.

FIGURE 11.4 The Isolate Selection tool is found on the Quad menu.

9. Open the Modify Panel and set the eyelid's Segments parameter to 13. Set the Hemisphere parameter to 0.5. These values create a sphere, as shown in Figure 11.5.

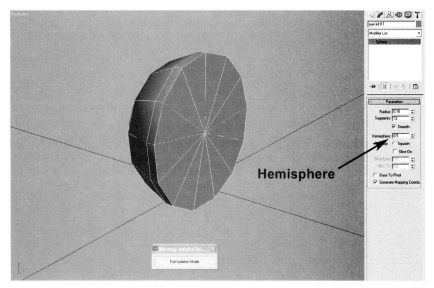

FIGURE 11.5 Create the eyelid from the eyeball. The eyelid comprises two half spheres.

10. Convert the eyelid to an Editable Poly object, then select and delete the center vertex on the flat side, as shown in Figure 11.6.

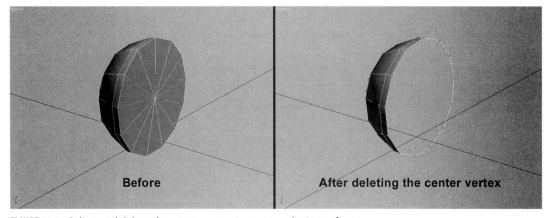

FIGURE 11.6 Select and delete the center vertex to remove the inner faces.

11. Turn off Sub-Object mode and apply a shell modifier with Inner Amount set to 0.02 and Outer Amount to 0.0, as shown in Figure 11.7.
12. Before modeling any further, make sure the pivot point of the eyelid is aligned to the world with the z-axis pointing up. With the eyelid selected, open the Hierarchy panel and click Affect Pivot Only. In the Alignment sec-

tion, click Align to World to realign the pivot point. Notice the z-axis of the pivot point is pointing up. This step is illustrated in Figure 11.8. Turn off Affect Pivot Only.

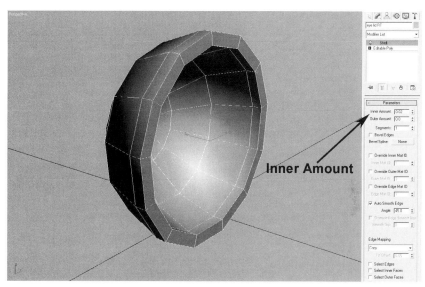

FIGURE 11.7 Use the Shell modifier to rebuild an inner wall where the polygons were deleted.

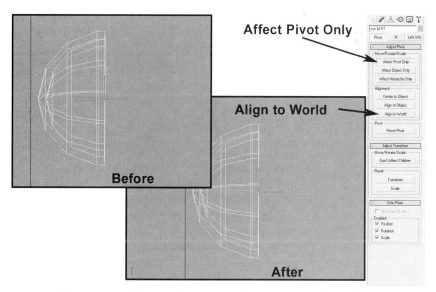

FIGURE 11.8 The Align to World option realigns the pivot point when Affect Pivot Only has been activated.

13. Be sure Affect Pivot Only has been turned off. Rename the eyelid *eyelid RT upper*, then use CTRL + V to clone a copy. Rename the copy *eyelid RT lower*.

14. In the Left view, create a point helper object, set the Size parameter to 0.25, and turn the Box option on. Align the point's center to the upper eyelid's pivot point, as shown in Figure 11.9.

FIGURE 11.9 Align the point helper to the pivot point of the eyelids.

15. With the point helper selected, align its pivot point to the world, as was done previously with the sphere.

16. With the lower eyelid selected, right-click and choose Wire Parameters from the Quad menu, as shown in Figure 11.10.

17. When the Wire menu appears, click Transform > Rotation > X Rotation. When the dashed line from the pointer appears, drag to the point helper object and choose its X Rotation as the wired parameter. Once they are wired, the Parameter Wiring dialog box opens, as shown in Figure 11.11.

18. In the Parameter Wiring dialog box, set the direction from the Point helper object to the lower eyelid in one direction only. In the expression section, set the X Rotation to be multiplied by (-1) so it rotates the same amount as

FIGURE 11.10 The Wire Parameters option is found on the Quad menu.

FIGURE 11.11 The Parameter Wiring dialog box.

the upper eyelid but in the opposite direction. The express should read X Rotation*(-1), as shown in Figure 11.12. Do not use the quotation marks.

19. Press the Connect button in the Parameter Wiring dialog box to activate the wired parameters, then close the dialog box.

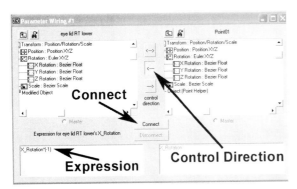

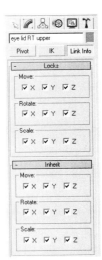

FIGURE 11.12 The Parameter Wiring dialog box is used for controlling the direction of the wired parameters, as well as any expressions.

FIGURE 11.13 Use the Link Info Lock options to prevent an object from being transformed directly.

20. Select the upper eyelid and link it to the point helper so that it rotates in the same direction as the point helper. Ultimately, all animated geometry will be controlled with helper objects, not directly.
21. To ensure that the eyelids can't be transformed directly, select the upper eyelid and open the Hierarchy panel, then activate the Link Info section. This section is where you can prevent an object from being transformed directly. Under the Locks section, make sure that all boxes are checked, as shown in Figure 11.13. If you try to move, rotate, or scale the upper eyelid directly, it won't work. It will, however, rotate based on the rotation of the point helper.
22. To keep the lower eyelid from being transformed directly, repeat step 20 on the lower eyelid.

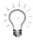 *When using the Link Info Locks, multiple objects can be selected to save time in applying the axis locks.*

23. To constrain how the point helper rotates, restrict its rotation to the x-axis by opening the Link Info tab and checking all boxes except the X Rotation, as shown in Figure 11.14.

FIGURE 11.14 Use the Link Info tab to restrict
the point helper to rotate only along its x-axis.

24. To determine how your first rig is working, click and rotate either of the
 eyelids or the point helper. If you've rigged it correctly, only the point
 helper rotates, and when it does, the eyelids open and close in unison, as
 shown in Figure 11.15.

FIGURE 11.15 After rigging the eye, the eyelids open and close simultaneously.

 To position the point helper so it is more accessible during animation, move it to the outside of the eye. Before the point helper can be moved, you must turn off the x-axis lock in the Link Info tab. If you turn on Don't Affect Children, then go to the Link Info tab. If the Don't Affect Children option is turned off, you'll need to turn it back on before proceeding.

25. In the Front view, select the point helper, open the Hierarchy panel and in the Pivot tab, activate Don't Affect Children, as shown in Figure 11.16.

Don't Affect Children

FIGURE 11.16 Use the Don't Affect Children option to move an object without affect any objects that are linked to it.

26. With Don't Affect Children active, move the point helper to the left side of the eyelids in the Front view, as shown in Figure 11.17. If the point helper doesn't move, be sure that you unlocked it along the x-axis in the Link Info tab.

27. Lock the x-axis in the Link Info tab after moving the point helper.

28. Rename the point helper *CTRL eye RT lid rotate*.

29. Repeat the entire rigging procedure for the left eye. The eye must be unlocked before the clone can be created. Clone the left eyelids from the left eye. Don't forget to align the pivots and lock the axes, as was done with the right eye.

30. Save the scene.

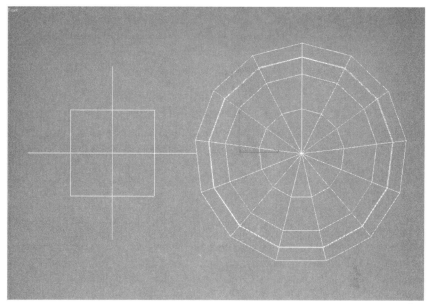

FIGURE 11.17 The Point helper is moved outside the eyelids for easier access.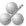

TUTORIAL ## FINISHING THE EYELIDS

You still have a little left to do to give the eyes some appeal and make them fit better in the eye sockets.

1. Continue with the previous scene or open *squirt_eyelids.max* from the companion CD-ROM.
2. To smooth out the eyelids, apply a MeshSmooth modifier to each of the eyelids. Set the iterations to 1. The eyelids should look like the ones shown in Figure 11.18.

When applying a modifier to similar objects that require the same modifier (such as the eyelids), try using an instanced modifier. By selecting all of the objects that need the modifier and then applying the modifier, it becomes an instanced modifier. You can then change the parameters for the modifier by editing any one of the objects.

The MeshSmooth modifier smooths the eyelids a bit, but you need to shape the eyes and the eyelids to fit the eye. For that, you'll use an FFD Space Warp. FFD

FIGURE 11.18 The new set of eyes after applying a MeshSmooth modifier to the eyelids and giving a small bit of rotation to the point helpers.

FIGURE 11.19 Create an FFD Box Space Warp around the eye to deform it to fit inside the eye socket.

is an acronym for Free Form Deformation. Using a FFD Space Warp, multiple objects can be deformed identically as they intersect the space of the FFD. The FFD Space Warps also don't interfere with the transforms applied to the objects.

3. In the Top view, open the Space Warps tab in the Create Panel, open the object class list, and choose Geometric/Deformable. In the Objects rollout, activate the FFD Box tool and create a box around the eye. The FFD Box (shown in Figure 11.19) is created using the same motion as a standard box object.
4. In the Modify Panel set all of the dimensions to 0.33, and position the FFD Space Warp centered on the eye, as shown in Figure 11.20.

FIGURE 11.20 Space Warp centered on the eye.

5. After creating a Space Warp, objects that you want to be affected by it must be bound to it. On the Main Toolbar is the Bind to Space Warp icon, next to the Link and Unlink buttons, as shown in Figure 11.21.

FIGURE 11.21 The Bind to Space Warp icon is used to link objects to a Space Warp.

6. Both the eyelids and the eyeball of each eye must be bound to the FFD Box Space Warp. Select the upper and lower eyelids of the left eye and the left eyeball, then click the Bind to Space Warp icon. Because multiple objects are selected, press the space bar to lock the selection, and drag the objects to the FFD Box. The objects are linked to the Space Warp. In the Modify Panel, each object has a Space Warp Binding entry, as shown in Figure 11.22.

The Space Warp Binding

FIGURE 11.22 After binding an object to a Space Warp, a Space Warp binding entry is found in the Modifier Stack.

The FFD Binding (WSM) entry in the Modifier Stack stands for Free Form Deformation Binding World Space Modifier. This entry indicates that the modifier, though object specific, works in World Space, which is constant. By using the FFD as an object-based modifier, you do not need to use an external binding, as is typical with Space Warps.

7. Now that the eye objects are bound to the FFD Box, modify the FFD's sub-object points to deform the eye, as shown in Figure 11.23.
8. Use the FFD Box as a modeling tool to shape the eye to fit into the socket, as shown in Figure 11.24.
9. Save the scene.

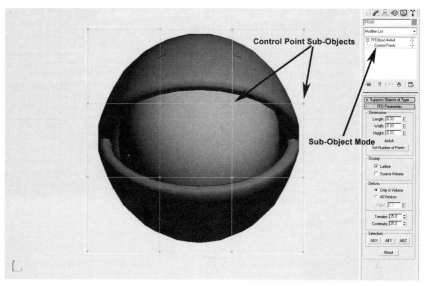

FIGURE 11.23 The FFD has sub-object points, which are manipulated to shape the FFD. The shape of objects that intersect the space of the FFD is influenced by the FFD's shape.

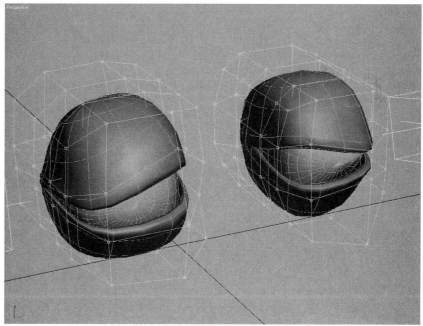

FIGURE 11.24 The eye components after shaping the FFD Box.

T U T O R I A L

CONTROLLING THE EYES WITH LOOKAT

An easy way to control the eyes is to give them something to look at. A controller called a LookAt Constraint is used to control which way an object is facing. By creating some controls for the eyeballs to look at, you can control where both eyes look simultaneously.

ON THE CD

1. Open *squirt_eye_look.max* from the companion CD-ROM.
2. In the Top view, create two point helpers and center them in front of each eyeball, as shown in Figure 11.25.

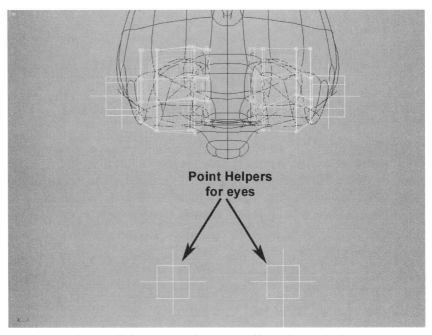

FIGURE 11.25 The point helpers are used to control where the eyes look.

3. Select the right eyeball object and open the Motion Panel. Open the Assign Controller rollout, select the Rotation: Euler XYZ entry in the controller list, and click the Assign Controller button, as shown in Figure 11.26.
4. In the Assign Controller dialog box (shown in Figure 11.27) select the LookAt constraint and click OK.
5. In the Motion Panel, notice that the Rotation has been assigned a LookAt controller. Now a target needs to be established, so click in the Add LookAt Target button, then click the point helper in front of that eyeball. The point helper is added to the list of targets, as shown in Figure 11.28.

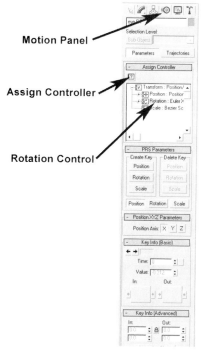

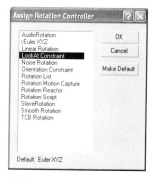

FIGURE 11.27 Choose the LookAt Constraint to provide a target at which an object can look.

FIGURE 11.26 The Assign Controller button is used to change how a transform or transform axis is controlled.

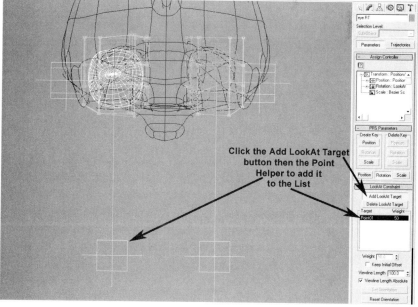

FIGURE 11.28 Use the Add LookAt Target to add a target to the list.

6. After assigning the LookAt controller and a target, the object may flip or rotate as it tries to point to the target, based on the LookAt axis. Adjust the LookAt axis by selecting the z-axis, as shown in Figure 11.29. This forces the object's z-axis to always point toward the target object.

7. Repeat the procedure with the other eye.

8. Save the scene.

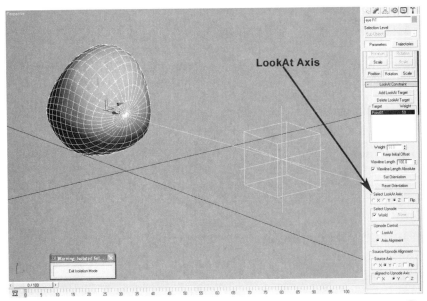

FIGURE 11.29 Adjust the orientation of an object by selecting the LookAt axis.

T U T O R I A L ## RIGGING THE BODY

After working through the previous tutorial of rigging the eyes, you can appreciate the difficulty in rigging more complex structures. In this section, you rig the body of the fish using geometry. Although you can use bones, the low poly geometry that you use for this tutorial functions like bones, except they provide greater feedback when animating because they represent the shape of the fish more closely.

There is nothing magical about using bones in rigging a character. Many animators prefer to use low poly geometry, instead of bones, for a more realistic representation of the model they are animating. The same Inverse Kinematics (IK) and Forward Kinematics (FK) tools used for bones can be applied to geometry.

1. Open *fish_rig_start.max* from the companion CD-ROM. This scene has the fish character used in previous exercises.
2. Open the Left view, and using the box modeling method, create a low poly version of the fish. Don't model any detail—simply model the rough outline shape on all dimensions, as shown in Figure 11.30. Create only one side, and use the Symmetry modifier to create the opposite side.

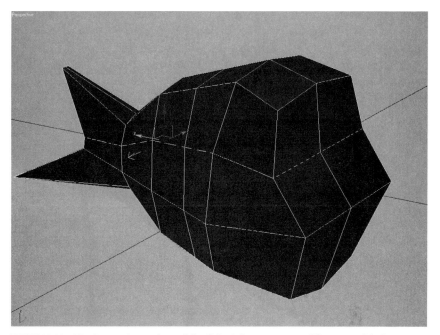

FIGURE 11.30 The low poly version of the fish. A Symmetry modifier was added to create the opposite half.

3. If you want to skip the low poly modeling portion of this tutorial, merge in the low poly fish object from *fish_low_poly.max*, found on the companion CD-ROM.
4. Hide everything except the low poly fish. Create a clone of the low poly fish and name it *fish head*. This object is the fish head bone.
5. Edit the vertices of the fish head by removing all vertices behind the fin area, as shown in Figure 11.31.
6. Continue creating clones and removing vertices of the clones until you have three tail sections and the head bone. Ultimately, you should have something similar to that shown in Figure 11.32.

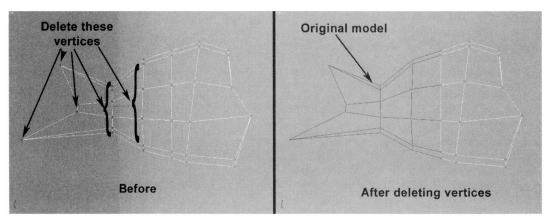

FIGURE 11.31 The fish head bone is created from a low poly version of the fish.

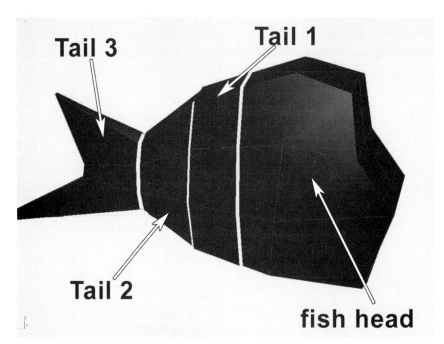

FIGURE 11.32 Create the bones for the fish from a low poly version of the model. After creating the low poly bones for the fish, be sure to check the pivot points. All of the pivot points must be aligned to the World Coordinate System and positioned at the correct point on the bone.

7. In the Left view, select the fish head and open the Hierarchy panel. Activate Affect Pivot Only and press the Align to World button. This aligns the pivot point with the z-axis pointing upward. Next, use the Align tool (with

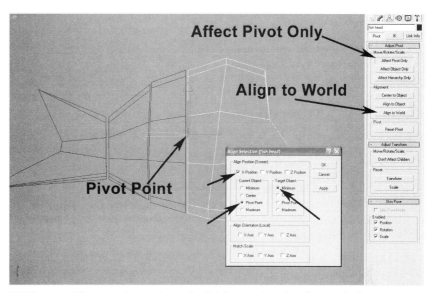

FIGURE 11.33 Align the pivot point to the fish head using the Align tool. Also be sure to align the pivot to the world, using the Align to World button.

Affect Pivot Only still active) to align the pivot point to the minimum x-axis of the fish head (itself), as shown in Figure 11.33.

8. Repeat this procedure with each of the tail bones, but align the pivot point to the maximum x-value (in the Left view).

9. Save the scene.

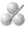

TUTORIAL

CREATING A HIERARCHY

After creating a bone structure, you must create a hierarchy. The hierarchy defines each member of the hierarchy that is affected by other members. Each member of the hierarchy has a parent, except for the root member, which is the ancestor of all other members in that hierarchy. The image in Figure 11.34 depicts the hierarchy of the fish that you will create in the following steps.

ON THE CD

1. Open *fish_rig_link.max* from the companion CD-ROM or continue from the previous exercise.

2. In the Top view, create a point helper and position it so that it is centered on the fish head. Set the size of the point helper to 1.5.

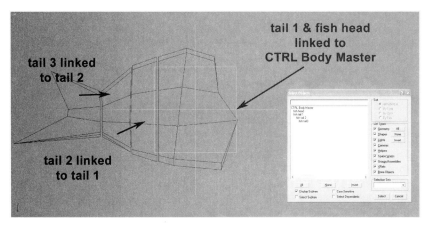

tail 3 linked
to tail 2

tail 1 & fish head
linked to
CTRL Body Master

tail 2 linked
to tail 1

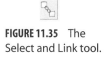

FIGURE 11.35 The
Select and Link tool.

FIGURE 11.34 The hierarchy of the fish bone structure.

3. Using the Select and Link tool (shown in Figure 11.35), click and drag from the *fish tail 3* object to *fish tail 2*. This action links *fish tail 3* to *fish tail 2*, where *fish tail 3* is the child of *fish tail 2*, as shown in Figure 11.36.

FIGURE 11.36 The *fish tail 3* object is a child of *fish tail 2*.

4. Continue linking the rest of the objects in the following order:

 • link *fish tail 2* to *fish tail 1*
 • link *fish tail 1* and *fish head* to *CTRL Body Master*.

5. Unhide the other controls using Unhide by Name from the Quad menu. All of the controls have the prefix *CTRL* in their name. The list is shown in Figure 11.37.

6. Using the Select and link tool, link both of the eye LookAt controls to *CTRL eye main*.

7. Link *CTRL eye main* and both eyelid rotator controls to *CTRL Body Master*. Your hierarchy is complete and should look like the structure shown in Figure 11.38.

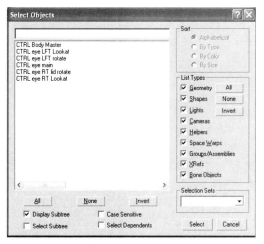

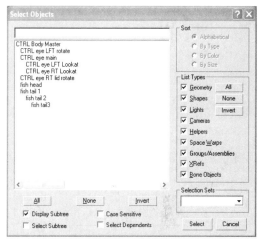

FIGURE 11.37 The list of control objects. Unhide all of these.

FIGURE 11.38 The completed hierarchy of the fish, including the eyes and eyelids.

8. Save the file.

CREATING A WORKING TAIL

Now that a hierarchy has been set up, create a working tail by wiring the rotation of each of the tail components. In this tutorial, the wired parameters require a simple expression to influence each component of the tail hierarchy.

1. Open *fish_tail.max* from the companion CD-ROM or continue from the previous exercise.

2. Select *fish tail 2*, right-click, and choose Wire Parameters from the Quad menu. Choose the x-axis rotation from the Transform menu, and wire *fish*

tail 2 to the *fish tail 3* x-axis rotation. The Wire Parameters dialog box appears. Set the control direction from *fish tail 3* to *fish tail 2*. Change the expression on the *fish tail 2* side (the *fish tail 3* expression is grayed out) to *X_Rotation *0.5*, as shown in Figure 11.39. Press the Connect button to wire the parameters.

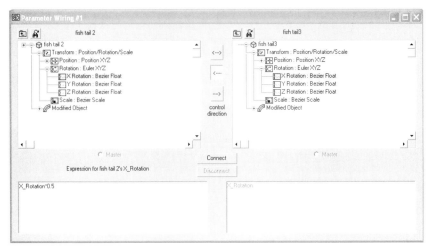

FIGURE 11.39 The Wire Parameters dialog box with the modified expression.

3. The expression on the *fish tail 2* side makes the end of the tail control the rest of the tail but at a lesser degree. In the Wire Parameters dialog box, click the y-rotation for both objects and set the direction to be from *fish tail 3* to *fish tail 2*. Multiply the expression by 0.5, as you did with the x-rotation. Press the Connect button.

4. Repeat the wiring procedure for the z-rotation and press the Connect button. When completed, each of the rotation parameters on the left side (*fish tail 2*) are shown in red (slave parameter) and the parameters on the right (*fish tail 3*) are shown in green (controlling parameter). Close the Wire Parameters dialog box.

5. Select *fish tail 1* and wire its x-rotation to *fish tail 3*, the same way you wired *fish tail 2*. Set the expression to be the rotation multiplied by 0.25. Repeat for the y- and z-axes.

6. After wiring the parameters, click and rotate *fish tail 3* in the Top view along the z-axis. As you can see, the entire tail moves with a nice bend, as shown in Figure 11.40.

7. Save the scene.

FIGURE 11.40 After wiring the tail, rotating just the end makes the entire tail bend.

TUTORIAL

SKINNING A FISH

Using a low poly skeletal structure is great, but without attaching it to a model, it doesn't always make for great animation. The process of attaching a rig to a model is known as *skinning*. Skinning is achieved by applying a Skin modifier to the detailed mesh. The Skin modifier provides controls for attaching bones (or geometry), which, in turn, create envelopes of influence. The envelopes are used to control the detailed mesh.

Before skinning any model, be sure that the model is in a neutral pose. If not, you may have difficulty skinning accurately. A neutral pose is one in which the character is not in an action pose.

The following tutorial teaches you how to skin a fish.

ON THE CD

1. Load *fish_skin.max* from the companion CD-ROM. Additional bones were added to the fins from the previous exercise.

2. Select the detailed fish model *squirt*. As you can see, the model has NURMS Subdivision turned on. Although this option is great for rendering, it's more difficult to skin or animate a model with it active. In the Modify Panel, go to the Subdivision Surface rollout of the Editable Poly and turn off Use NURMS Subdivision. The model will be smoothed later with a MeshSmooth modifier.

 Use the MeshSmooth modifier after applying the Skin modifier to make skinning easier. It is much easier to skin a couple hundred vertices than several thousand.

3. With *squirt* still selected, apply a Skin modifier.
4. In the Parameters section of the Skin modifier, click the Add button so that bones may be added to the model. An Add Bones dialog box opens, from which you can choose bone objects, as shown in Figure 11.41.
5. Select *fish tail 1*, *fish tail 2*, and *fish tail 3* from the list and click OK. The three tail bones are added to the bones list in the Skin modifier. Select *fish tail 1* from the list and click the Edit Envelopes button, as shown in Figure 11.42.

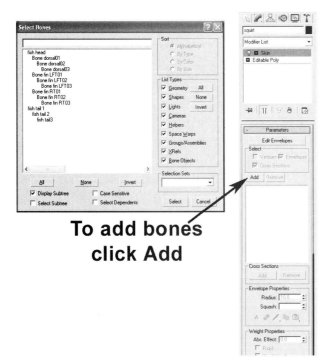

FIGURE 11.41 Click the Add button to add bones to the Skin modifier.

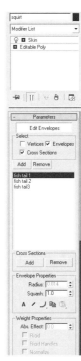

FIGURE 11.42 After adding a bone to the list, the Edit Envelopes button is used to edit how the bone affects the associated

 Envelopes are used to control the geometry of the mesh with the Skin modifier applied. Each bone has a single envelope to control. By adjusting the envelopes, you can control how the mesh reacts at places like joints and muscles.

6. After pressing the Edit Envelopes button, an envelope appears that defines the volume of influence the bone has on the mesh. The envelope for *fish tail 1* is shown in Figure 11.43.

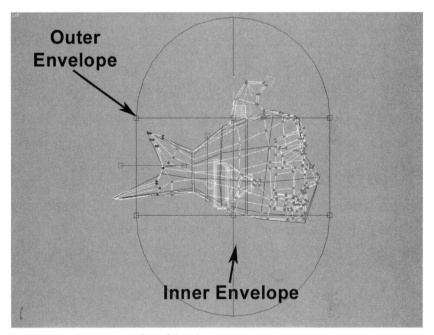

FIGURE 11.43 The envelope from *fish tail 1*.

 The vertices of the mesh are color coded based on their influence. Red vertices have the strongest influence, then orange, yellow, and blue. Viewing the model in shaded view reveals an image of how the bones influence the associated mesh.

7. The default size of the envelope is too large for this model, so you must resize it. Select a node on the inner envelope, then use the Radius parameter in the Envelope Properties dialog box to change the inner envelope size to 0.235 and the outer envelope size to 0.32, as shown in Figure 11.44.
8. Edit the envelope of *fish tail 2* by selecting it from the envelope list. Set its inner and outer radius to 0.186 and 0.3, respectively. Your actual numbers may vary if you're using your own model, but for a start, use these numbers.

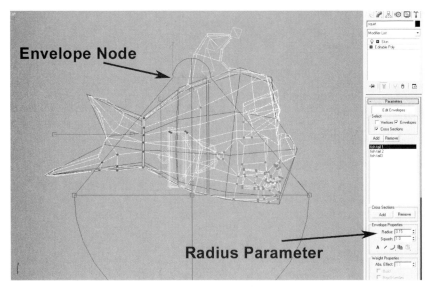

FIGURE 11.44 Use the Radius parameter in the Envelope Properties dialog box to change the size of the envelopes.

9. Select *fish tail 3* from the list and reduce its radius values down to 0.173 and 0.265 for the end of the envelope closest to the body and 0.173 and 0.364 for the end of the envelope near the tip of the tail. Be sure that all of the vertices at the tip of the tail are enclosed, as shown in Figure 11.45.

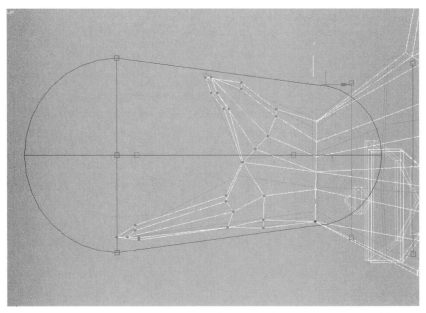

FIGURE 11.45 Enclose the vertices at the tip of the tail to be sure they are part of the control.

10. Unhide *CTRL Body Master* and drag it away from the mesh to see how the skin is holding up. As you can see from Figure 11.46, some of the mesh isn't attached. Undo any transforms you performed to test the mesh.

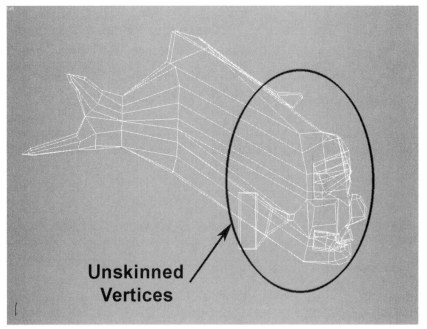

Unskinned Vertices

FIGURE 11.46 The mesh isn't completely skinned, so some polygons get stretched when the rest move.

11. Select the detailed fish mesh, and in the Skin modifier, click the Add button and select *fish head* from the list of objects to add to the list of envelopes. Turn on Edit Envelopes and click the *fish head* envelope. As shown in Figure 11.47, the envelope is too large and encompasses most of the body.

12. Resize the envelope to encompass just the head portion (radius values between 0.325 and 0.6). Switch the view to Shaded mode, then select an envelope to see its effect on shaded surfaces. In Figure 11.48, the head envelope and its influence on the mesh can easily be seen.

13. For the final part of the rigging, add the fin bones. Leave the envelope settings at their default, and test your mesh by moving the Body Master control. If the entire mesh moves with the control, you've managed to encompass all vertices within the envelopes of the associated bones. If not, make some adjustments.

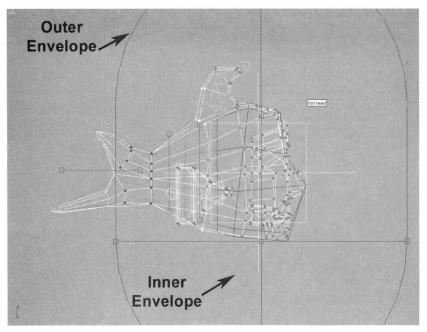

FIGURE 11.47 The original envelope on the head must be smaller, because it encompasses the entire model.

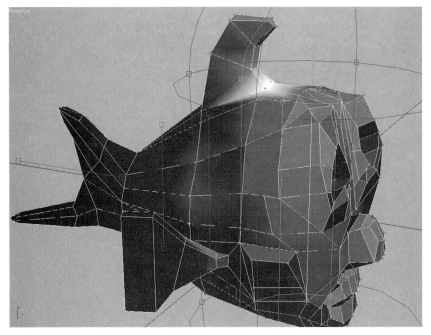

FIGURE 11.48 The effect of the head envelope on the mesh in a shaded view.

Setting some basic key frames and scrubbing the Time Slider let you determine how well the Skin envelopes are working.

14. Save the scene.

Skinning can be an intricate process. This exercise just touches on the basic capabilities of the Skin modifier. You may find that you'll have to adjust some of the envelopes because of their interaction. The Skin modifier is capable of controlling how vertices react around limbs and joints, including muscle bulging.

TUTORIAL **ANIMATING THE RIG**

Now that your character is rigged, you can animate the low poly rig. By animating a low poly skeletal structure, you have better interactive feedback in the viewports and less structure to get in the way of setting a pose. In the following tutorial, you animate the fish with the rig created in the previous exercise.

ON THE CD

1. Open *fish_anim_start.max* from the companion CD-ROM. This scene has lights and cameras already set up. The fish and controls have already been merged into this scene, as well.

To keep the clutter easier to control, objects were separated into layers. The Layer Manager, shown in Figure 11.49, separates objects onto layers. Each layer has attributes (such as Hide, Freeze, Renderable) that can control the entire layer or individual objects within a layer.

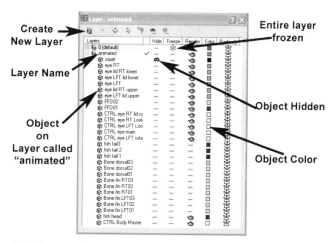

FIGURE 11.49 The Layer Manager is used to organize objects.

2. Start by hiding the layer with the background objects. Click the Layer Manager icon on the Main Toolbar (shown in Figure 11.50) to open the Layer Manager. In the Layer Manager, click on the dashed line under the Hide category for the layer named *0(default)* to hide the entire layer.

FIGURE 11.50 The Layer Manager icon.

3. Activate the Left view, and in the Select by Name dialog box, select all of the objects with the prefix *CTRL* and press OK. There are six total control objects. With these objects selected, type *ctrl fish* in the Selection Set list on the Main Toolbar as shown in Figure 11.51.

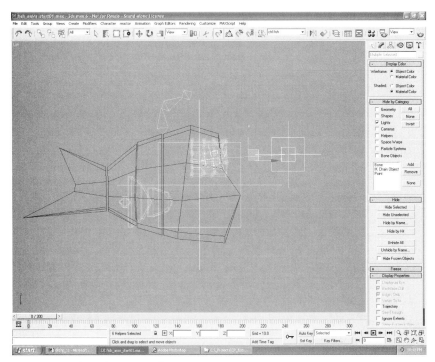

FIGURE 11.51 The Selection Set list.

By creating the Selection Set of the fish controls, you can quickly create key frames for all control objects using the Set Key mode. In the Set Key selection list, all object Selection Sets are listed. By highlighting a Selection Set in that list, key frames are created for every member of the Selection Set when you press the Set Key icon.

4. Reduce the amount of clutter in the scene by selecting and hiding unnecessary controls. Select the three fish tail objects, the fish head, and the Body Master, then choose Hide Unselected from the Quad menu. This action reduces the clutter for controlling the animation.

5. Open the Layer Manager and unhide layer 0 by clicking the sunglasses icon for that layer. Notice that the default layer has been frozen (snowflake icon). Items on that layer can't be selected. Close the Layer Manager.

6. Select CTRL Body Master in the Top view. Press the spacebar to lock this selection, then move CTRL Body Master so that it is in front of the nasal cavity of the skull, as shown in Figure 11.52. You'll need to check the position in the Left view, as well.

FIGURE 11.52 Because the master control of the character rig has all other controls linked to it, positioning it positions everything, including the detailed mesh.

7. Change the Move coordinate system to Local and move the Body Master along the y-axis so that it is farther from the fish. Set the lower-left viewport to Cam Close Animated by pressing the C key and choosing the camera by name. Position the body master control until the fish is just out of frame, as shown in Figure 11.53.

You can quickly change coordinate systems by using ALT + right-click to open the animation Quad menu.

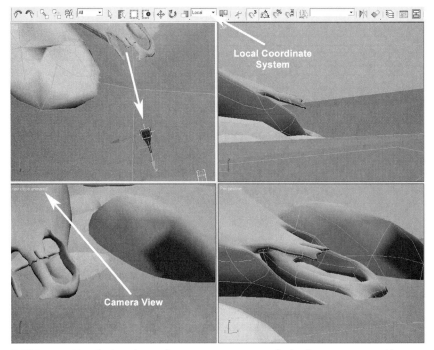

FIGURE 11.53 Use the Local coordinate system to move the body master control in a straight line along the y-axis.

8. Turn on Set Key mode (found at the base of the interface) and choose ctrl fish from the selection menu. Press the Key Filters button and check Position and Rotation as the filter choices (then close the filter dialog box). Figure 11.54 illustrates these tools.

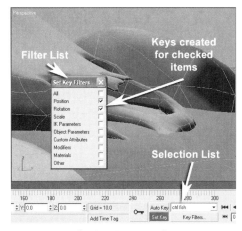

FIGURE 11.54 The Set Key controls.

9. With Set Key mode on, click the large key icon to set a key frame. Because the time slider is at frame 0, a key frame is created at frame 0, setting the initial position of the fish.

10. Drag the Time Slider to frame 105. Move CTRL Body Master along its local y-axis so that it enters the nasal cavity. Use the Arc Rotate tool in the Perspective view to check for and avoid geometry intersection. The position should be similar to that shown in Figure 11.55. Press the Set Key icon to create another key.

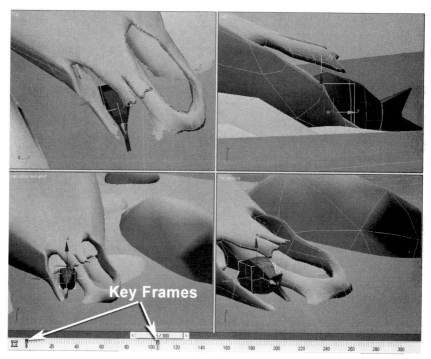

FIGURE 11.55 Position the fish inside the nasal cavity by moving the master body control.

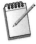

An important point to note is that key frames are created for all of the objects in the Selection Set, not just the CTRL Body Master object. By creating keys for all of the control objects, there is less chance of "drifting" limbs because of missing key frames locking down a position.

11. Set the Time Slider to frame 130 and move the body master away from the skull. Use the Set Key icon to create a key, then repeat the in-and-out motion a couple of times, every 15 to 20 frames. Be sure to use the Set Key icon to create a key before you move the Time Slider or the motion will be lost.

When in Set Key mode, be sure to press the Set Key icon prior to moving the Time Slider, if you want to create a key frame. Moving the Time Slider before setting the key frame results in the loss of the transformation. This process also comes in handy when you've moved lots of controls and haven't pressed Set Key yet. By moving the Time Slider before pressing the Set Key icon, you can undo all of the motion at that frame.

12. After animating the fish trying to get into the nasal cavity, move the time slider to frame 245. Position the body master so the fish is just outside the eye socket, as shown in Figure 11.56. Don't worry about rotation. Set the main position first. Be sure to position along all axes, if necessary.

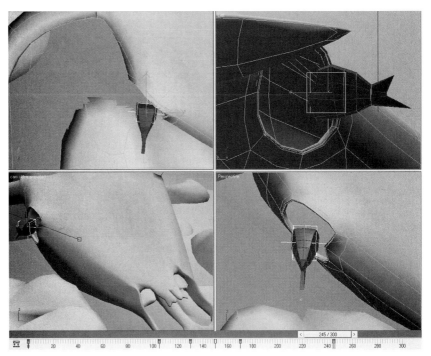

FIGURE 11.56 Position the fish outside the eye socket using the body master control.

13. Go back to the last key frame before frame 245. In the animation shown, the fish backs out for the last time at frame 170. At that key frame, set the rotation of the body master so the fish begins to head in the right direction but isn't aiming straight for the eye. Create a key with the Set Key icon.
14. Move the Time Slider to frame 200 and complete the rotation of CTRL Body Master so the fish is swimming alongside the skull. Set a key frame.

15. Move the Time Slider to frame 245 and adjust the rotation slightly on CTRL Body Master so the fish rotates smoothly between the key frames. Press the Set Key icon to create a key frame.
16. Move the Time Slider 10 frames to frame 255. This is the frame in which the fish darts quickly inside the eye socket, so the time span is shorter. Set the position of the fish so it is inside the skull, completely out of view. Press Set Key and review your animation.

ON THE CD

17. Save the scene. The companion CD-ROM contains the animation up to this point in the file *fish_anim_done.max*.

When you're ready to render the scene, simply unhide the detail mesh and hide the low poly controls. You can also flag the low poly controls to not render through their property settings or in the Layer Manager.

SUMMARY

Animation can be a tedious affair—not for the fainthearted. Take your time and study the motion before key framing anything. Setting up the proper rigging and having storyboards to define the action are a major plus when animating a character.

In this chapter you learned how to:

- Create a skeletal hierarchy for controlling a mesh
- Skin a mesh and edit envelopes
- Use Set Key mode to create key frames

This shot has a long way to go before being complete. The head and tail need to be animated to go along with the position of the fish. Continue working with the previous exercise, adding as much emotion to the character as you can. Try animating the fish in different moods. The fish could be hyper and dart all over the skull. It could be lazy and try once to get in through the nasal cavity and stop there, resting half inside. You have lots of possibilities, so experiment working with a rig that you're comfortable with before moving to something more complex. Most of all, have fun!

12

MATERIAL BASICS

In this chapter

- Basic Material Parameters
- Adding and Applying Maps
- Shader Types

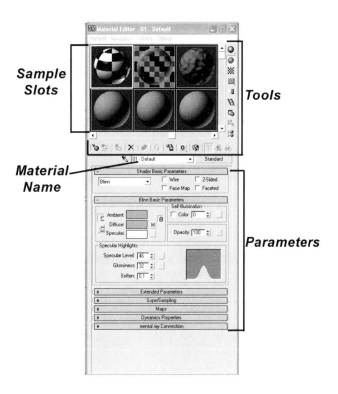

Sample Slots

Tools

Material Name

Parameters

Materials are used to give the surface of 3D geometry different attributes, such as color, reflectivity, and transparency. In most cases, it is the material that makes the model complete. A mediocre model can look stunning if the proper materials and lighting are applied. 3ds max offers many types of material, enabling you to build complex materials to satisfy every need for a surface description. In this chapter you learn the basics of creating and applying materials to objects created in previous tutorials, as well as objects supplied on the companion CD-ROM.

Project Assessment: Create different material types to apply to a variety of models.

THE MATERIAL EDITOR—THE KEY TO CREATION

The Material Editor is the epicenter of material creation. Attributes and material characteristics are adjusted and combined through the Material Editor to create every conceivable surface characteristic. Materials are then applied to an object to give that object the appearance of a certain substance, such as concrete, water, sand, alligator skin, or whatever.

Material Editor Overview

The Material Editor is a complex structure. It's not difficult to understand, but it offers many features and so much can be done with it, artists who are new to it may find it somewhat daunting. In this chapter, you learn the basics, one step at a time. You open the Material Editor by pressing the M key or by clicking the Material Editor icon (shown in Figure 12.1), found on the Main Toolbar.

The Material Editor (shown in Figure 12.2) consists of three major sections: the Sample Slots, the Material Editor tool bar, and the Parameters section.

FIGURE 12.1 The Material Editor icon.

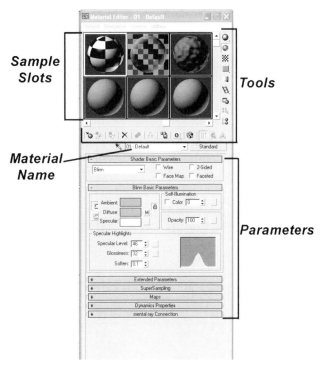

FIGURE 12.2 The Material Editor consists of three sections: Sample Slots, Tool Bar, and Parameters.

Sample Slots: Renders a preview of the materials. Each material has its own sample slot.

Tool Bar: Contains tools for applying, saving, or loading materials.

Parameters: Contains dynamic attributes associated with the selected material.

 The Material Editor can hold only 24 materials at any one time. Therefore, although a scene can have an unlimited number of materials, only 24 materials can be edited at one time. When all the Sample Slots are filled, simply replace the slot with another material for editing. Materials do not have to be loaded in the Material Editor once they are applied to an object.

 You can change the number of Sample Slots visible by right-clicking in a Sample Slot and choosing a configuration of either 3x2, 5x3, or 6x4. When all 24 materials are not visible (3x2 and 5x3), click and drag a Sample Slot border to pan the view of the materials.

TUTORIAL ## SELECTING A SHADER

In a previous chapter, you built an elastic-propelled atmospheric transporter—a rubber-band-powered plane. In this tutorial, you create a simple material to apply to a banner that will be pulled behind the plane. You learn the basics of material creation and what some of the parameters are used for. Other tools and parameters are discussed in later tutorials.

When creating a material, the first decision to make is to select a Shader. A Shader is an algorithm that defines how light affects the material. Blinn is the default shader and is the best choice when your understanding of shaders is minimal. Eight shaders ship with the 3ds max 6 default scan line renderer. Other shaders are used with the Mental Ray renderer and are discussed later. A list of the default shaders and what they are used for follows:

Anisotropic: Creates elongated highlights, such as those found in hair.
Blinn: Creates soft highlights. This all-purpose shader can be used in most materials.
Metal: Creating metal highlights.
Multi-Layer: Creates complex highlights in multiple directions.
Oren-Nayar-Blinn: Creates highlights on matte surfaces, such as cloth.
Phong: Creates soft hightlights, similar to the Blinn shader, but more pronounced, which tends to make materials look more like plastic.
Strauss: Creates highlights that are good on metal.
Translucent: Creates soft highlights, similar to the Blinn shader, but with additional parameters enabling light to be scattered as it passes through the material.

The following exercise walks you through creating a simple material.

ON THE CD

1. Open *banner.max* from the companion CD-ROM. This file contains a single box object named *banner*.
2. Open the Material Editor by pressing the M key or by clicking the Material Editor icon.
3. Use the default Blinn shader as the shader choice. Click in the Diffuse Color swatch. The default color selector opens, as shown in Figure 12.3.

Diffuse Color is the primary color of the material. This swatch shows how the material looks under "normal" daylight or in a bright room. The Ambient Color is how the material looks in low light or in shadows. By default, the Ambient Color is locked to the Diffuse Color, and the rendering engine calculates the ambient color properly.

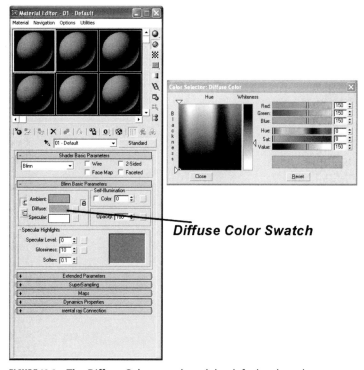

FIGURE 12.3 The Diffuse Color swatch and the default color selector.

4. In the Color Selector, click in the upper-left corner of the color palette to choose a red, then drag up on the Whiteness slider to increase the saturation of red, as shown in Figure 12.4. Notice how the sphere in the sample slot changes color to reflect the color change of this material. Close the Color Selector.

5. Now that a color has been assigned to the material, click and drag the sample slot from the Material Editor onto the box object. The material is applied to the box and the box changes color to match that of the material applied.

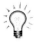

Apply a material to an individual object using the drag-and-drop method or use the Assign Material to Selection button when applying the same material to several selected objects. When using the drag-and-Drop method, if several objects are selected, you are prompted to apply the material to all objects selected or just the object on which the material was dropped.

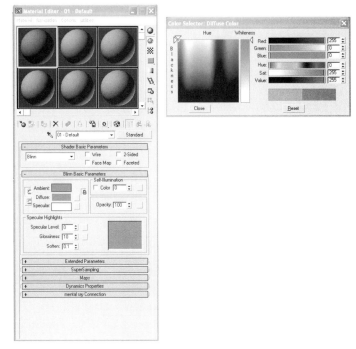

FIGURE 12.4 Using the Color Selector to choose a Diffuse Color.

Specular Controls

Specular controls are used to control how highlights (shown in Figure 12.5) appear on the surface of a material. By controlling the specular light, a surface can be made to look very shiny and glossy or dull and matte. The Specular controls work by changing the spread of the reflected light from a surface.

The specular controls for the Blinn shader follow:

Specular Color Swatch: Sets the color of the highlight. Can be used to simulate colored light or the glow of another object.

Specular Level: Sets the intensity of the highlight. Values over 100 tend to be very hot and make the highlight the same as the Specular Color swatch.

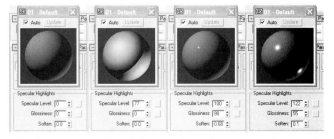

FIGURE 12.5 Four examples of different Specular and Glossiness settings.

Glossiness: Simulates how shiny a surface is by diminishing the size and spread of the highlight. Very slick surfaces such as glass have a very tight highlight, whereas metals and rough plastics tend to spread the highlight more.

Soften: Softens the highlight, diminishing its strength along its edges.

6. Continuing with the material already created, set the Specular Level to 31 and the Glossiness value to 18. These values give the material a medium sheen with a light gloss.

Maps

Whereas adding color to a material is a great start, the real power behind a material is in its maps. A map (with regard to materials) is an image that can be applied to a material. Images that are used as maps can be bitmaps, .avi files, QuickTime® movies, image sequences, compositing systems, and procedural maps (mathematical algorithms that produce patterns of color).

7. Continue with the previous material and click the Map button next to the Diffuse Color swatch, as shown in Figure 12.6, to choose a map to be applied to the Diffuse Color.

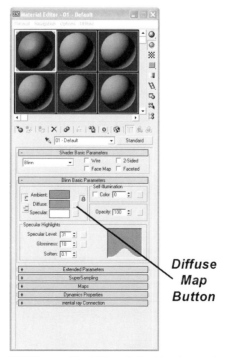

Diffuse
Map
Button

FIGURE 12.6 The Diffuse Color Map button is used to apply a map to the Diffuse Color attribute.

8. After clicking the Diffuse Color Map button, the Material/Map Browser (shown in Figure 12.7) opens. From here, you have several options for choosing a map type. For this exercise, choose the Bitmap type by double-clicking it or selecting it and pressing OK at the bottom of the Material/Map Browser.

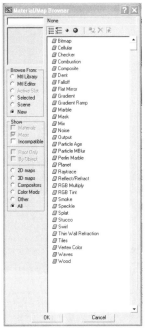

FIGURE 12.7 The Material/
Map Browser.

ON THE CD

9. After choosing the bitmap type from the Material/Map Browser, a Select Bitmap dialog box opens, as shown in Figure 12.8. Use the standard Windows navigation tools to select an image file to apply as a map. Navigate to the companion CD-ROM and choose *duck_banner.bmp* from the *Chapter 12* images folder. Click the Open button when the desired bitmap is found.

10. After selecting an image file, the image becomes part of the material and the mapping options are displayed, as shown in Figure 12.9.

11. To see the image on the geometry in the modeling view, click the Show Map in Viewport button in the Material Editor (shown in Figure 12.10). The bitmap is visible in any view that has shading turned on.

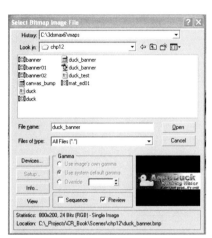

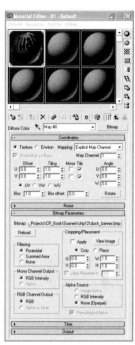

FIGURE 12.8 The Select Bitmap dialog box is used to choose a bitmap file from a connected or networked drive.

FIGURE 12.9 The Bitmap mapping options are a subset of the entire material.

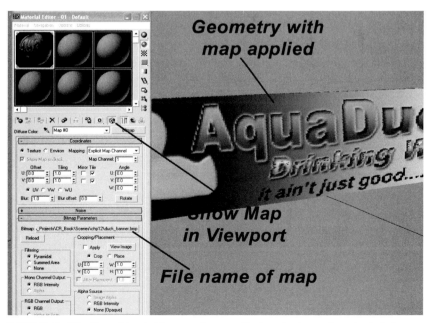

FIGURE 12.10 The Show Map in Viewport button displays the image in a shaded view. This action makes positioning of the map much easier.

Although the Show Map in Viewport option is great for viewing how a map is applied, this option uses video memory. As such, it isn't a great idea to leave the Show Map in Viewport option on for every material that uses a map, because doing so slows down the screen redraws when modeling.

12. Activate the Perspective view and press the F9 key to render the Perspective view and the material applied to the box.

When a map is applied to a material attribute, the map replaces any color that was associated with that attribute. In this case, the Diffuse color has been replaced by the bitmap image. Using Blend controls, however, you can mix multiple colors and maps to create complex materials.

13. Save your work.

Notice how the bitmap overrides the Diffuse color. The bitmap is now part of the entire material yet has its own set of parameters used for positioning the bitmap onto geometry. The process of positioning a bitmap or algorithmic pattern onto geometry is called *mapping*.

MAPPING

For a 3D program to understand how an image is to be applied to geometry, it must be told how to map the image. Though it's seldom done manually at the pixel level, mapping is the process of determining where each pixel is positioned on geometry. Figure 12.11 illustrates an example of how geometry can be broken down to position an image file on complex geometry. Before getting to that extreme, you have simpler options for simpler geometry.

Mapping can become a tedious process, and more complex mapping exercises come later. For now, review Figure 12.12, which corresponds to the following bullet points, regarding the Coordinates parameters found in every map type:

Map Name Field: Names the map. Numeric names are generated automatically, but you can create more meaningful names.

Map Type: Changes the type of map used, such as Bitmap, Checker, Noise, and so on.

Mapping Type: Selects the type of map to be applied. Mapping can be applied relative to the object (using the Texture option) or relative to the entire scene (using the Environ option). The map appears

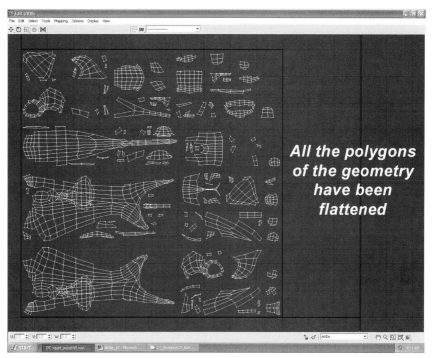

FIGURE 12.11 Tools like the Unwrap UVW modifier are used to position image maps on complex geometry.

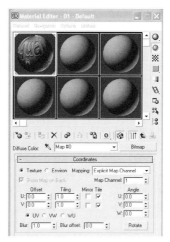

FIGURE 12.12 The Coordinates parameters are common to all maps.

differently for each setting, and there are different mapping options for each.

Map Channel: Applies multiple maps to an object. Each map can be applied differently using the Map Channel parameter to distinguish between materials.

Offset: Uses the U and V parameters to change the position on the object's surface. When talking about mapping, the x-, y-, and z-axes are referred to as U, V, and W, respectively. By changing the offset value, you can move the map across a surface.

Tiling: Specifies how the map covers the surface. One tile means the map covers the entire surface. By increasing the tile value, you reduce the map size and repeat its occurrence across the surface along the U, V, or W axis.

Angle: Rotates the bitmap on a surface. The Rotate button opens a freeform rotation dialog box.

Blur and Blur Offset: Makes the image less clear on the surface. The Blur value increasingly blurs the pixels of the map as they get farther from the camera (to avoid pixelization), and the Blur Offset option blurs the pixels of the map regardless of its distance from the camera.

Mapping Problems and Solutions

To make mapping easier, you have several types of default mapping options. These built-in options enable you to apply a material with maps to different types of geometry. In Figure 12.13, the same material has been applied to all of the objects, yet it maps differently for each one.

Because the default mapping isn't always ideal, 3ds max uses modifiers to control complex mapping. Mapping comes in a variety of choices, including the UNWrap UVW, which lets the artist decide how each polygon is mapped explicitly. Descriptions of the common mapping choices follow:

Planar: The map is placed on a flat plane and projected onto the surface. This mapping choice causes distortion around curved surfaces as the map is stretched across the surface.

Cylindrical: A cylinder gizmo is placed around the object and the map is projected onto the cylinder. The Cap option creates a planar map on the cap of the cylinder and projects the image onto the cap separately from the cylinder, alleviating a warped image. A seam from the map edges is visible at the back of the object unless a tileable map is used.

FIGURE 12.13 Because each object has a different shape, 3ds max attempts to map the material correctly for each object. Notice that in some cases (such as the fish), the default mapping isn't ideal.

Spherical: Similar to the Cylinder mapping option except the gizmo is shaped like a sphere. The map is gathered at the poles and has a single seam at the back of the object.

Shrink Wrap: This mapping option is spherical in shape, yet the map is gathered at a single point to prevent a seam, associated with other mapping choices.The map is stretched closer to the fused point.

Box: The gizmo is shaped like a box, projecting the image separately to each of the six sides of the box shaped gizmo.

Face: The image is mapped entirely on each polygon of the object.

XYS to UVW: The map is applied using the xyz coordinates of the geometry and moves with the geometry if its vertices are animated. Use this option when the topology of an object changes and the map is intended to move with the geometry. It is also useful to stick procedural maps to an animated surface.

With all mapping choices, except Face and XYZ to UVW, you can position, rotate, and scale the gizmo to affect the way a material is mapped to that object.

The images shown in Figure 12.14 through Figure 12.18 illustrate how different models react to the same mapping type.

FIGURE 12.14 Planar mapping applied to all objects.

FIGURE 12.15 Cylindrical mapping applied to all objects.

FIGURE 12.16 Spherical mapping applied to all objects.

FIGURE 12.17 Box mapping applied to all objects.

FIGURE 12.18 Face mapping applied to all objects.

Bump Maps and Other Material Attributes

Mapping is used not only in applying a Diffuse Color map but also in many other attributes as well. In fact, 12 attributes in a Blinn shader can utilize maps, and maps can use other maps. Therefore, you have infinite possibilities, limited only by the computing power of your system.

Of the 12 attributes found in the Blinn shader, most are common to all shaders. You've already learned about Ambient and Diffuse Color as well as the Specular Highlights parameters. Additionally there are Opacity, Bump, Reflection, Refraction, and Displacement attributes. The following list describes what each attribute controls:

Self-Illumination: Simulates the material giving off light. Though no light is actually given off, self-illumination works by toning down the shadow attribute of a material.

Opacity: The opposite of transparency. Surfaces that are 100 percent opaque are solid, such as steel and wood. Surfaces that are 0 percent opaque are transparent or clear, such as water and glass.

Bump: Gives the surface the illusion of texture. Add a bump map to a material to make the object's surface look rough. Bump maps do not change an object's geometry; it's merely a rendering trick.

Reflection: Simulate a reflection on a surface.

Refraction: Controls how light is bent as it passes through a material. All clear substances have an Index of Refraction, or IOR. Using the correct IOR is essential for a glass material to look like glass and not plastic or water. Maps may also be used to fake refraction.

Displacement: Unlike the bump map, a displacement map actually changes the topology of geometry. Use displacement maps to create changes in geometry, such as a ripple on a lake or a dent in a surface.

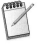

When using a map for attributes other than Diffuse, Reflection, or Refraction, the attribute is affected by the luminance values. As such, gray scale images typically work much better than color images. More important, areas of lighter color (or white) affect the attribute more, whereas colors closer to black affect it less. For example, in an opacity map, the white areas are opaque and the black areas are transparent. Gray colors become semi-transparent.

General Map Options

When using maps in a material, the maps are listed in the Maps rollout of the material, along with options for setting how much control the map has on the attribute. Figure 12.19 illustrates an example of several maps being

used, along with the Material Editor, Material/Map Navigator, and the rendered image. The maps have been loaded into each of the sample slots so you can see how the map looks alone. Descriptions of the Maps rollout controls follow:

Map On/Off: When the box is checked, the map is active and is used by the material. Otherwise, the map has no affect on the material. This control is useful when testing to see how a map looks alone before integrating it with other maps.

Attribute Name: The map controls this attribute. Some are listed elsewhere in the material, such as Diffuse and Opacity.

Amount: The blend amount. The default value for all except the Bump attribute is 100. The default value means the map controls the associated attribute 100 percent and overrides any other settings that attribute may have. By changing the blend amount to a value of less than 100, you can mix the map with the attribute color or value,

FIGURE 12.19 The material with its Maps rollout visible. The Material/Map Browser (shown) displays the hierarchy of the maps and which attributes they affect.

such as tinting a map with the Diffuse color by setting the Diffuse map amount to 75.

Map: Lists the map being used by this attribute. The number of the map is unique; if the same number appears in two attributes, they are instanced, and any changes made to one will affect the other.

 Use the Material/Map Navigator to traverse complex materials. The Material/Map Navigator is accessed through the icon on the Material editor that looks like two spheres stacked vertically.

SUMMARY

The Material Editor is a complex tool with endless possibilities. This chapter is only a brief introduction into the expansive world of materials creation. An entire book could be written about how to create and manipulate materials, so take these exercises as a warmup. Materials are discussed in more detail in subsequent chapters.

In this chapter you learned:

- Creating a basic material
- Applying a material to an object
- Adding a map to a material

Experiment with adding different maps and seeing how they affect each attribute. Mapping can become quite complex, so knowing more about how each map works is greatly beneficial. As with any aspect of 3D modeling, experiment to see what is possible, because the possibilities are endless.

13

MATERIALS UNWRAPPED

In this chapter

- Diffuse and Reflection Maps
- UVW Mapping, Mapping Gizmos, Unwrap UVW Modifier
- Instanced Modifiers

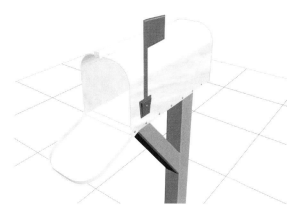

M aterials make the difference in every model, regardless of the
quality of the geometry. In the previous chapter, you created
some very basic materials and learned about the most common
parameters. In this chapter you learn to build and apply materials for the
objects already created in previous lessons.

Project Assessment: Create materials for objects in the final animation.
Object: Mailbox
Modifiers:

- UVW Mapping
- Unwrap UVW

TUTORIAL **CREATING AND APPLYING MATERIALS FOR THE MAILBOX**

In this chapter, you create and apply materials using existing models or mod-
els created in the previous tutorials. The materials start out simple then
progress to more complex materials and mapping issues.

The first tutorial demonstrates how to apply materials to a mailbox that
was modeled in a previous chapter. This exercise provides experience in
putting together materials for related objects.

ON THE CD

1. Open *mailbox_start.max* from the companion CD-ROM.
2. Activate the Perspective view and press the F9 key. You see a mailbox with
 default colors applied but no attributes, as shown in Figure 13.1.

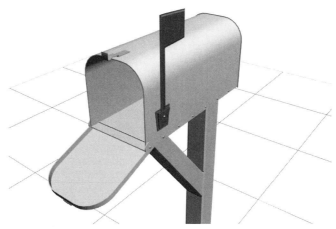

FIGURE 13.1 The mailbox prior to any materials being
applied.

3. Press the M key to open the Material Editor. In the first sample slot, click the Diffuse Color swatch and set the color to a bright red (RGB values 249, 29, 29). Set Specular Level to 56, Glossiness to 23, and name the material, as shown in Figure 13.2.

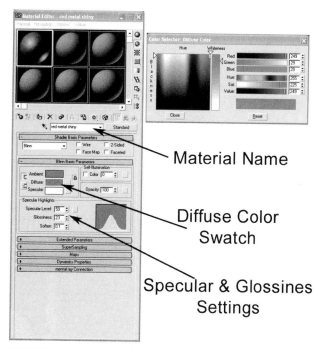

FIGURE 13.2 The settings for the material for the mailbox flag.

4. Drag the material sample to the mailbox flag to apply the material.

The next material to create is for the metal mailbox. In this case, several objects use the same material, so they are selected first so the material can be applied to all simultaneously.

5. Use the already created selection set to select all the mailbox metal components. To do this, click on the Named Selection Sets list (shown in Figure 13.3) and select *metal components* from the list. All the objects in that selection set are selected.

Create selection sets when related objects need to be selected again and again. Selection sets are extremely handy during animation and modeling. You can create selection sets at the object level and sub-object level (such as a vertex) by selecting the objects and typing a unique name in the Selection Set text box. The new selection set is available immediately. For sub-object selection sets, you need to be at the same sub-object level for that object as the set.

FIGURE 13.3 Selection sets are used to easily select objects or sub-objects.

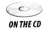

ON THE CD

6. In the Material Editor, activate the second sample slot and name the material *galvanized metal*.

7. Open the Maps rollout, click the Reflection map button, and load *Metals. Ornamental Metals.Galvanized.jpg* from the *max 6 maps\metals2* directory.

8. Click the Assign Material to Selection button to apply the material to all of the metal components. Press the F9 key to render the image. The output looks like that shown in Figure 13.4.

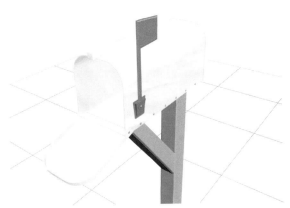

FIGURE 13.4 The metal components with an unadjusted reflection map.

9. Notice how intense the reflection is on the metal. The default value is 100 percent reflections, so that setting needs to be toned down. Because you're at the Map level, use the Go To Parent button on the Material Editor toolbar (shown in Figure 13.5) to traverse to the material level.

FIGURE 13.5 The Go To Parent icon is used to move up one level in the current material's hierarchy.

10. After clicking the Go To Parent button, you are at the Material level. Set the Blend Amount value for the Reflection map to 43, as shown in Figure 13.6. This value tones down the strength of the reflection, resulting in a more

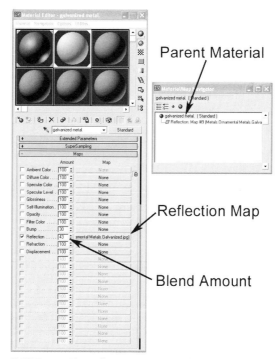

FIGURE 13.6 The reflection amount is found in the Maps rollout of the main Material rollout. You must traverse up the material hierarchy from the reflection map parameters to find the Blend Amount parameters.

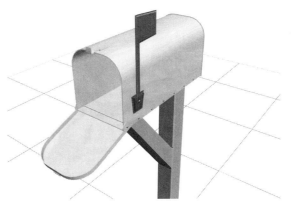

FIGURE 13.7 After toning down the reflection value by setting its Amount parameter to 43, the metal looks much more realistic.

realistic look. Press the F9 key to render the image. The result should be like that shown in Figure 13.7.

11. Although the rivets are going to be similar in color, to make them stand out, create a new material of a basic gray. In the third sample slot, type *rivet* in the material name text box. Set the Specular Level to 55 and use the rivets selection set (already created) to select all of the rivets in the scene. Use the Assign Material to Selection to apply the new material to the rivets.

12. Save your work.

T U T O R I A L

MAPPING WITH UNWRAP UVW

The mailbox post is made of wood, so a wood material needs to be created. You can create wood in a number of ways. When a true wood grain look is required, most artists use a bitmap to create the grain. The bitmap can be either from a photograph or an image created to look like wood. In this tutorial, you will give the mailbox a look of weathered wood. Because the geometry extends across several planes, mapping needs to be adjusted.

ON THE CD

1. Open *mailbox_wood.max* from the companion CD-ROM.
2. Open the Material Editor and set the name of the first sample slot in the second row to *weathered wood*.
3. Go directly to the Maps rollout and click the Diffuse map button, then double-click Bitmap as the Map type from the Material/Map Browser, as shown in

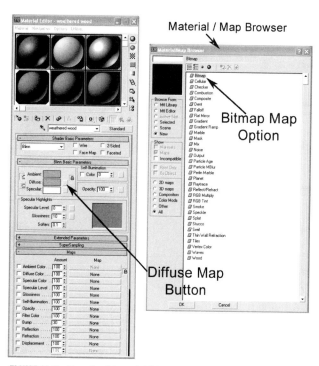

Material / Map Browser

Bitmap Map Option

Diffuse Map Button

FIGURE 13.8 Use the Material/Map Browser to select a bitmap, in this case, wood.

ON THE CD

Figure 13.8. You are prompted for an image file. Choose *weathered_wood.jpg* from the companion CD-ROM and click the Open button. The map is placed in the material's diffuse map slot, as shown in Figure 13.8.

4. After you choose the Diffuse Map image file, the map is placed in the materials' Diffuse Map slot and the map's parameters are visible. Navigate to the top of the material using the Go To Parent button or the Material/Map Navigator.

5. Apply the material to the post and press the F9 key to render the image. Be sure to render it in the Perspective view. The rendered image can be seen in Figure 13.9. Your perspective may show a slightly different angle.

The F9 key is the Render Last command. By selecting the Perspective view and pressing the F9 key the first time the scene is rendered, the F9 can be used to render from the Perspective view, even if it isn't the active view. This method comes in handy when working in one of the orthographic views at full screen and rendering quick test shots in the Perspective view without having to change viewports.

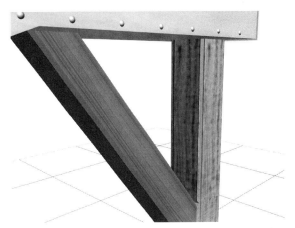

FIGURE 13.9 The mailbox post after applying the wood material. Notice that the support beam in front has the material stretched across it.

Notice that the post in the front doesn't look right. The material is stretched across the beam and doesn't look like wood—that's due to the default mapping. You can change the mapping by adding a mapping modifier, in this case the Unwrap UVW modifier.

6. With the post object still selected, click the Modifier list and add a Unwrap UVW modifier to the object. Click + (plus sign) on the Unwrap UVW modifier to reveal its Select Face sub-object, and activate it by clicking it, as shown in Figure 13.10.

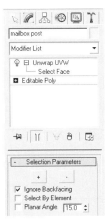

FIGURE 13.10 The Unwrap UVW modifier has one level of sub-object, the Select Face mode.

7. With Select Face sub-object mode active, click the post support beam that extends toward the front of the mailbox, then click the Planar Map button in the Parameters section of the Unwrap UVW modifier. You may notice a mapping gizmo appear around the selected polygon, as shown in Figure 13.11.

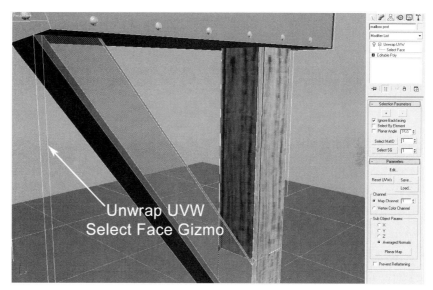

FIGURE 13.11 Using the Planar Map button creates sub-object selections and mapping gizmos associated with them. These items help place maps on complex geometry.

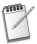

When Select Face sub-object mode is active in the Unwrap UVW modifier, you can create mapping gizmos for the selected faces by selecting one or more faces and clicking the Planar Map button. When the object is rendered, those mapping gizmos are used internally to adjust the image on the geometry.

Press the F9 key to see how the mapping has changed for the support beam. Although it's still not right, it's better than it was, as shown in Figure 13.12. From here we need to adjust the orientation of the mapping gizmo so that it is mapped correctly on the geometry.

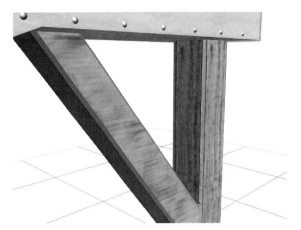

FIGURE 13.12 Using the Planar Map button creates a sub-object mapping gizmo, resulting in a map that can now be altered to fit the selected faces.

8. Under the Parameters section of the Unwrap UVW modifier, click the Edit button to open the Edit UVWs dialog box, as shown in Figure 13.13.

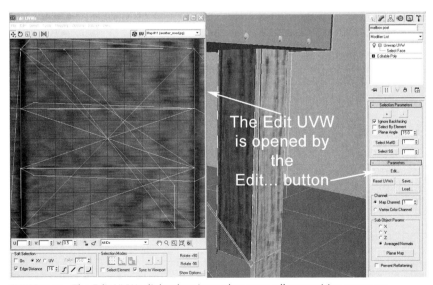

FIGURE 13.13 The Edit UVWs dialog box is used to manually reposition maps on geometry.

9. To minimize the confusion, view only the selected polygons by clicking the Filter Selected Faces button, next to the small open lock icon, as shown in Figure 13.14. This action uncomplicates the mapping window somewhat.

10. Now the map has to be adjusted. Click the Show Options button in the lower-right corner of the Edit UVWs dialog box to reveal the Bitmap options. Make sure that Custom Bitmap Size is turned off, as shown in Figure 13.15. When checked, it resizes the bitmap to fit the parameters shown, in this case causing the bitmap to become stretched.

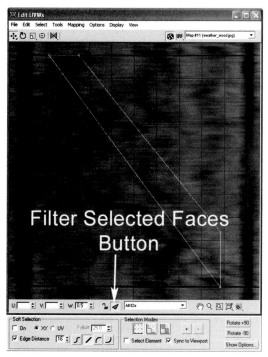

FIGURE 13.14 The Filter Selected Faces toggle only displays the selected polygons. This view is essential when manipulating polygons to fit on a map.

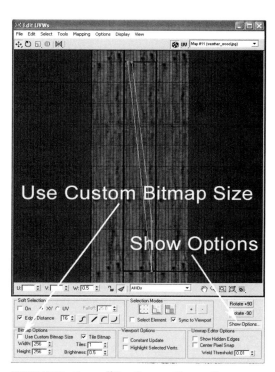

FIGURE 13.15 Turn off Use Custom Bitmap Size to keep the bitmap's original size and aspect ratio.

11. By now, you should be able to see the map properly in the dialog box. If the map isn't visible, click the Show Map (shown as a checkered box) icon at the top of the dialog box. The icon can be seen in Figure 13.16.

12. In the Edit UVWs dialog box, select and move the vertices of the polygon that's being displayed. The vertices can be positioned to fit on the map, as shown in Figure 13.17.

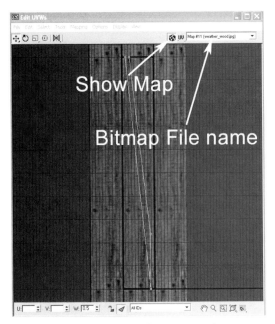

FIGURE 13.16 The Show Map button is used to turn the map on and off in the dialog box. To the right of the Show Map button is the map that's being displayed, which can be altered if other maps are in the applied material.

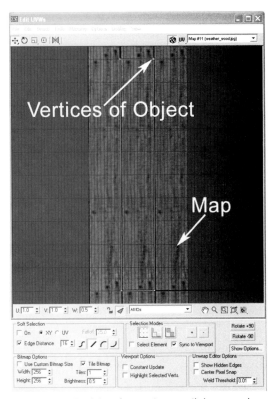

FIGURE 13.17 Position the vertices until they match the displayed map. This action maps the image to the selected polygon based on the position of the vertices.

13. After manipulating the vertices to change the mapping, close the dialog box and press the F9 key to view the newly mapped image. The result should look like that shown in Figure 13.18.

14. Repeat this procedure on the other polygons of the support beam. A summary of the entire procedure follows:

Activate Select Face sub-object mode in the Unwrap UVW modifier.
Select the faces to be part of a single mapping. (Use the CTRL key for multiple faces.)
Click the Planar Map button.
Click the Edit button to open the Edit UVWs dialog box.
Adjust the vertices to fit the map.

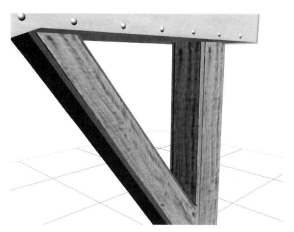

FIGURE 13.18 The newly mapped polygon results in a more appropriate mapping of the image on the geometry.

15. Save your work.

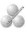

AGING THE MAILBOX

As it is, our mailbox looks too new. One of the problems with 3D modeling is that artists typically create objects that look clean and sterile. Adding nicks, scratches, and age effects to an object makes it look more realistic. In this section, you use additional maps and modifiers to age the mailbox.

ON THE CD

1. Open *mailbox_age.max* from the companion CD-ROM.
2. Open the Material Editor (M key) and select the galvanized metal material. It is located in the second material slot.
3. Click the Diffuse Color Map button and apply a bitmap to the Diffuse attribute. When the Select Bitmap Image File dialog box opens, apply the *PlateOx2.jpg* map found in the 3ds max 6 maps directory under Metal. This map has also been included on the companion CD-ROM for your convenience. Figure 13.19 illustrates the buttons mentioned here.

ON THE CD

4. After applying the bitmap, render the shot from the Perspective view. You receive the error message shown in Figure 13.20. This problem arises because the geometry of the mailbox and mailbox door doesn't have the proper mapping coordinates required to map the image on the geometry. Click the Continue button to render the image.

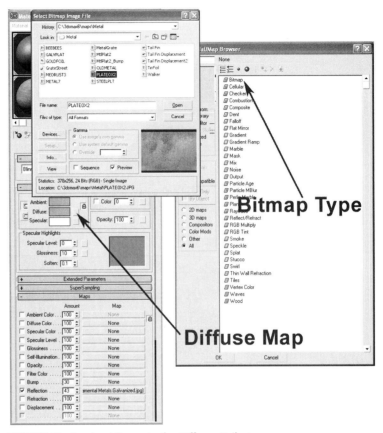

FIGURE 13.19 Apply a bitmap to the Diffuse attribute.

FIGURE 13.20 The Missing Map Coordinates dialog box warns you that 3ds max doesn't know how to position a map on the specified object. To alleviate the problem, an Unwrap UVW or UVW Mapping modifier can be added.

You may wonder why the image used in the Reflection map for the mailbox didn't give this error, but the map in the Diffuse attribute did. The reason is that the Reflection map was mapped to an artificial environment, based on the chosen parameters. The default is a spherical environment on a reflection map. In such a case, the map for the reflection is mapped to a sphere large enough to encompass the entire environment and that is used to project the image onto surfaces that use it in the reflection map.

As shown in Figure 13.21, the body of the mailbox rendered fine, but the door doesn't show the map. This inconsistency occurred because the Extrude Modifier has built-in mapping coordinates, whereas the Editable Poly object derives its mapping from the object from which it was created. In this case, the door was created from a spline object and converted to an Editable Poly object. The spline object doesn't come with mapping coordinates built in, so the door doesn't have any.

FIGURE 13.21 The map doesn't show up on the door because there are no mapping coordinates. This is due to the fact that the door was originally modeled from a spline object, which has no built-in mapping coordinates.

5. To alleviate the mapping problem for the door, select the door object, open the Modify Panel, and apply an Unwrap UVW modifier.

Although a UVW Mapping modifier applied to the door would remove the error message, stretching would occur along the vertical edges of the door. As such, use an Unwrap UVW modifier to gain more control over how the mesh is mapped.

6. Click the Modifier List and choose the UVW Mapping modifier to apply it to the door. Leave the default settings and press the F9 key to render again. The door should look similar to the one shown in Figure 13.22.

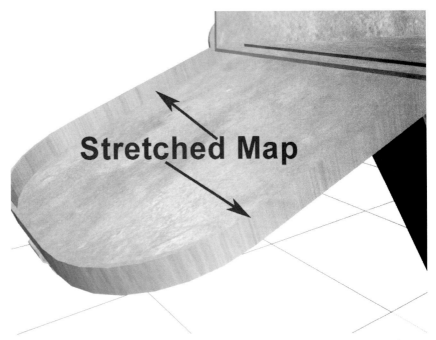

FIGURE 13.22 Whereas most of the door looks correct, the map along the vertical edges is stretched.

7. Activate Select Face mode in the Unwrap UVW modifier and select the long face close to the mailbox. Select similar faces on the inside of the door, as shown in Figure 13.23.

 To keep the number of planar maps created to a minimum, select faces that have similar mapping projections. Select all the faces that face the same direction before clicking the Planar Map button to create a single map for all of the selected faces.

8. After selecting the faces on both the inside and outside of the door ridge (14 faces were selected), click the Planar Map button.
9. Click the Edit button in the Parameters section to open the Edit UVWs dialog box. Turn on Filter Selected Faces and Show Options and turn off Use Custom Bitmap Size, as illustrated in Figure 13.24. You did this step earlier in this exercise.

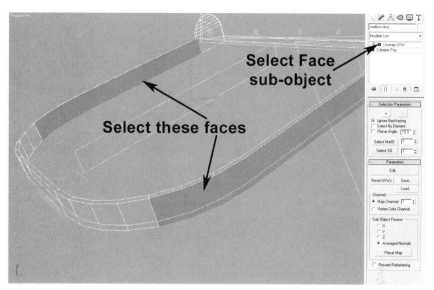

FIGURE 13.23 Select multiple faces before clicking the Planar Map button to create a single map used by multiple faces. This action minimized the maps used by this object.

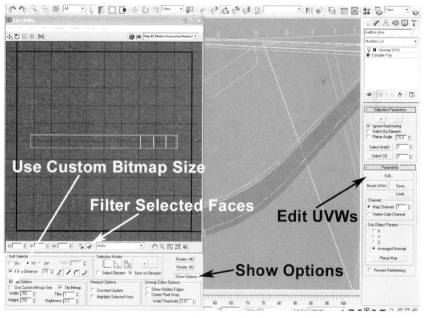

FIGURE 13.24 The Edit UVWs dialog box. Remember to turn on and off certain options to manipulate the map and the vertices of the geometry.

10. In the Edit UVWs dialog box, notice that the map showing is the galvanized metal map. Because multiple maps are used in this material, you need to specify which map to display in the editor. Click the list shown in Figure 13.25 and choose *PlateOx2.jpg*.

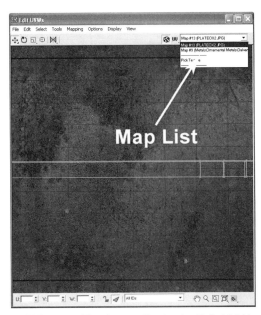

FIGURE 13.25 The image list in the Edit UVWs dialog box. Choose which map is displayed so that faces can be manually mapped. This choice does not change which maps are applied to the object.

The map displayed in the Edit UVWs dialog box is used for mapping only. Changing the displayed map has no effect on the rendered map. The material controls the rendered map .

11. Render the shot again. Figure 13.26 shows a comparison of the edges now that the mapping has been applied.
12. In addition to how the image is mapped on the geometry, you can also decide which portion of the map is mapped. In the Edit UVWs dialog box, move the selected faces to a portion that contains more rust. You can manipulate faces and vertices in the Edit UVWs dialog box just as you do in the modeling space, except that you can move them only along a two-dimensional plane.
13. Repeat the mapping procedure on the faces on the front part of the door ridge.
14. Save your work.

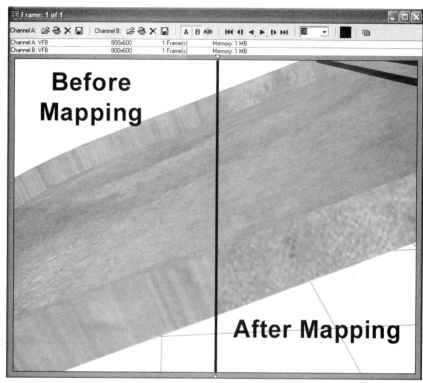

FIGURE 13.26 The left side of the image shows the mapping with no planar maps added in the Unwrap UVW modifier, whereas on the right, mapping has been defined.

TUTORIAL ## AGING THE FLAG

Like the rest of the mailbox, the flag looks too new. You can adjust its material to create an aged look. For this tutorial, you merely blend some mapping options.

1. Open *mailbox_flag.max* from the companion CD-ROM, or continue from the previous exercise.

ON THE CD

2. Open the Material Editor and select the *red metal shiny* material in the first slot and drag it to the fifth slot, as shown in Figure 13.27. A copy of the material is created.

3. Rename this material *aged red metal*.

Each material must have a unique name. Assigning a material with the same name results in a warning, prompting you to either change the name of the material or replace the existing material, as shown in Figure 13.28.

Cloned
Material

FIGURE 13.27 By dragging a material to another sample slot, you can clone a material.

4. Click the Diffuse Map button in the aged metal material and choose Bitmap from the Material/Map Editor. When the Select Image dialog box opens, choose the *medrust3.jpg* image. This material can be found in the 3ds max 6 *maps* directory under the Metals subdirectory, as well as on the companion CD-ROM.

5. Because the new material was cloned, it has similar characteristics to the original. However, it does not inherit the objects to which the original was applied. The cloned material must be applied to those objects. Assign the aged metal material to the flag and the flag holder by dragging it to them or by using the Assign Material to Selection (being sure those objects are selected).

6. Render the shot to see if mapping needs to be adjusted for these objects, as shown in Figure 13.29.

FIGURE 13.28 The Assign Material warning. Each material must have a unique name, so you must either rename the material or replace it in the scene.

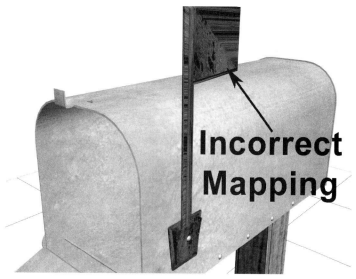

FIGURE 13.29 The map is stretched across the surface of the flag and could use a UVW Mapping modifier.

7. With both the flag and the flag holder objects selected, click the Modifier list and add a UVW Mapping modifier. This action creates an instanced modifier to each of these objects. Adjusting the parameters of one propagates to the other instances of that modifier. When a modifier is instanced, it shows up in italic in the Modifier List, as shown in Figure 13.30.

FIGURE 13.30 The UVW Mapping modifier is instanced to both the flag and the flag holder. A modifier that is instanced is shown in italic.

8. Click + (plus sign) next to the UVW Mapping modifier to access its sub-object. The only sub-object for the UVW Mapping modifier is the gizmo. Using the Rotate tool, rotate the gizmo 90 degrees along the y-axis to change the way the map is applied, as shown in Figure 13.31. Alternatively, you can use the Alignment buttons on the UVW Map to rotate the Mapping gizmo.

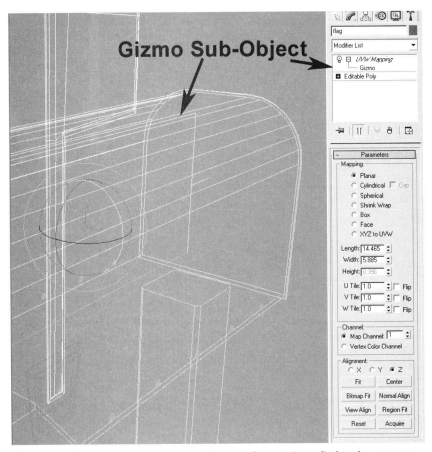

FIGURE 13.31 Rotate the gizmo to change the way the map is applied to the geometry.

9. Render the image to see if the mapping looks better, as shown in Figure 13.32

10. The map still needs some adjustment. Adjust the diffuse color to a brown (RGB 147, 84, 29), set the Specular Level to 29, and adjust the Diffuse Blend (found in the Maps rollout) to 46 to blend between the map and the new color. The material settings and the rendered image are shown in Figure 13.33.

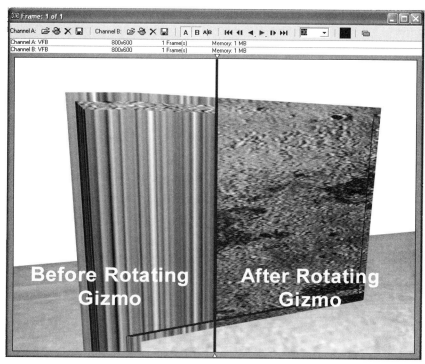

FIGURE 13.32 The before (left) and after shots of rotating the Mapping gizmo.

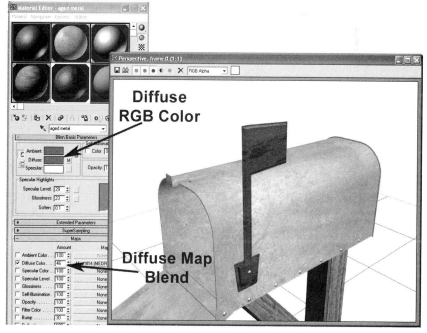

FIGURE 13.33 The adjusted material settings and the rendered image.

11. Save your work.

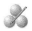

SUMMARY

In this chapter, you learned how to use the mapping modifiers to apply maps to complex geometry. Through the use of the Unwrap UVW modifier, you learned that you can place specific portions of an image on the exact geometry desired. You also learned about:

- Adjusting the mix amount of a map
- Reflection maps
- Bump maps

Use the same concepts used in this chapter to prepare materials for the other objects you have created, including the water tower and the plane.

14

LIGHTING AND ATMOSPHERICS

In this chapter

- Merging Components to Build a Scene
- Basic Light Types
- Fog and Volumetric Light Atmospheric Effects

M onet could control his audience's eyes with oil paints and contrasts in light, and Ansel Adams uses the natural lighting of his photographs to evoke emotional responses to the grandeur of nature. It is the artist's responsibility to control lighting with whatever means possible within the art form. As a 3D artist, you have complete control over the lighting of your scene. But, like a cinematographer, you need to make correct choices in lighting to capture the essence of your subject. Lighting is an art, not the flip of a switch.

Project Assessment: Create an underwater environment using lighting effects.

Objects:

- Omni light sources
- Direct light sources

Tools: Environment Atmospheric Effects

BEFORE THE LIGHTING BEGINS

To create the correct lighting, first you have to decide what type of lighting to emulate. Is the scene going to take place indoors or in the wilderness? Is the environment hot or cold? Is the shot to convey contentment or conflict? To do that, you must know what the scene looks like and what the story is. Even in the same scene file, the lighting can change (especially during animation) to convey different emotions.

INTERIOR LIGHTING (INSIDE THE PUDDLE)

Two different environments are used in this animation. The opening shot is an exterior shot establishing the desert environment. Throughout the animation, an additional plot and storyline include shots inside the water tank and in a puddle below the tank. Most of the animation within the tank and puddle are outside the scope of this book, but the lighting for the puddle is discussed here.

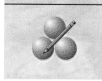

TUTORIAL | ## ADDING LIGHTS TO A SCENE

In the following tutorial, you add a couple of lights to the scene to replace the default lighting. The default lighting isn't visible or readily editable; it is intended to serve as a generic lighting setup so objects are visible when rendered.

ON THE CD

1. Open *puddle.max* from the companion CD-ROM.
2. Activate the Perspective view and press the F9 key to render the scene. The scene and its contents are visible due to the default lighting that's provided by 3ds max, as shown in Figure 14.1. This scene lacks depth and environment as it is.

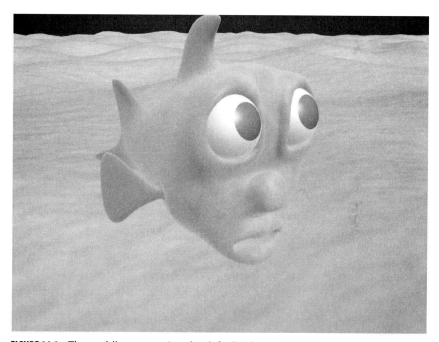

FIGURE 14.1 The puddle scene using the default 3ds max 6 lighting.

3. Open the Create Panel and click the Lighting tab to see the different light choices, as shown in Figure 14.2. You have two classifications of lights: Standard and Photometric.

FIGURE 14.2 The Create Panel with all the light choices. This image has been modified so all is visible simultaneously.

Lights are classified as Standard and Photometric lights. Most of the Standard lights have been part of the 3ds max light set in previous releases and are visually based, in that their parameters are based on 3ds max units, not physics. The Photometric are more accurate and are physics based. The photometric lights use photons and candlepower to calibrate the correct amount of light. For this reason, they require more information to light a scene correctly.

4. In the Create Panel, choose an Omni light from the Standard lights, then click in the Top view to place an Omni light in the center of the view. Notice how both the view and the rendered image become much darker, as shown in Figure 14.3.

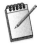

The scene will normally get darker when the first light is added because 3ds max has a two-light default lighting setup in the scene before any lights are added. The default lighting is turned off when the first light is added manually. If the last light is deleted from the scene, the default lighting is reactivated.

5. The problem with the light is that it is below the geometry and there is only one light. In the Left view, click and drag the Omni light 20 units along the y-axis to raise it above the sand bottom object, as shown in Figure 14.4.

6. In most cases, you won't use an Omni light to light the entire scene, so additional lights need to be added. For this scene, you use a Direct light to give most of the illumination on the scene. (You will also use it later for some volumetric lighting effects.) In the Create Panel, click the Free Direct

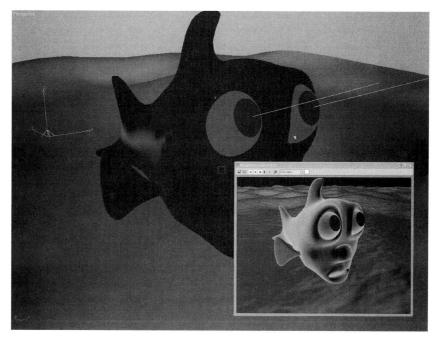

FIGURE 14.3 When the first light is added to the scene, the rendered image typically gets darker.

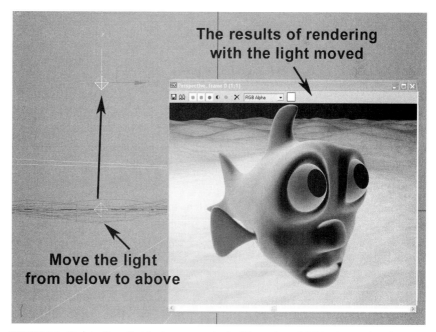

FIGURE 14.4 Lights, like all objects, are created with a value of 0.0 in the z-axis value when created in an orthographic view. That setting places the light below the sand.

Light button, then click in the Top view to create a Free Direct light, as shown in Figure 14.5.

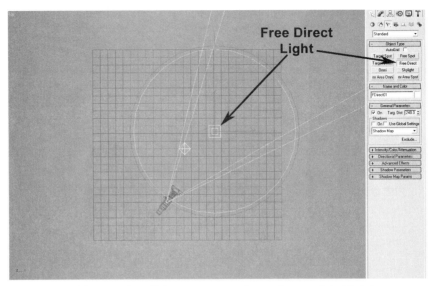

FIGURE 14.5 Add a Free Direct light to your scene for outdoor or global lighting.

Direct lights differ from other lights because their rays are all parallel. This structure gives the illusion that the light is far away. The parallel rays create shadows that stretch uniformly from the object. Other light types distort and stretch shadows from objects, based on the cone angle of the light cone.

The Direct light comes in two flavors, the Free Direct and the Target Direct. The Target Direct has a target object attached to it to which the light always points. Targeted lights are great for when the light needs to follow a subject, because the target can be linked to another object, such as an animated character. Free Direct lights do not have a target.

7. The Free Direct light is going to be used to cast rays of light through the water, so change the position and angle of the light. With the Free Direct light selected, set the following position values (105, 18, 124) in the Transform Type-In dialog box at the bottom of the 3ds max 6 interface. Then set the rotation values to (0, 40, 0). The result is a light that is off to the side and shining on an angle into the scene, as shown in Figure 14.6.
8. Save your scene.

FIGURE 14.6 After setting the position and angle of the Free Direct light.

If you render the scene, you'll notice there isn't much change, other than a hot spot on the ground plane where the light shines. Using the controls in the following steps is essential to getting the light to illuminate the scene as desired.

T U T O R I A L ## CUSTOMIZED LIGHTING

In the Modify Panel, observe the many lighting parameters when a light is selected. Although the controls are extensive, with a few simple adjustments, you can achieve acceptable lighting. The completely expanded light parameters are shown in Figure 14.7.

Naturally, the parameters of the lights are adjustable (and can be animated). The Standard lights have many common parameters. A short list of the general parameters and a brief explanation of what is found there follows. This list and the discussion of the light parameters is not exhaustive but merely an introduction of what type of parameters are found in each section. Through-

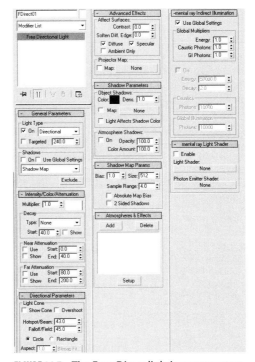

FIGURE 14.7 The Free Direct lighting parameters.

out the lessons in this and subsequent chapters, many of these parameters are discussed.

General Parameters: Controls such as light type, shadow type, and whether the light and/or shadows are turned on for this light.

Intensity/Color/Attenuation: Controls the color, brightness, and decay of a light.

Directional Parameters: Provides the angle of the rays of light based on the light type.

Advanced Effects: Controls what attributes of lighting are active and contrast levels. Maps can be applied to lights in this section.

Shadow Parameters & Shadow Map Parameters: Controls the color and density of shadows, as well as other shadow parameters.

Atmospheres & Effects: Applies special post-rendered effects to the light.

mental ray Indirect Illumination and mental ray Light Shader: When you use the mental ray renderer, these parameters control the way the light is processed.

After this brief introduction of lights, work with them to create some light and lighting effects in your scene.

ON THE CD

1. Continue with the previous scene, or open *puddle_lites.max* from the companion CD-ROM.
2. Select the Free Direct light and rename it *light beams*.
3. Open the Modify Panel and in the Intensity/Color/Attenuation rollout, click the color swatch next to the Multiplier value, as shown in Figure 14.8. In the Color Selector, set the RGB values to (139, 210, 183). This color is a

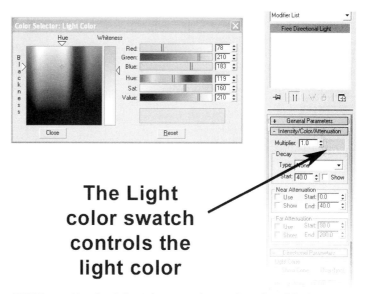

The Light color swatch controls the light color

FIGURE 14.8 Use the Color Selector to change the color of the light.

light sea-green. Close the Color Selector and render the image in the Perspective view to view the effect of the color on the scene.

When adding color to your lights, keep the colors somewhat muted, unless strong light colors are desired. When a light is colored, it affects everything that it illuminates in the scene. Because the color is additive, it changes the characteristics of your materials. In that case, some materials that looked fine in white light may change dramatically if the color isn't complementary to that used in your materials. Try to develop your materials in the light that will be used in the scene.

4. Another important attribute is the Multiplier value. This attribute controls how intense the light shines. Lower values provided less illumination. For this light, set the Multiplier value to 0.3. This value reduces the amount of light cast onto the scene by this light. The Multiplier is found next to the Color swatch in the Intensity rollout.
5. Because the ground plane is rectangular and you want to cover the entire ground plane, set the Light Cone shape to Rectangle in the Directional Pa-

rameters rollout and turn on the Overshoot option, as shown in Figure 14.9. Leave the Hotspot and Falloff fields at the default value of 43 and 45, respectively.

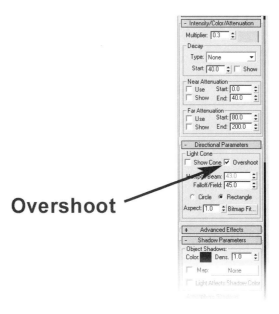

Overshoot

FIGURE 14.9 Use the Overshoot option to illuminate a wider area.

The Overshoot option provides a great way to get more from a light. With Overshoot turned on, the selected light casts light in all directions (illuminating a wider area), but the shadows and projection maps affect only the area within the light's cone (saving rendering time).

Projection Maps and Advanced Effects

6. Continuing onward, you now provide a means for faking caustics in the light projected on the puddle floor. Caustics are the areas of bright light that naturally occur when light is refracted through a clear liquid, such as water.

ON THE CD

7. With the Free Direct light still selected, click the Projector Map button in the Advanced Effects rollout (shown in Figure 14.10). When the Material/Map Browser appears, choose Bitmap and select *caustic.gif* from the companion CD-ROM or from the *\3dsmax6\maps\lights* directory. The map is now used to block light in the areas that are black on the image.

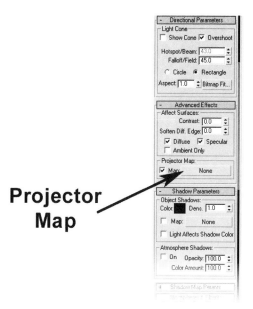

Projector Map

FIGURE 14.10 Add the caustic map to the Projector map of the Free Direct light.

 For animated caustics, use a turbulent Noise, animate the Phase value, place the map in the light's projection map.

8. The map must be loaded into the Material Editor and adjusted, so choose an empty sample slot and click the Get Material button, then choose the Scene option in the Browse From options in the Material/Map Browser. Set the Tiles to 2.0 and the tile type to Mirror. These settings can be seen in Figure 14.11.

9. To avoid having too much light when other lights are added, check the box labeled Ambient Only in the Advanced Effects rollout. This setting causes the light to only affect the ambient light on materials, not the diffuse or specular attributes of any materials.

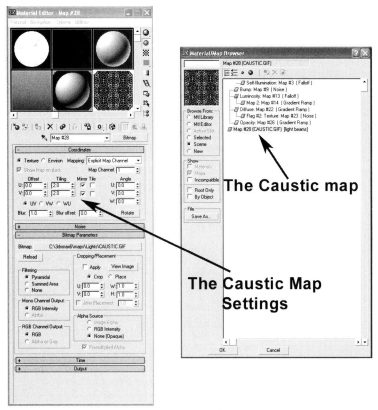

FIGURE 14.11 Adjust the map applied to the Free Direct light through the Material Editor.

10. Save your work.

TUTORIAL

ADDITIONAL LIGHT SOURCES

To completely illuminate the scene, you must add additional lights. Start by positioning the first Omni light placed in the scene.

1. Continue from the previous exercise, or open *puddle_lites02.max* from the companion CD-ROM.

2. Select Omni01 and set its position using the Place Highlight tool, found under the Align tool flyout menu on the Main Toolbar, shown in Figure 14.12. After selecting the Place Highlight tool, click and drag the geometry. The light positions itself automatically so that its light reflects off of the selected polygon. A small blue arrow projects from the selected polygon

FIGURE 14.12 Use the Place Highlight tool to align a light to the surface normal of a specific polygon.

indicating the surface normal of that polygon. The light is positioned based on that polygon's normal. Release the mouse button when the desired highlight is achieved. For this example, the light should be positioned approximately at (–6.5, –5.75, 7.75) by clicking on the fish's right side of the right eye socket.

3. Because this light is going to illuminate only the fish, click the Exclude button found in the General Parameters dialog box. From the Exclude/Include list box, select *squirt* and click the top double arrow to move it to the right side of the list, as shown in Figure 14.13. Also select Include and Illuminate to set the light to illuminate only this object. Objects not in the list are not be affected by this light.

FIGURE 14.13 The Exclude/Include button is used to limit the objects affected by the selected light.

 Use the Exclude/Include button to direct light to specific objects. Lights that are not in the list for that light are not be affected by the light or its parameters.

4. Render the image to see the difference when *squirt* is the only object included to be affected by the Omni01 light. Figure 14.14 shows the comparison effect on the scene.

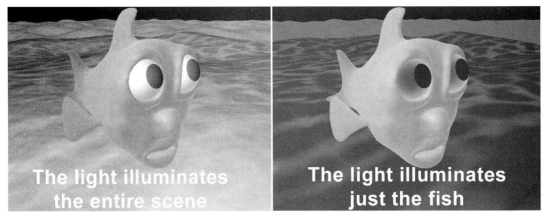

FIGURE 14.14 When the Exclude/Include option is set to include only the fish (right), the rest of the scene gets darker.

5. Now you need to adjust the light multiplier and color. Using the technique described previously, set the Multiplier value to 0.625 and the color to RGB (232, 231, 203). Render the image to see the difference. Though slight, it does make a difference in the final image.

6. In the Top view, hold down the SHIFT key and drag the first Omni light to clone another Omni light. Choose Copy as the clone type and set its position to (–1, –5.6, 11.65). Rename this Omni light *Omni sand Illum*. Click the Exclude/Include button and include only the *sand bottom* object. Use the right direction arrow to remove *squirt* from the list.

7. Add another Omni light in the Top view. Position it at (5.5, –2.2, 6.5) and set its Multipler value to 0.3 and its color to RGB (226, 244, 237). Be sure that nothing is in the Exclude list.

8. Save your work. Press the F9 key preview the image.

The scene needs some depth. Continue to the next exercise to give the puddle some characteristics that provide the sense of environment.

| **TUTORIAL** | ## ADDING DEPTH TO WATER |

Simulating a moving liquid is probably the hardest effect to create accurately. Creating an environment inside the liquid is easier but still presents challenges. The challenge is a balance between the liquid being visible, yet not blocking the viewer from seeing the characters or objects in the scene. In this exercise, you use volumetric light and fog to create part of the environment inside the puddle.

ON THE CD

1. Open *puddle_fog.max* from the companion CD-ROM, or continue from the previous exercise.
2. The background color is black by default in 3ds max. Create a gradient background to give the illusion that you're under water. Press the 8 key, or click Environment from the Rendering menu. Click the Environment Map button and choose Gradient Ramp as the map type. The Environment and Effects dialog box and Material/Map Browser are shown in Figure 14.15.

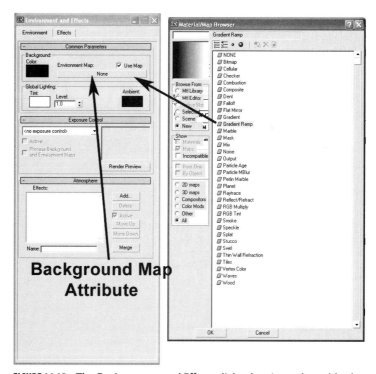

FIGURE 14.15 The Environment and Effects dialog box is used to add color and special effects to the environment.

3. After double-clicking Gradient Ramp, the map is put into the Environment Map parameter, but the map isn't visible; it needs to be edited first. Press the F9 key in the Perspective view to see the effect of the Environment map before any changes are made. The rendered image is shown in Figure 14.16.

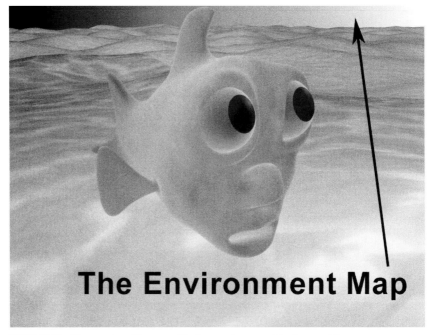

FIGURE 14.16 The rendered image with the environment before making any adjustments.

4. Open the Material Editor (M key) and choose a sample slot that doesn't contain any material yet. Click the Get material button on the Material Editor and select Scene in the Browse From options. Locate the map used by the environment by locating it on the list, as shown in Figure 14.17. Alternatively, you can drag the map from the Environment and Effects dialog box to the Material Editor directly .

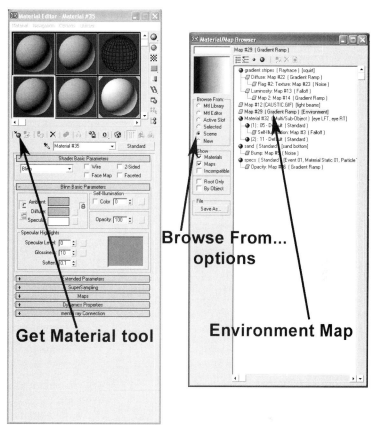

FIGURE 14.17 Choose the Environment map to edit it.

 An Environment map can be created in the Material Editor and then assigned the environment or vice versa. If the map already exists in the Material Editor, simply choose Mtl. Editor in the Browse From options and select the map from the existing Map list.

5. Inside the Material Editor, the colors of the gradient as well as the angle of the gradient need to be changed. Start with the angle. In the Coordinates section of the material, set the W value to 90, as shown in Figure 14.18. This value rotates the map 90 along the z-axis.

Map Angle parameters

FIGURE 14.18 Use the Angle parameters inside the Coordinates section of a map to rotate the map.

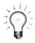 *The term UVW is used to describe the XYZ axes, respectively. To avoid confusion between the object transformation and mapping coordinates, UVW is used in place of XYZ.*

6. Now you must change the colors to give the illusion of distance in the water. Even though this is just a puddle, you're looking at it from the scale of this small fish. In the Gradient Ramp parameters dialog box, you see three small, pointed boxes on the gradient control. You control the color ramp by setting the position and color of these flags . Double-click the flag at the white end to open the Color Selector. Set the color to a medium blue-green, such as RGB (88, 179, 146). Leave the Color Selector open. The gradient flags are shown in Figure 14.19.

**Double click
to set
flag color**

**Flags control
color and
gradient**

FIGURE 14.19 Double-click a flag to change its color.

7. With the Color Selector still open, you can now click the other gradient flags to set their colors. Set the middle flag to RGB (64, 143, 131) and the left flag to RGB (77, 84, 27). These colors give the background a gradient of light and dark bluish greens.

8. Change the position of the middle flag by clicking and dragging it to the left until Pos=44 is shown as the position. This step is illustrated in Figure 14.20.

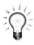

You can add new flags by clicking in the gradient. The flag takes the color of the gradient at that position. To remove a flag, drag it to either end. The cursor changes to an arrow pointing into a trash can. At that point, release the mouse to delete the flag.

Position & color indicator

Position flags by dragging

FIGURE 14.20 Flags can be positioned by clicking and dragging them.

Though the entire gradient can't be seen in the background, this environment is set up this way so that when the camera moves to reveal more water and less of the ground plane, the background will have an appropriate color scheme.

 Right-click a gradient flag to access the flag's properties. In the Flag Properties dialog box, the position and color can be edited. You can also apply a map to control the color, as shown in Figure 14.21.

FIGURE 14.21 The color flag in the gradient ramp can have a map applied to control its color.

9. Open the Environment and Effect dialog box again (8 key). In the Atmosphere section, click the Add button and choose Fog to add it to the list of Atmospheric Effects. The dialog boxes are shown in Figure 14.22.

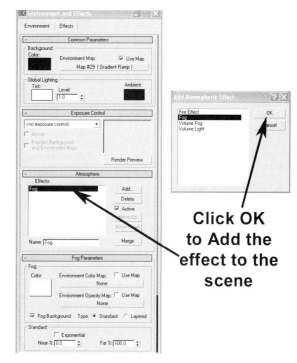

FIGURE 14.22 The Fog Effect is added to the environment to simulate looking through water.

10. Now that the Fog Effect has been added to the environment, you need to adjust its parameter. First, set the fog color. The fog color should match the background color. To do this, render a shot, then right-click in the image where you'd like to extract color to get the Eye Dropper tool. The color is placed in the Color swatch in the rendered image, as shown in Figure 14.23.

11. After the color is loaded into the Color swatch, drag that color to the Fog Color swatch. When the Copy or Swap dialog box opens, choose Copy to replace the fog color, as shown in Figure 14.24.

12. Render the image with the default settings to see how the fog changes the scene. The rendered image is shown in Figure 14.25.

Right click in image to see this data

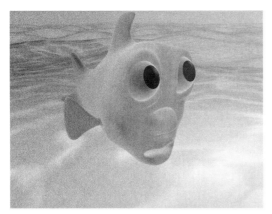

FIGURE 14.23 Right click in the rendered image to retrieve the color of the background.

FIGURE 14.24 Use the Copy or Swap dialog box to move color from the image to the Fog Color attribute.

13. In the Fog settings, turn off Fog Background and turn on Exponential. By turning off Fog Background, the background color isn't affected by the fog color. The background color was used to create the fog color so the two would blend. The Exponential check box increases the density of the fog with distance. The result can be seen in Figure 14.26.

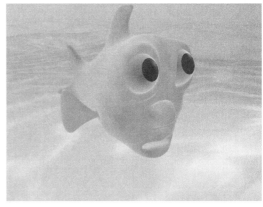

FIGURE 14.25 The default fog settings give a slight indication of fog in the image.

FIGURE 14.26 The rendered image with the fog attributes adjusted. Notice how the sand fades into the background.

14. Save your work.

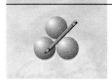

TUTORIAL **CREATING STREAKS OF LIGHT THROUGH THE WATER**

To increase the illusion of water, add streaks of light to give the illusion of light shining through the water. You use the Direct light that was added earlier, along with some Atmospheric effects.

ON THE CD

1. Open *puddle_streaks.max* from the companion CD-ROM, or continue from the previous exercise.
2. Open the Environment and Effects dialog box by choosing Environment from the Rendering menu or by pressing the 8 key.
3. In the Environment and Effects dialog box , click the Add button in the Atmospheric section (as was done with the fog exercise). In this case, choose Volume Light and press OK to add the effect to the list of Atmospheric effects, as shown in Figure 14.27.
4. To implement the volumetric lighting in the scene, the effect must be attached to a light source. In the Volume Light parameters, click the Choose Light button, then click the Free Direct light to add the effect to that light source. The light is shown in the list of affected lights in the Volume Parameters, as shown in Figure 14.28.

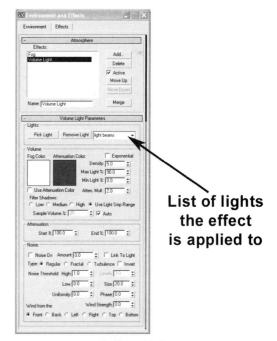

List of lights the effect is applied to

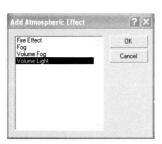

FIGURE 14.27 Choose Volume Light to add the effect to the list.

FIGURE 14.28 List of affected lights.

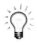

Pressing the H key opens the Select by Name dialog box. From here you can choose the light to apply the effect (provided you name your lights something meaningful). More than one light can be assigned to a volumetric lighting effect.

5. To keep the light in sharp contrast with the water fog, keep the default white setting of the fog color. This setting lets the light streaks stand out more in the water. If the streaks become too prominent, you can change the color later.

6. Set the Density value to 68 to make the light more visible through the existing fog. Under normal volumetric light (such as light shining through a window), values of less than 7.0 are optimal. Because this light also has a fog effect, the density has to be increased greatly.

7. To make the streaks of light higher in contrast, set the Attenuation Start percent to be close to that of the End percent. In this case the Start % value is set to 92.5 and the End % value is left at 100.

8. Finally, be sure that Noise is checked. Noise is used to simulate dust particles in the volumetric light or fog and breaks up the continuity for a more realistic look. Set the noise value to 0.51. All of the parameter settings described are shown in Figure 14.29.

FIGURE 14.29 The Volume Light parameters.

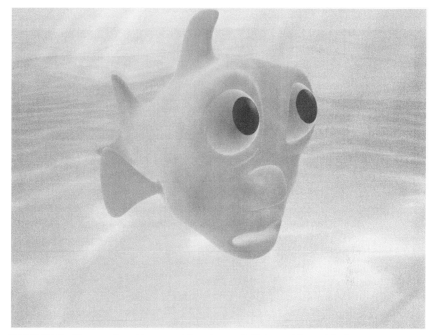

FIGURE 14.30 The rendered image with volumetric light and fog added to create an underwater environment.

9. Render the image using the F9 key. Be forewarned — volumetric light increases rendering times dramatically. The rendered image is shown in Figure 14.30.
10. Save your work.

SUMMARY

In this chapter you learned how to add some basic lighting to your scene, as well as how to create some atmospheric effects to add more to the environment. Working with lighting effects can take a lot of rendering time. For the best results, change one parameter at a time until you understand how those parameters work. Changing too many things at one time can lead to frustration and a lack of understanding of which parameters actually change the lighting.

In this chapter, you learned about:

- Different light types
- How to control light color and strength
- How to create an environment with atmospheric effects.

You still have more effects to be added to the puddle scene. The water needs more debris, which will be added in the Particles and Special Effects chapter. You can experiment with light in this chapter by trying other fog effects or by adding an animated map for the caustics map in the Free light.

RENDERING—
GETTING TO PIXELS

In this chapter

- Create Cameras for Rendering

- File Output Options

- Advanced Lighting Options

- Post Processing

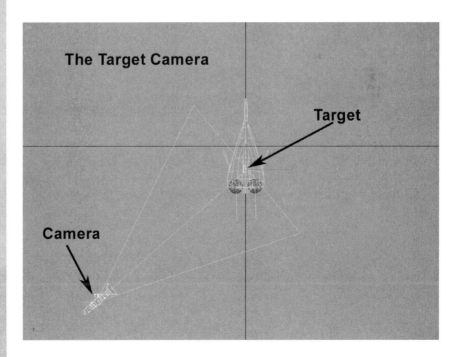

The Target Camera

Target

Camera

U p to this point, you've spent most of your time modeling and animating your scene. In the previous chapter, you did some lighting and even rendered a few images. Although many believe that animating comprises the entire process of 3D modeling, rendering and post processing can easily take as much time or more. For film and video production artists, this step is just the beginning of their workday.

In this chapter you will learn how to use some of the render tools to generate the imagery required to put life into your animation.

Project Assessment: Render an animation sequence.

WHAT IS RENDERING?

Simply stated, rendering is the process of applying mathematical equations that calculate the interaction of light and surfaces to create an image. Depending on the final medium, rendering can vary greatly. Film and print have different requirements, as does Web site and game design. The rendering process for the computer graphics artist is to use the many options available within the software to deliver the highest quality images possible.

| TUTORIAL | **CREATING A CAMERA** |

Up to this point, all rendering has been done through the Perspective view, but cameras play an important role in the image creation process. Cameras inside 3ds max are fairly simple to use and are intended to mimic real-world cameras. 3ds max 6 provides a choice of two camera types, Target and Free. Cameras appear as wire-frame icons in a 3ds max scene, as shown in **Figure 15.1**.

Cameras are found under the Camera icon in the Create Panel. You can create camera in two ways: by icon or by view. The following tutorial teaches you both methods.

ON THE CD

1. Open *cam_demo.max* from the companion CD-ROM.
2. Open the Create Panel and click the Camera tab to see the camera choices. 3ds max offers two types of cameras, as shown in Figure 15.2.

FIGURE 15.2 The two camera types found in 3ds max.

FIGURE 15.1 The camera icons in 3ds max.

3. Click the Target Camera button, and in the Top view, click and drag from the lower-left corner to the middle of the fish, then release the mouse button. You've just created a Target camera. Your Top view should look like the one shown in Figure 15.3.

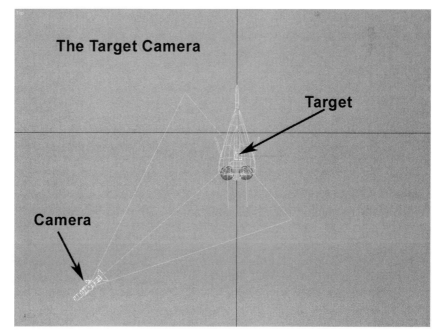

FIGURE 15.3 After creating the Target camera.

4. The Target camera consists of two distinct yet linked objects: the camera and the target object. Both are linked but may be animated and controlled separately. The Select by Name dialog box is shown in Figure 15.4, illustrating the two separate camera objects.

5. To view the scene through the camera, activate the Perspective view and press the C key to change the current view to the Camera view.

6. Because the camera always looks at the target, adjust the target so that the camera can see the fish. With the camera still selected, use the Quad menu to choose the camera's target, as shown in Figure 15.5.

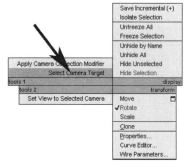

FIGURE 15.4 In the Select by Name dialog box, you can see that the camera and its target are two

FIGURE 15.5 Use the Quad menu to access the target quickly.

The camera icons don't change size. Zooming the view in or out won't bring the camera closer or change the size of the icon. Using the Uniform Scale tool on the camera merely resizes the cone, where the Non-Uniform Scale tool distorts the image.

7. With the target selected, use the Align tool (CTRL + A) to position the target at the center of the fish body. After alignment, the target is centered on the fish, and the camera view should look like those shown in Figure 15.6.

8. To adjust the view of the fish, move the camera (not the target) away from the fish. Use the Dolly Camera tool (shown in Figure 15.7) to move the camera along its local z-axis away from the target. Keep four views open so you can see your adjustments as they happen.

FIGURE 15.6 The view through the camera after aligning the target to the center of the fish.

FIGURE 15.7 The Dolly Camera tool is found on the View Tools. It moves the camera along its local z-axis toward and away from the target.

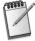 *The Dolly tool has a camera version and a target version, with each moving its respective object along its local z-axis.*

The fish has already been animated along a simple path for purposes of this exercise. If you scrub the Time Slider, you'll notice that the fish goes out of the frame by frame 15. To keep the fish within the frame of the camera, link the camera's target to the fish. Select the camera's target.

9. Be sure the Time Slider is on frame 0. From the Main Toolbar, click the Select and Link tool and drag from the camera's target object to the fish, then release the mouse button when the pointer is over the fish. The fish flashes white for one second, indicating that it is now the target's parent object.

FIGURE 15.8 A series of images showing how the camera follows the target, which is linked to the fish, keeping the fish within the frame throughout the animation.

10. Drag the Time Slider to see that the camera now points to the fish for the entire animation, as can be seen in Figure 15.8.

CREATE A CAMERA FROM A VIEW

The Arc Rotate tool isn't available for Camera views. Other tools, such as the Roll Camera and Orbit Camera tool, are available, but in my opinion, nothing beats the Arc Rotate tool for shot composition. I use the Arc Rotate hot key (press the ALT key while pressing the middle mouse button or wheel, then moving the mouse) in a Perspective view to compose my shot. After composing the shot, I can then add a camera to match that view, all in a single keystroke.

By using the CTRL + C hot key in a Perspective view, a new camera is created to match the current view. The new camera is a Target camera matching the Lens and Field of View of the current Perspective view.

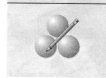

TUTORIAL | **RENDERING OUTPUT TO FRAMES**

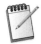

You have basically two forms of output when rendering. Output can be in the form of a self-contained movie file using the standard windows format (.avi) or the QuickTime format (.mov).

To render to QuickTime format, you must have QuickTime installed on your system. Rendering to an .avi file requires no plug-ins, because the .avi format is native to all versions of Windows supported by 3ds max.

In the following tutorial, you use a simplified scene to keep render times to a minimum.

ON THE CD

1. Open *rndr_demo.max* from the companion CD-ROM.
2. Start by rendering a single frame. In the past, you've been instructed to use the F9 key to render a frame. This time, press the F10 key. The Render Scene dialog box shown in Figure 15.9 opens. At the bottom of the Render Scene dialog box, press the Render button to render the image.

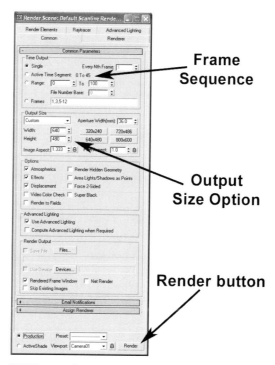

FIGURE 15.9 The Render Scene dialog box.

3. Though rendering a single image is fine, you must render the entire se-
quence, so choose the Active Time Segment option from the Common tab
in the Render Scene dialog box, as shown in Figure 15.10.

*The Active Time Segment is the time that's visible in the Track bar at the bottom of
the 3ds max interface. Use the Time Configuration dialog box to adjust the time seg-
ment. The CTRL and ALT keys with the left or right mouse buttons can also be used
to adjust the Active Time Segment interactively. Click in the Track bar holding the
CTRL and ALT keys. Clicking with the left mouse button adjusts the left side of the
track bar, whereas the right mouse button controls the right side of the track bar.*

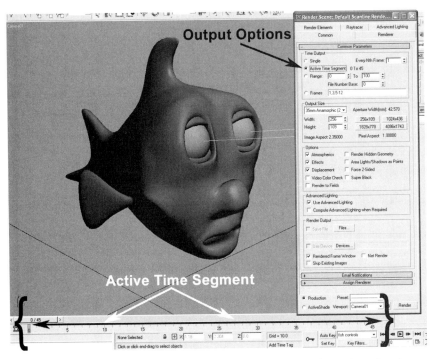

FIGURE 15.10 The Active Time Segment option is used to render the entire animation
based on the active time segment (the frame count shown in the Track Bar).

Next, you must choose the output size. In this case, you want to render a
small set of test images, so the quality and size are set appropriately. The Output
size has several aspect ratio presets in the Output Size format list, along with pre-
set size buttons for each format option chosen, as shown in Figure 15.11.

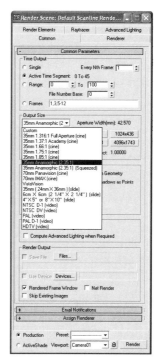

FIGURE 15.11 The Output Size list offers several preset sizes compatible to industry standard media types.

4. Click the Output Size format list and choose 35mm Anamorphic (2.35:1). This format is a wide-screen format commonly used in feature-length films. Leave the width and height to the default value of 256x109, as shown in Figure 15.12. This setting keeps render times to a minimum.

5. Now that you've set the output format and size, be sure to turn on Show Safe Frame from the view window's drop-down menu. If this option isn't turned on, you may find that much of your image isn't going to be within frame, especially if you've chosen a wide-screen film format, as shown in Figure 15.13. The Show Safe Frame option doesn't change the output; it just makes the viewport match the output size.

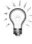 *Right-click any of the output size preset buttons to create your own custom output size. This preset is saved as part of your preferences. With a preset format chosen, the aspect ratio is locked automatically.*

6. After turning on Show Safe Frame, be sure to compose the scene so that the subject is within frame. It is a good idea to choose the output size at the beginning of the project to ensure that the camera captures all the action.

Preset output sizes based on output format

FIGURE 15.12 After choosing one of the Output Size format presets, you have several options for size.

No Safe Frame shown

Safe Frame show image cutoff

The output is the same whether safe frame is on or not

FIGURE 15.13 The image before and after turning on Show Safe Frame.

7. After choosing an output size, you must choose an output location. In the Render Output section of the Render Scene dialog box (shown in Figure 15.14), click the Files button to choose a file location. When the Render Output File dialog box appears, navigate to an empty directory in which to save your files.

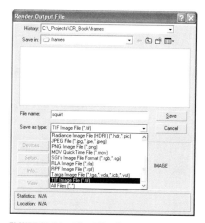

FIGURE 15.14 The Files button.

Always place an image sequence in an empty directory. Doing so enables you to keep the images organized for post processing or removal. Image sequences use lots of disk space, and keeping frames organized helps when you need to delete unused frame sequences to make way for new frames.

8. After choosing a directory, choose an output name and type. It's best to keep names short, because when rendering a sequence, sequential numbers are appended to the filename.

9. After choosing the filename, choose a file type. You can simply type the extension (such as .tif, .avi, .jpg) if you know the extension of the type of file you'd like to create. Each output type has different capabilities and different advantages and disadvantages. The advantages of each format is listed in Appendix A. For this example, choose the .tif format. TIFF images provide an alpha channel, which can be used for compositing in post-production.

10. After you choose a file format, the Setup dialog box appears in which you can configure the output for that file type. Figure 15.15 shows examples of several file types' Setup dialogs boxes.

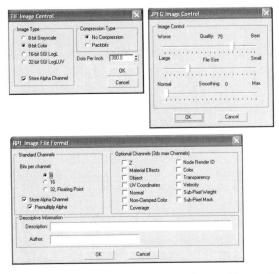

FIGURE 15.15 The Setup dialog boxes of several image file types.

11. After setting the file type and output name, you must choose a viewport from which the image is rendered. From the drop-down list, choose Camera01. Any of the existing views can be chosen.

When choosing a view from the Viewport list, only the views that are currently visible can be loaded. In other words, if you have several cameras in your scene, only the ones that are using one of the four views can be accessed through the list. If the viewport is maximized (using the Min/Max toggle), only that view can be accessed from the Render Viewport list.

12. Finally, press the Render button to begin the rendering process. A Rendering progress window (shown in Figure 15.16) is displayed with a synopsis of the options chosen for output.

In some cases, the rendering process is a great time to grab a drink, a snack, dinner, or maybe even go on vacation—render times can be lengthy. For this short sequence, the render time is less than 30 seconds for all images. For a full-length animated 3D feature, studios typically have hundreds of machines running 24 hours a day for many months to render a sequence of images.

A default value is to show the rendered frame during the rendering process. Although it is great to see what the image looks like while it is rendering, this value slows the process. Turn off the Rendered Frame Window option or click the X in the window's title bar to close the window. You can view the sequence later.

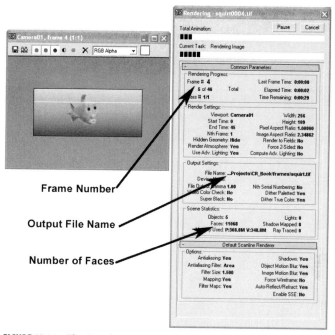

Frame Number

Output File Name

Number of Faces

FIGURE 15.16 The Rendering progress window displays information about the current rendering job.

Network Rendering

The idea is simple: Use all available processors to render an image or sequence of images. 3ds max has always had unlimited render nodes. (The actual limit is 10,000 machines). By setting up a network of rendering computers (also called a render farm), you can increase the output speed by dividing a job among many computers instead of a single computer. Network rendering also enables jobs to be batched processed or scheduled to render during off-peak hours when computers typically sit idle.

TUTORIAL ## SETTING UP A RENDER FARM

For the purposes of this book, assume that all default settings are used, unless otherwise noted. When 3ds max is installed, backburner (the network rendering component) is also installed. There is no program called Backburner, but a directory called *backburner 2* contains the components of backburner. The *backburner 2* directory can be found inside the 3ds max 6 directory.

The following tutorial guides you through the process of setting up a simple render farm. This exercise assumes that you have sufficient privileges on the network and computer to install software.

1. Before network rendering can begin, 3ds max must be installed on all the systems that will be part of the render farm. The render nodes do not have to be authorized to run as rendering nodes, because this is the intent of the software. However, the render nodes cannot be used as modeling stations unless an authorization code is given.

2. Navigate the Start Menu, and click All Programs > discreet > Backburner 2 > Manager.

3. The first time Manager is run, a Settings dialog box opens (shown in Figure 15.17) prompting you to set up some of the general parameters. Choose OK to accept the default settings. These settings create a *backburner.xml* file used to store the configuration settings.

One machine must be running the Manager application before the Server application will run properly. The Manager is used to coordinate all of the servers and controls the network rendered jobs.

4. After the Manager is running, run the Server application. The Server application is found in the same backburner menu as the Manager. Again, the first time the Server application is run, a Settings dialog box opens (shown in Figure 15.18) prompting for TCP/IP settings. Whereas the default parameters work in most cases, you may need to talk to your network administrator for information regarding the TCP/IP configuration for your network, especially with the Subnet Mask. Click OK to accept these settings.

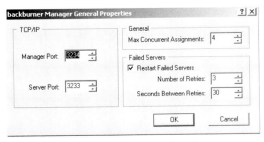

FIGURE 15.17 The Manager General Settings parameters.

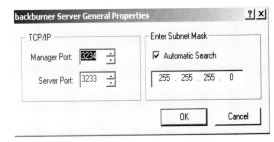

FIGURE 15.18 The default settings of the Server application.

Be sure that the Manager and Server port parameters match those used in the Manager. If the default values were used, the parameters match.

5. Now that both the Manager and Server are running on one machine, run the Server application on all machines that will become part of the rendering farm. The Manager needs to run only on a single machine; the Server application needs to run on each machine that intends to render.
6. The render farm is now ready to render.

T U T O R I A L ## USING NETWORK RENDERING

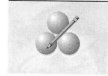

After setting up the Manager and Server applications on the appropriate machines, you're ready to begin network rendering. Network rendering is useful whether you're rendering a single image or several images over many computers.

To use Network Rendering, be sure the render farm is set up as described in the previous section before continuing with the following tutorial, which describes the steps to Net Render.

ON THE CD

1. Open *net_rendr.max* from the companion CD-ROM, or use your own scene to render.
2. Press the F10 key to open the Render Scene dialog box, or click the Render Scene icon (shown in Figure 15.19), located on the Main Toolbar.

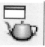

FIGURE 15.19 The Render Scene icon opens the Render Scene dialog box, which is used to control many aspects of rendering an image.

3. In the Common tab of the Render Scene dialog box, set any required output parameters, such as the Time Output, Output size, and File location. Then check the Net Render option near the Render button, shown in Figure 15.20.

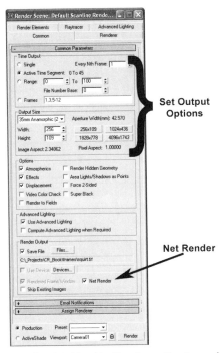

FIGURE 15.20 The Net Render option is used to distribute a rendering job across a rendering farm.

Be sure to check your output filename. If you forget to set an output filename, your images won't be saved to disk. If no filename is chosen, the images are rendered to RAM and are lost immediately. Although a warning pops up (shown in Figure 15.21), if no filename has been set when rendering over a network, most people ignore such warnings only to find out after hours of rendering, they have nothing to show for it. Also be sure the output path is visible by all computers on the farm or they will fail when attempting to store an image.

4. After all output options have been chosen, check the Net Render option, then click the Render button. 3ds max disappears for a second or two, and the Network Job Assignment dialog box (shown in Figure 15.22) opens. From here, choose your options for rendering the job, such as a job name and description and the assignment of rendering servers.

FIGURE 15.21 The output sequence warning message warns that the rendered output isn't going to be saved.

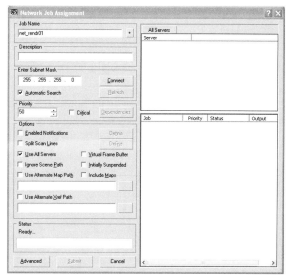

FIGURE 15.22 The Job Assignment dialog box is used to choose options for the entire job being rendered, including which servers will render and what the job will be called.

5. Within the Job Assignment dialog box, click the Connect button to connect to the Manager to see what servers are available and what jobs are currently active. If a connection is made, you should see a list of servers in the dialog box, as shown in Figure 15.23.

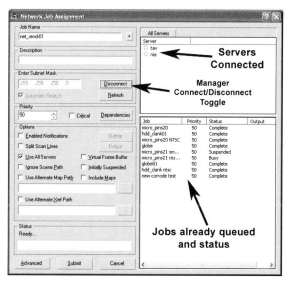

FIGURE 15.23 The Job Assignment dialog box, after clicking the Connect button.

6. After clicking the Connect button and a list of servers are shown, click the Submit button (shown in Figure 15.24) to submit the job to the rendering Manager. Usually, the default options should work fine. Be sure Use All Servers is turned on if you'd like to use all of the available servers. Turn off Virtual Frame Buffer to keep the image from being displayed on each computer after it is rendered. Turning off this option saves rendering time.

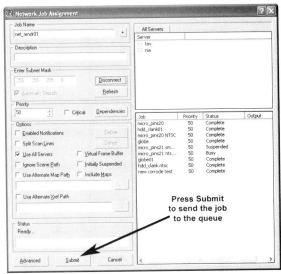

FIGURE 15.24 Click the Submit button to send the job to the rendering Manager. Check all your options before sending.

7. After clicking the Submit button, the Job Assignment dialog box closes and 3ds max returns. The job now renders in the background. The progress of the rendering can be followed via each server's progress dialog box (shown in Figure 15.25) or by using the Queue Monitor.

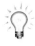

Running the Manager and Server as a Windows Service is a little less intrusive. The downside is you don't receive immediate feedback of the rendering progress on that machine through progress dialog boxes or server windows. To get an instant status on the progress of any rendering server, use the Queue Monitor.

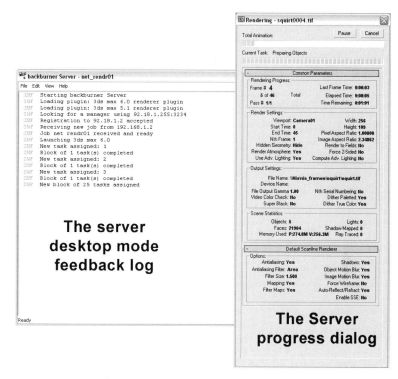

FIGURE 15.25 A rendering Server progress dialog box.

THE QUEUE MONITOR

The Queue Monitor is a small application that is installed with Back-burner. The Queue Monitor is used to control rendering jobs after they've been submitted and the rendering servers associated with each job. To open the Queue Monitor click Start Menu > All Programs > discreet > Backburner 2 > Monitor. The Queue Monitor window (shown in Figure 15.26) appears.

Before the Queue Monitor can be of any real use, you must connect to a Manager on the network. To do that, click the Connect button to open the Connect to Manager dialog box shown in Figure 15.27. From

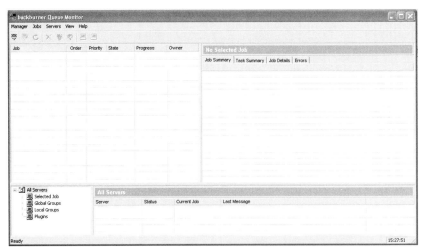

FIGURE 15.26 The Queue Monitor window.

here, set the correct subnet mask (talk to your network administrator for the correct settings), though the default values work in many cases. Then click OK to connect to a rendering Manager.

Leave Automatic Search on to search the network for any rendering Managers that are running. If you turn Automatic Search off, you must enter an IP address or a Manager name that is currently running.

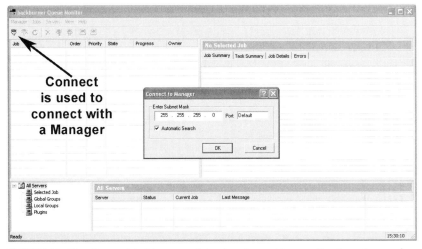

FIGURE 15.27 The Connect to Manager dialog box is used to specify where to search for a rendering Manager.

EDITING JOB OUTPUT

Once connected to a rendering Manager, you not only see the details of a job but also can change some of the settings as well, such as output destination, output size, or even which servers will work on this job. To edit the settings of a job, right-click the job to reveal the job menu, as shown in Figure 15.28, and choose the Edit Settings option.

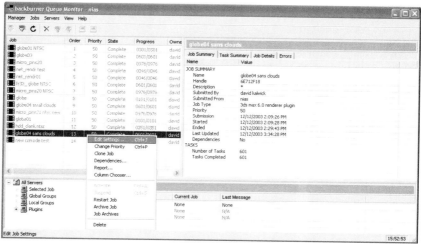

FIGURE 15.28 Rendering parameters can be changed after a job has been sent by editing the job settings.

Inside the Edit Settings dialog box (shown in Figure 15.29), you find many of the rendering parameters from the Render Scene dialog box. Click a field to edit it. For options that are On/Off or Yes/No, double-click the option to toggle it.

FIGURE 15.29 The Edit Settings dialog box lets you change parameters of an existing job.

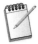 *Before a job is edited, it should be suspended first, using the Suspend Job icon. If settings are changed while a job is rendering, the rendering process is stopped when you click OK in the Edit Settings dialog box.*

CONTROLLING RENDERING SERVERS

The bottom half of the Queue Monitor displays information about all rendering servers that have contacted the current Manager. As shown in Figure 15.30, the left side of the server section shows the established groups of servers, whereas the right side displays information about the servers themselves.

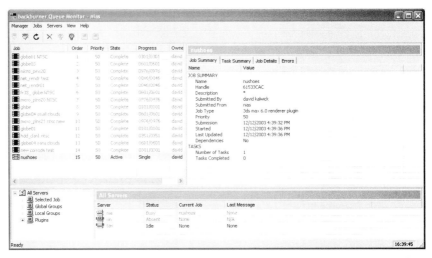

FIGURE 15.30 The server groups and individual servers are shown at the bottom of the Queue Monitor.

Using the toolbar (shown in Figure 15.31) at the top of the Queue Monitor, you can also activate or deactivate servers from the selected job. To use these tools, first select the job from the list below the toolbar, then click the appropriate tool.

Descriptions of the tools follows:

- Connect—Connects to a rendering Manager. The Queue Monitor must be connected to a Manager to retrieve information about any current or past rendering jobs.
- Disconnect—Disconnects the Queue Monitor from the current Manager. You must disconnect from the current Manager to connect to another Manager.

FIGURE 15.31 The toolbar is used for controlling jobs and servers.

Refresh: Refreshes the information shown in the Queue Monitor. Use when Auto-Refresh is turned off. Auto-Refresh is controlled in the Manager menu.

Delete Job: Deletes the current job from the queue. It is best to suspend a job before deleting it. Jobs deleted from the Queue Monitor cannot be undone and the job must be resubmitted from 3ds max if you deleted the job in error.

Activate Job: For a job that has been suspended, this tool takes the job out of suspension mode.

Suspend Job: Temporarily suspends the job from rendering. Use this tool if you need to make changes to the parameters or if you'd like to turn off rendering for the selected job temporarily.

Assign Server: Becomes active when a server is chosen from the server list at the bottom of the Queue Monitor. With a server selected, click a job and then click the Assign Server button to assign that server to work on the selected job.

Remove Server: Removes a server from the selected job. Use this tool if a server is causing errors or its resources are required elsewhere.

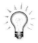 *Even if you don't have a network, setting up a single machine network lets you use the Net Render option to batch process rendering jobs.*

THE SPLIT SCANLINE OPTION

Now that you've got Net Rendering going, 3ds max 6 offers a Split Scanline option for images that have lengthy render times. With this option checked (as shown in Figure 12.32), you can split the rendering of a single image to several networked machines. Turn this option on, then proceed with network rendering. The image is divided among every machine included in the render job. Each machine renders its part, then all of the rendered pieces are recompiled into a single image that is saved as the chosen target image.

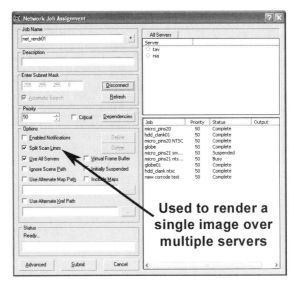

Used to render a single image over multiple servers

FIGURE 15.32 Use the Split Scanline feature to use multiple machines to render a single image.

SUMMARY

Now that the process of getting your job rendered is complete, what do you do with all those frames? At this point, you begin the process of post-production. Among other things, you can use the frames to composite into live action, you can add special effects, or you can simply compress the images into a self-contained .avi or .mov file.

In this chapter you learned about:

- Creating cameras
- Rendering images
- Network rendering

The saying "the end of one journey is the beginning of another" is applicable to 3D graphics creation. Each time a process ends, another follows. Rendering frames is just one small part of the entire process. In the next chapter you learn about using post-production tools and special effects to put it all together.

PARTICLE FLOW FOR MODELING AND EFFECTS

In this chapter

- Particle Flow
- Operators and Tests
- Linked Events

Particle systems are used for many things, including smoke, water, or even for creating lots of objects, such as a swarm of bees or a field of grass. One of the more exciting aspects of 3ds max 6 is the addition of Particle Flow as part of the core application. With Particle Flow, animators have more control over how particles are derived and animated.

Project Assessment: Create bubbles flowing from the skull.
Objects: Particle Flow

WHAT IS PARTICLE FLOW?

Particle Flow is a robust, event-driven particle system for creating complex particle-based effects. A Particle Flow particle system starts with a PF Source object, which is then connected to events and tests that can be customized to create anything from simple particle effects to complex inter-particle or inter-object collisions and much more.

TUTORIAL

THE PF SOURCE

A Particle Flow object is not like other objects within 3ds max. It uses events, not the Modifier Stack, to modify its appearance. Though the departure from the Modifier Stack–based object may seem incongruous at first, the event-driven concept is one that has a broad range of applications, not just in particle systems. Being of an event-driven system, the Particle Flow base object is one with little power. It merely serves as the engine or source of particles. It is the events attached to it that make it powerful.

In the following tutorial, you create a simple particle system using the Particle Flow source object.

ON THE CD

1. Open *bubble_start.max* from the companion CD-ROM. This scene contains some objects with which Particle Flow interacts.
2. The Particle Flow object is found in the Create Panel under the Particles category. Seven particle systems are shown, but Particle Flow is the only particle system within 3ds max that is event driven. The entire list of particle systems found in the Create Panel under the Particle Systems category can be seen in Figure 16.1.
3. Click the PF Source button, then click and drag a rectangle in the Top view. This action creates a PF Source object, as shown in Figure 16.2.

Particle System category

Particle Flow Object

PFlow parameters

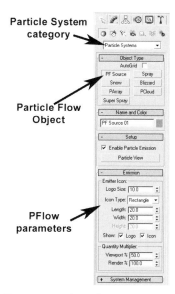

FIGURE 16.1 Though several particle systems are available in 3ds max, PF Source is the only one that is event driven.

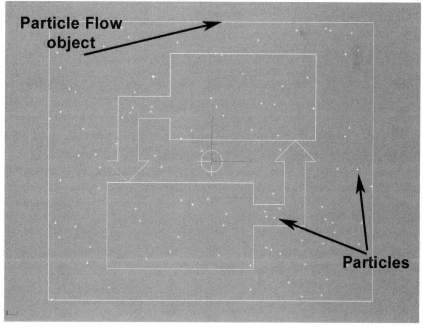

Particle Flow object

Particles

FIGURE 16.2 The PF Source object is just an icon in the scene.

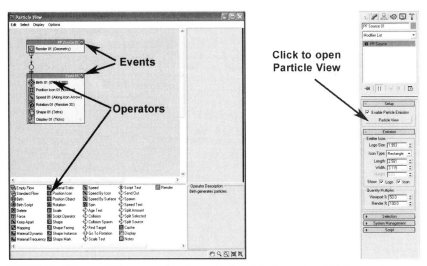

FIGURE 16.3 When a PF Source object is created, a global event and birth event are created.

4. After creating the PF Source object, open the Modify Panel and click the Particle View button, or press the 6 key. This action opens the Particle View window (shown in Figure 16.3), where the PF Source global event and birth event can be found.

Inside Particle view are two events, the PF Source global event and the birth event, which contains several operators, including a birth operator. When a PF Source object is created, these events are always created as well. A brief explanation of Figure 16.4 follows:

Global Event: Contains a render operator. This event is required for the particle system to be rendered. Any operators in this event are applied to every event linked to the global event.

Birth Event: This event is required for particles to be created. The birth operator is the only required operator in this event and should always be the first event. Other operators are used to control various particle parameters.

5. Drag the Time Slider and watch as tick marks emanate downward from the PF Source icon, as shown in Figure 16.5.

The Particle View editor can be accessed by pressing the 6 key, clicking the Particle View button in the Modify Panel (when PF Source is selected), or choosing Particle View from the Graph Editors menu.

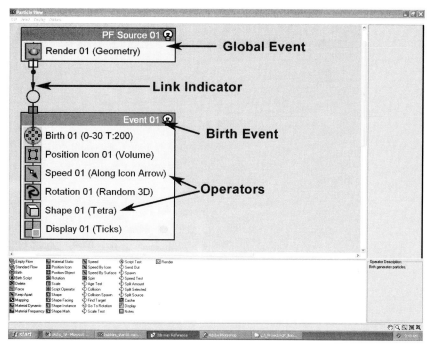

FIGURE 16.4 The Particle Flow diagram.

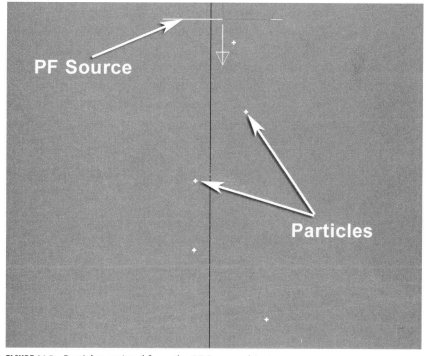

FIGURE 16.5 Particles emitted from the PF Source object.

6. Now change some parameters. Open the Particle View window and click the Birth operator to select it. Its parameters are shown on the right side of the Particle View window, as shown in Figure 16.6. In the Birth operator parameters, set the following parameters:

- Emit Start: −10 (starts particles flowing before the first frame)
- Emit Stop: 300 (continues to create particles until last frame)
- Rate: 200 (controls the density or frequency of particles created per second)

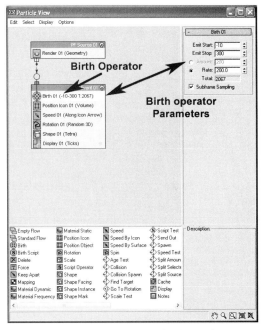

FIGURE 16.6 Setting parameters for the Birth operator.

7. Each of the operators are designed for a specific purpose, giving the animator complete control over what happens and when. Select the Speed operator in Event01 and change its Speed parameter to 2. This value sets each particle's speed to travel two units in one second. Notice how much denser the particles appear in Figure 16.7. This density is because the speed parameter doesn't affect the birth rate parameter.

8. Because you are creating bubbles for this effect, select the Shape operator and choose Sphere from the Shape parameter list. Change the Size parameter to 0.1. This value sets the size of each particle, not the entire particle stream. Though the particles still show as tick marks in the viewport, press

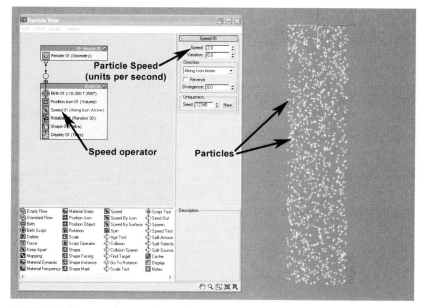

FIGURE 16.7 Because the speed was slowed, the particle flow becomes denser.

the F9 key in the Perspective view to see that they render as spheres, as shown in Figure 16.8.

FIGURE 16.8 The particles render as spheres, even though they are displayed as tick marks.

9. The Display operator (shown in Figure 16.9) changes how particles appear within the modeling environment and have no effect on the particles when rendered.

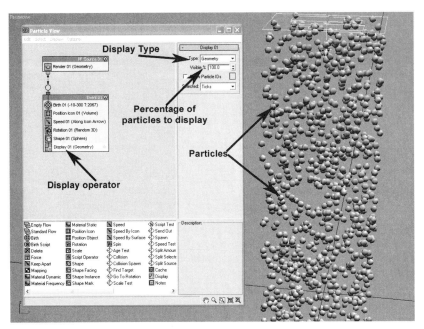

FIGURE 16.9 The Display parameters control how many particles are displayed in the modeling environment.

Reducing the Visible % parameter reduces the number of particles visible in the viewport but the full amount are still rendered. This setting is used to speed interactivity with a PFlow system.

10. In the Display operator, set the Visible % parameter to 50. Only half of the particles generated are displayed.
11. In the Front view, rotate the PF Source icon 180 degrees along the view's z-axis. The particles are now moving upward. Position the PF Source icon in the center of the skull object, so the bubbles are moving straight through the head, as shown in Figure 16.10.
12. The effect is to have bubbles coming out of the eye of the skull. As such, position the PF Source icon so that it pushes particles out of the eye socket closest in view. Resize the PF Source icon so it is smaller than the eye socket. Change the icon type to circular, as well. These adjustments are all shown in Figure 16.11.

FIGURE 16.10 The particles are now moving upward, through the head.

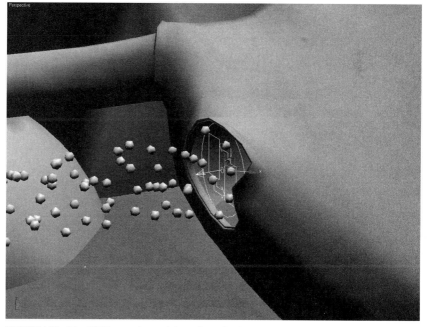

FIGURE 16.11 The PF Source is positioned inside the eye socket.

13. To make the particles float to the top, use a Gravity Space Warp. In the Create Panel, open the Space Warp tab, choose Forces from the object list, and finally click the Gravity button. Click and drag in the Top view to create a Gravity Space Warp. Rotate the Gravity icon so it is pointed up, because the bubbles will float upward, as shown in Figure 16.12.

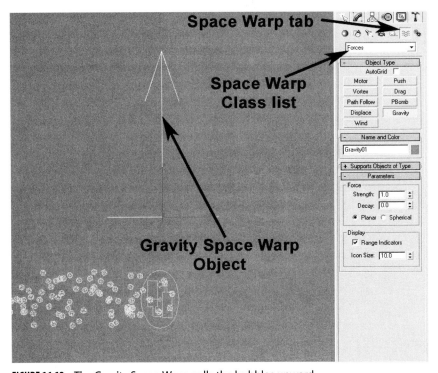

FIGURE 16.12 The Gravity Space Warp pulls the bubbles upward.

14. Because the default value of the Gravity Space Warp is too high, set the Strength parameter to 0.1.
15. The Gravity now needs to be applied to the Particle Flow by adding an operator to an event in the Particle View window. Drag a Force operator from the operator depot at the base of the Particle view window, to Event 01, as shown in Figure 16.13. When you drag it over the event, either a blue or red line appears. Position the cursor so it is below the Display operator and a blue line appears. Release the mouse button to position the Force operator at the end of the event list.
16. Select the Force operator in the event to access its parameters. Click the Add button, then click the Gravity Space Warp icon in the scene to add it to the list. Change the Influence percent to 100, as shown in Figure 16.14.

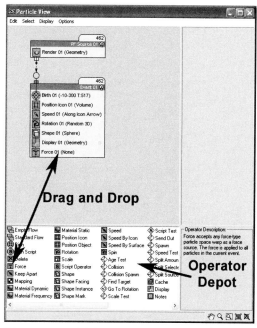

FIGURE 16.13 Add the Force operator by dragging from the operator depot to the event.

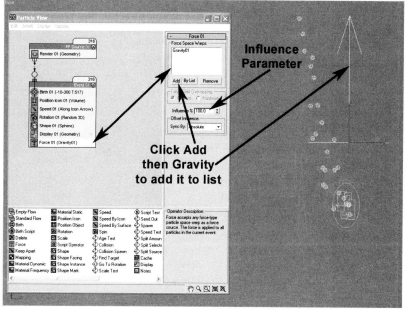

FIGURE 16.14 Add the Gravity Space Warp to the Force operator.

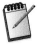 *When changing the Influence value in an operator that contains a list, such as the Force operator, the value is applied to all members of the list.*

17. In the Perspective view, click the Play button to preview the effects of the particles.
18. You still need to adjust the bubbles. In the Space Warp tab, click and add a Wind Space Warp. Position it so it is near the eye socket and pointing upward. Set the Strength value to 0.0. (Let the Gravity Space Warp control speed.) Set the Turbulence value to 0.14 and the Frequency to 0.03. All other parameters can be left to their default values.
19. In the Particle View window select the Force operator (don't add a new one), click the Add button, then click the Wind icon in the viewport to add it to the list, as shown in Figure 16.15.

FIGURE 16.15 Add a Wind Force to vary the bubble flow.

20. Save the scene. Drag the Time Slider or press the Play button to see how the particles waver slightly as they move toward the surface.

TUTORIAL　**APPLYING MATERIALS TO PARTICLES**

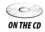

Unlike other objects in 3ds max, dragging a material from the Material Editor to a PF Source doesn't apply the material to the particles. This action does apply the material to the PF Source object, but the materials don't inherit the material properties. To add a material to a particle, use the Material operators, as explained in the following exercise.

ON THE CD

1. Continue from the previous exercise or open *bubbles_mat.max* from the companion CD-ROM.
2. Open the Particle view window (6 key). Drag a Material Static operator from the operator depot to the Event 01 window. Position it between the existing operators. A blue line appears. Release the mouse button when the blue line appears. The Material operator is positioned in the event as shown in Figure 16.16.

To replace an existing operator, drag a new operator to the event and drop it on top of the operator to be replaced. A red line appears when the operator is replaced. Operators can also be deleted using the Delete key or from the shortcut menu within the Particle View window.

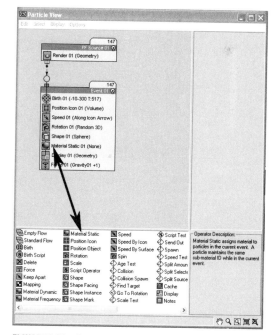

FIGURE 16.16　Drag a Material Static operator to the existing event window.

3. A material needs to be created to add to the particles, so create a simple bubble material by placing a falloff map (with default values) in the opacity channel of the material. Increase the Specular and Glossiness values and call the material *bubble*. You can also add color, if desired.

4. In the Particle View window, select the Material Static operator in Event 01 to see its parameters. Click the Assign Material button and choose from Material Editor. When the Material/Map Browser appears, select the bubble material and press OK. It is then applied to each of the particles in the PF Source. Figure 16.17 illustrates those parameters.

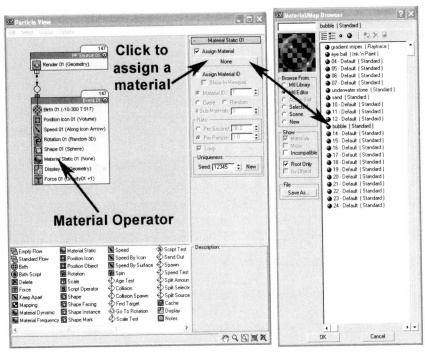

FIGURE 16.17 Materials are applied using a Material operator.

5. Render the image. Notice the quality of the bubbles is poor, as shown in Figure 16.18. The built-in particle shapes are low poly. You can change the shape using a Shape Instanced operator.

6. Create a sphere with a radius of 0.125 and 18 segments. Call it *single bubble*.

7. In the Particle View window, click and drag a Shape Instance operator and drop it on top of the existing Shape operator. A red line indicates the existing operator is replaced.

8. Select the Shape Instance operator to view its parameters, click the Particle Geometry Object button, then click the *single bubble* object to make the particle shape, as shown in Figure 16.19.

FIGURE 16.18 The built-in sphere shapes are low poly and render poorly when viewed closely.

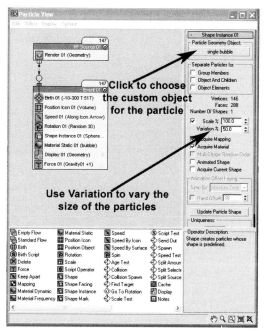

FIGURE 16.19 Replace the default Shape operator with a Shape Instance operator to use a custom shape for the particle.

9. Set the Scale to 100 percent and the Variation parameter to 50 percent to get a variety of bubble sizes, as shown in Figure 16.20.
10. Save the scene.

FIGURE 16.20 Use the Scale and Variation parameters to create bubbles of different sizes.

TUTORIAL

EVENTS, TESTS, AND BRANCHING

Tests can be given to a particle system to enable the particles to change their course of action based on some tests, such as age, collision, and position. The possibilities are endless because a script operator can be used to create additional tests. The following example teaches you how to use a test operator:

ON THE CD

1. Open *bubbles_collision.max* from the companion CD-ROM. The low poly fish object has been added and animated for this example.
2. Open Particle View and drag a collision operator from the operator depot to the end of Event 01, as shown in Figure 16.21.

The Collision test uses a deflector as a collision test. If particles collide or will collide (within a specified number of frames) with the deflector, the parti-

cle is sent to the next event. Because you want to use custom geometry for the deflector (the low poly fish), a UOmniFlect space warp needs to be used.

3. In the Front view, add a UOmniFlect Space Warp, found in the Deflectors section and choose the low poly fish as the object, as shown in Figure 16.22.

When creating collision objects, don't use high poly meshes. Using them only lengthens the particle calculation time without producing better results. In some cases, the result may actually be worse.

4. In the Collision test parameters, click the Add button to add a collision object, then click the UOmniFlect object to add it to the list, as shown in Figure 16.23.

As the parameters become true (the particles collide with the low poly fish), they are sent to the next event. To retain attributes of the current event, they must be added to the next event.

5. In the Particle View window, drag a Speed operator from the operator depot to an empty area in the Particle View window to create a new event, as shown in Figure 16.24.

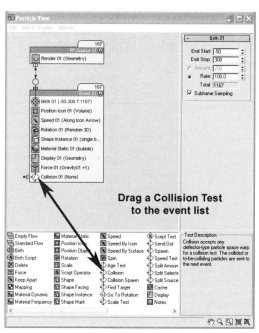

FIGURE 16.21 Add a collision test to the existing event.

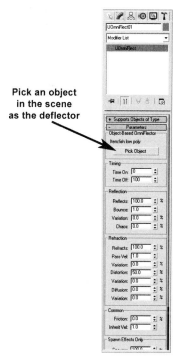

FIGURE 16.22 Use an UOmniFlect Space Warp to create a collision object out of the low poly fish.

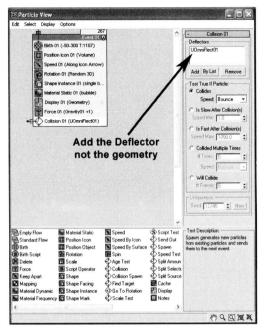

FIGURE 16.23 When using a deflector for collision, add the deflector, not the geometry.

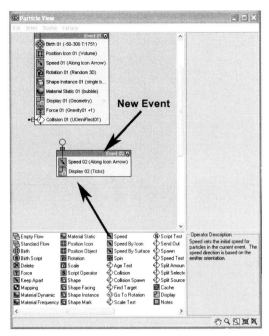

FIGURE 16.24 Create a new event by dragging an operator to a blank area in Particle View.

Dragging an operator to an empty area in the Particle View window creates a new event. The new event automatically has a Display event attached to it as well.

6. Set the Speed parameter of the Speed operator to 1.5.
7. Right-click the Shape Instance operator in Event 01 and choose Copy, then right-click in Event02 and choose Paste Instance to paste the operator in the new event.
8. To keep objects similar, similar operators must also be added. To do that, copy from Event 01 and paste instanced operators of the Material Static and the Force operator. Event 02 should look like the one shown in Figure 16.26.

When an operator is to be applied to all events, place it in the Global event (PF Source event). All operators in the global event are passed to every particle.

9. Click the Material Static operator icon in Event 02 to turn off that operator. Click the colored circle on the Display operator of Event 02 and change the Color Swatch to a bright color so the particles that enter this event are easily identified in the modeling view.
10. Link the event to the test output by clicking and dragging from the input connector at the top of the new event to the output connector of the Collision test, as shown in Figure 16.27.

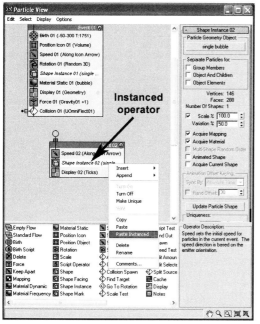

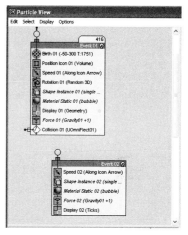

FIGURE 16.25 Paste an instanced operator to keep consistency among particles moving to other events.

FIGURE 16.26 The new event has many similar operators to replicate the look of the original particles.

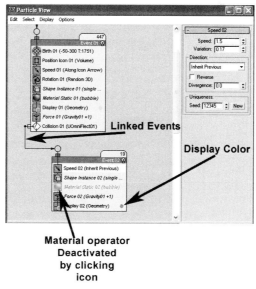

FIGURE 16.27 The linked events have a wire connecting them.

Some of the parameters, such as the speed, gravity affect, or the collision detection events, may need adjusting. Additionally, events such as the Keep Apart operator are used to keep particles from running through each other. Experiment with these and other operators, because the possibilities are endless.

SUMMARY

You can do many more things with Particle Flow. Using other operators such as the script operator, the capabilities of Particle Flow are uncharted. It is arguably the best new feature added to 3ds max 6, and many good things should come from it. In this chapter, you learned how to:

- Create a basic PFlow system
- Change operators
- Add materials to a PFlow event
- How to link PFlow events

Experiment with multiple events and tests. Using test operators leading to other tests operators and script operators can lead to some powerful results.

3DS MAX FILE FORMATS

This appendix describes the many output file formats available in 3ds max 6. Many files contain alpha channel information. An alpha channel, also known as a matte, is a grayscale image used to describe the borders of objects against a background. You can use other channels to show depth, motion blur, and focal length, to name a few. Each file format has advantages, and several formats are similar in their abilities.

AVI: Audio-Video Interleaved—the standard Windows format for movie files. This format is a self-contained movie file that can be played from a variety of sources and can use many available CODECs (compression and decompression algorithms). When rendering to the .avi format, you can use only a single machine.

BMP: The standard image format for Windows. Files can be saved with either an 8-bit palette (256 colors) or a true color 32-bit (16.4 million colors) format. Because these files have little or no compression, the images are crisp when the 32-bit option is used. Files sizes can be more than 1 MB for video resolution.

CIN: The Kodak Cineon format, which stores high-definition images as part of a video data stream. Used in film, this format does not support alpha channels.

EPS and PS: Encapsulated PostScript format. Rendering to this format enables most desktop publishing software packages to read and print images across multiple platforms. This format cannot be used when implementing maps in materials or as environment maps within 3ds max.

FLC: An Autodesk format, which was designed for digital animation using a single palette based on the first frame (low option) or an optimized palette of 256 colors based on analyzing every frame

(medium option). Palettes can also be created from an external palette when multiple animations must share the same color palette.

HDR: High Dynamic Range format. This format is used to capture all of the true color present in the world. In the real world, film can't capture the true range of existing color. This format is useful as backgrounds for compositing and as reflection maps.

JPEG: Joint Photography Experts Group format—a lossy compression algorithm with variable settings for quality and size of file. This format is popular due to its small file size and portability across multiple platforms. JPEG does not support alpha channels.

PNG: Portable Network Graphic format used with Web graphics. This format contains variable settings for optimized palette and data transfer and can contain alpha channel information.

MOV: The QuickTime movie file format developed by Apple. This format is popular for creating digital movies for use on the Internet and DVD. Audio tracks can also be stored with this format.

RLA: An SGI format that supports multiple channels for additional information, such as Z buffer and material effects. Files sizes are typically larger due to the added channels. Pixel depth can be 8-, 16-, or 32-bit.

RPF: Rich Pixel Format. Similar to the RLA but with more information storage possible. RPF files can store 13 additional channels (excluding the alpha channel). This format is extremely useful during compositing and creating motion blur.

RGB: Developed by SGI®, this format supports 8- and 16-bit color depth. Alpha channel information can also be saved.

TARGA: Developed by Truevision for their video boards, this file format supports 32-bit true color images, including the 8-bits for the alpha channel. This format is popular for rendering a sequence of images to videotape.

TIFF: Tagged Image File Format. Used across multiple platforms, this format is used widely in desktop publishing and printing. The TIFF format supports several bit depth choices, as well as alpha channel storage and lossless compression.

B

ABOUT THE CD-ROM

The CD-ROM included with this book contains all of the files needed to complete the tutorials in the book, including all of the image maps and full color figures. The files are set up by chapter.

This CD-ROM will run on any standard PC running Windows. 3ds max 6 is required to open the scene files. A demo version of 3ds max 6 can be downloaded at www.discreet.com.

SYSTEM REQUIREMENTS

Windows: XP Professional (SP1), Windows 2000 (SP4), or XP Home (SP1); Internet Explorer 6; DirectX 9 Recommended (DirectX8.1 minimum); Open GL; Intel® Pentium III or later processor or AMD® running at 300 MHz minimum (Dual Intel® Xeon or dual AMD Athlon system recommended); 512 MB RAM and 500 MB swap space minimum (1 GB RAM and 2 GB swap space recommended); graphics card supporting 1024x768 16-bit color with 64MB RAM (preferred: OpenGL and Direct3D hardware acceleration supported, 3D graphics accelerator 1280x1024 32-bit color with 256MB RAM); Windows-compliant pointing device (specific optimization for Microsoft Intellimouse®, Wacom Intuos or similar pressure-sensitive tablet recommended for vertex paint); CD-ROM drive; optional: sound card and speakers, cabling for TCP/IP-compliant network, 3D hardware graphics acceleration, video input and output devices, joystick, MIDI-instruments, 3-button mouse.

INDEX